SPECTACULAR HOMES
of Texas

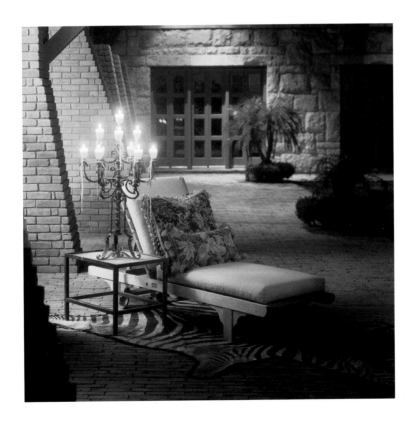

AN EXCLUSIVE SHOWCASE OF TEXAS' FINEST DESIGNERS

Dedicated to:
Brian, Max and all my wonderful friends –
my home would not be truly spectacular without them in it.

Published by

SIGNATURE
PUBLISHING GROUP

13747 Montfort Drive, Suite 100
Dallas, Texas 75240
972-661-9884
972-661-2743
www.spgsite.com

Publisher: Brian G. Carabet
Designer: Derrick Saunders

Distributed by Gibbs Smith, Publisher
800-748-5439

PUBLISHER'S DATA

Spectacular Homes of Texas

Library of Congress Control Number: 2003096944

ISBN No. 0-9745747-0-8

First Printing 2003

10 9 8 7 6 5 4 3

On the Cover:
Susie Johnson, Susie Johnson Interior Design, Inc., Austin, Texas.
See page 102. *Photo by Mark Knight.*

Previous Page:
Toni McAllister, McAllister Designs, San Antonio, Texas.
See page 148. *Photo by Swain Edens.*

This Page:
Mark Smith and Joe Burke, Design Center, Austin, Texas.
See page 120. *Photo by Thomas McConnell.*

*An interior designer in Texas must fulfill certain educational and testing requirements. A registered
interior designer is knowledgeable about the Texas Accessibility Act, the International Building Code,
and other health and safety issues. This group of professionals can be identified by the credentials
appending their names. "Decorators," "designers" and "interior designers" may possess different
educational backgrounds and experiences.*

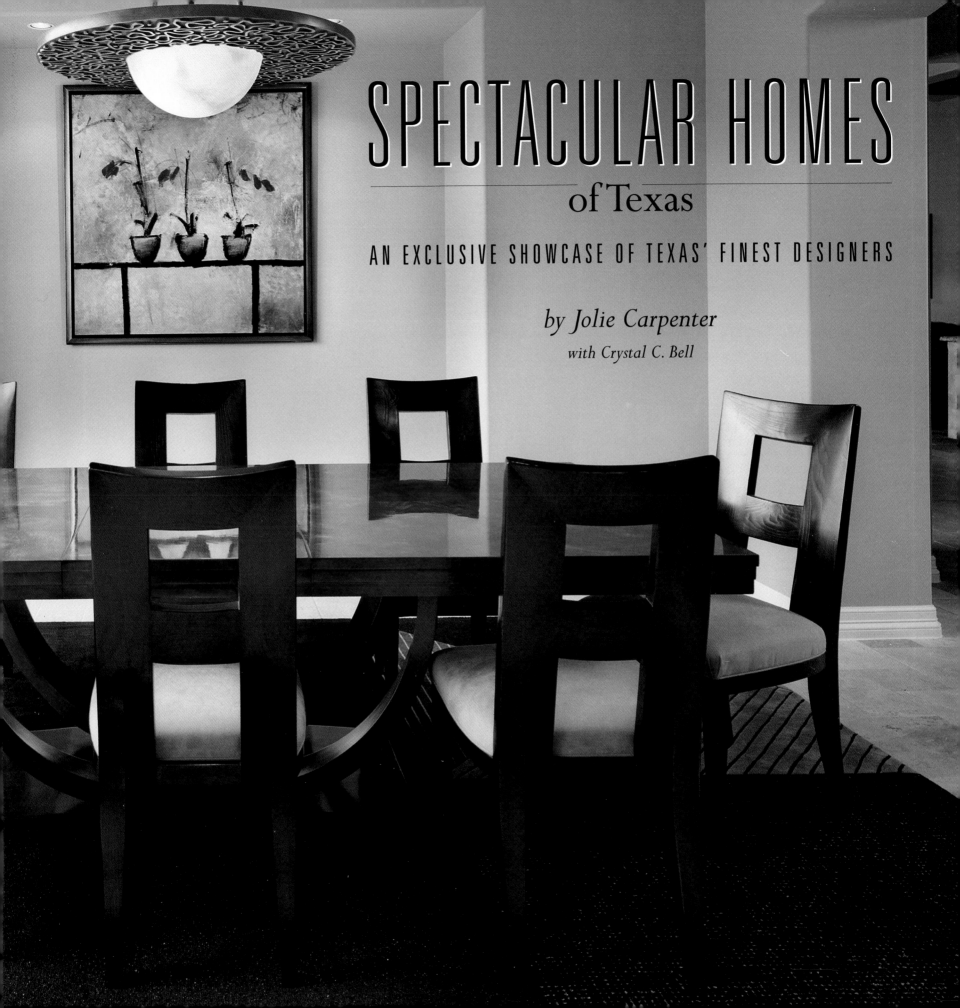

SPECTACULAR HOMES

of Texas

AN EXCLUSIVE SHOWCASE OF TEXAS' FINEST DESIGNERS

by Jolie Carpenter

with *Crystal C. Bell*

Introduction

This book represents a few things I love: interesting people, beautiful homes and Texas. As a 7th generation Texan, I wanted to show the world the Lone Star State's grand elegance. I combed the state, in search of the finest interior designers and decorators, who set the standard for style and innovation in Texas. It is a great honor for me to present to you some of the most spectacular homes in Texas and the interesting people whose outstanding design talent shines within. You will get an intimate glimpse into their lives and discover what stirs their creativity. As I spent hours getting to know these artists, their personalities emerged as colorful as the photographs. I was so inspired by all the tasteful homes we reviewed for this book that I gathered a few useful design tips for myself. I left several designers studios with a new item or idea – transforming my home during the evolution of this book.

Jolie and her dog Max at home in Dallas, Texas.

On the following pages, you will find well-known names behind projects such as the Venetian in Las Vegas and ASID Design Ovation award-winning showhomes. Some of the designers express themselves through custom-made bronze furniture or one-of-a-kind beds. Some received their education from prestigious design schools, while others apprenticed with highly respected leaders in the design field. Regardless of education or experience, each was selected on merit of visual consciousness.

Each chapter is lavishly illustrated with photos that feature beautiful furniture, art and a wealth of other luxurious interior furnishings. Whether it's the designer's personal home or that of a client, the photographs define extraordinary decorating and design excellence. There is something for all to appreciate, from a breathtaking French chateau on Lake Austin to a contemporary and sophisticated high-rise apartment overlooking the Houston skyline.

A home is not truly spectacular unless it reflects your personal taste with treasures that have special meaning for you. I hope this book inspires you to develop an environment that reflects your passions, as it did for me. I encourage you to surround yourself not only with the material comforts that bring you peace, but also with cherished friends and family who make your house a home every day.

All the best,

Jolie Carpenter

Table of Contents

DALLAS — CHAPTER ONE

Paige R. Baten-Locke8
Kathryn Clinton .10
David Corley .14
Adrienne Faulkner-Chalkley18
Sherry Hayslip .22
John Holstead .28
Kim Johnson, Kim Milam & Justin Seitz34
Allan Knight .40
Diane Linn .42
Lisa Luby Ryan .46
James McInroe .50
Marilyn Rolnick Tonkon52
David Salem & Lolly Lupton58
Beth Speckels .62
Neal Stewart & Doug Horton66
Richard Trimble .72
Cheryl Van Duyne76
Trisha Wilson .80
Joanie Wyll .86

AUSTIN — CHAPTER TWO

Bryn Butler .92
Julie Evans .94
Marla Henderson .98
Jenny Heusner .100
Susie Johnson .102
William Alexander Kincaid106
Gay Ratliff .108
Fern Santini .114
Mark Smith & Joe Burke120

SAN ANTONIO — CHAPTER THREE

Debbie Baxter .128
Orville Carr .134
Derrick Dodge .138
Charles A. Forster144
Toni McAllister .148
Christi Palmer .150
Don Yarton .154

HOUSTON — CHAPTER FOUR

Renea Abbott-Manteris162
Kelly Gale Amen .166
Ginger Barber .172
Richard Branch .178
Jane-Page Crump .184
Gloria Frame & Hilary Crady190
Helen B. Joyner .192
Marcia Kaiser .198
Ken Kehoe .200
Edwina Vidosh .206
Sherri Zucker .210

Acknowledgements212
The Publishing Team213
DIFFA .214
Photography Credits215
Index of Designers216

Neal Stewart Design Associates, page 66.

Dallas

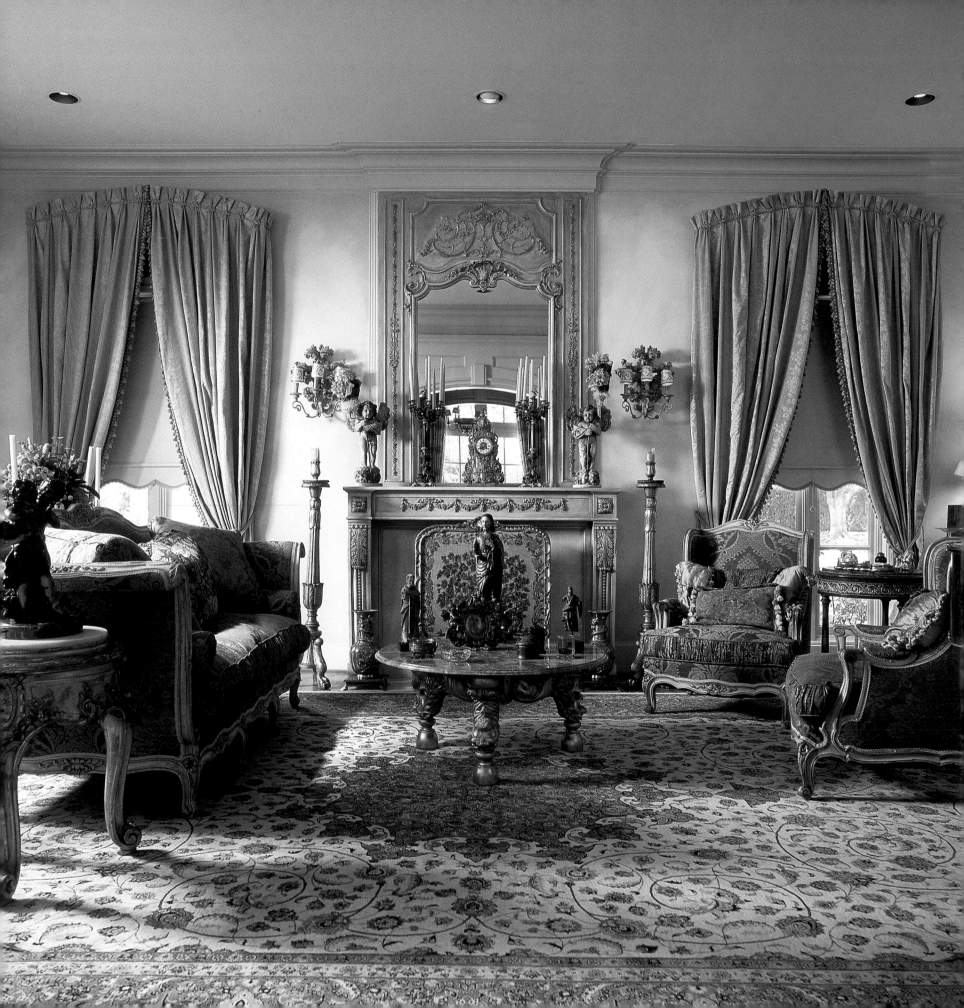

PAIGE R. BATEN-LOCKE

Paige R. Baten-Locke, ASID
Paige R. Baten-Locke Designs
4400 Purdue
Dallas, Texas 75225
214-365-0931
214-577-7327

For Paige R. Baten-Locke, variety is the spice of the design business. The majority of Paige's work is residential, with a significant dose of commercial projects, just to keep things interesting.

Paige and her design associate, Lisa Bennett, believe there's a psychology to every space, and query their clients closely so they can make their wishes about the ideal place to live or work come true. They relish serving as liaison between the architect-contractor teams and their clients, excelling at balancing a multitude of desires, demands and deadlines to achieve success.

Paige's goal is to create warm, inviting surroundings, no matter a client's style preference. She favors adding personal elements to the environment so the client can truly claim it as his or her own, like the time she hung a client's childhood drawing over the mantel in a ranch guest house for the perfect artist-in-residence touch.

When she graduated from the University of North Texas with a bachelor's degree in fine arts, determined Paige already was armed with a tax number

and business cards so she could immediately launch her Dallas design business. Her mother has been her biggest cheerleader since childhood, recognizing Paige's artistic talent early and enrolling her in painting and pottery classes.

Paige believes she is blessed to be living her dream, although she's open to suggestion and new opportunities. Among the priorities on her to-do list are two books she wants to write — a novel and a cookbook.

Paige is devoted to her husband and daughter, who was indoctrinated into the design business as a toddler, often accompanying Paige on design research ventures in her stroller.

Left: The formal French-style living room is a grand salon for entertaining.

Right: The open floor plan of this fresh, eclectic home is perfect for the empty nesters who enjoy life in this setting.

Far Right: Paige R. Baten-Locke (left) and her design associate, Lisa Bennett.

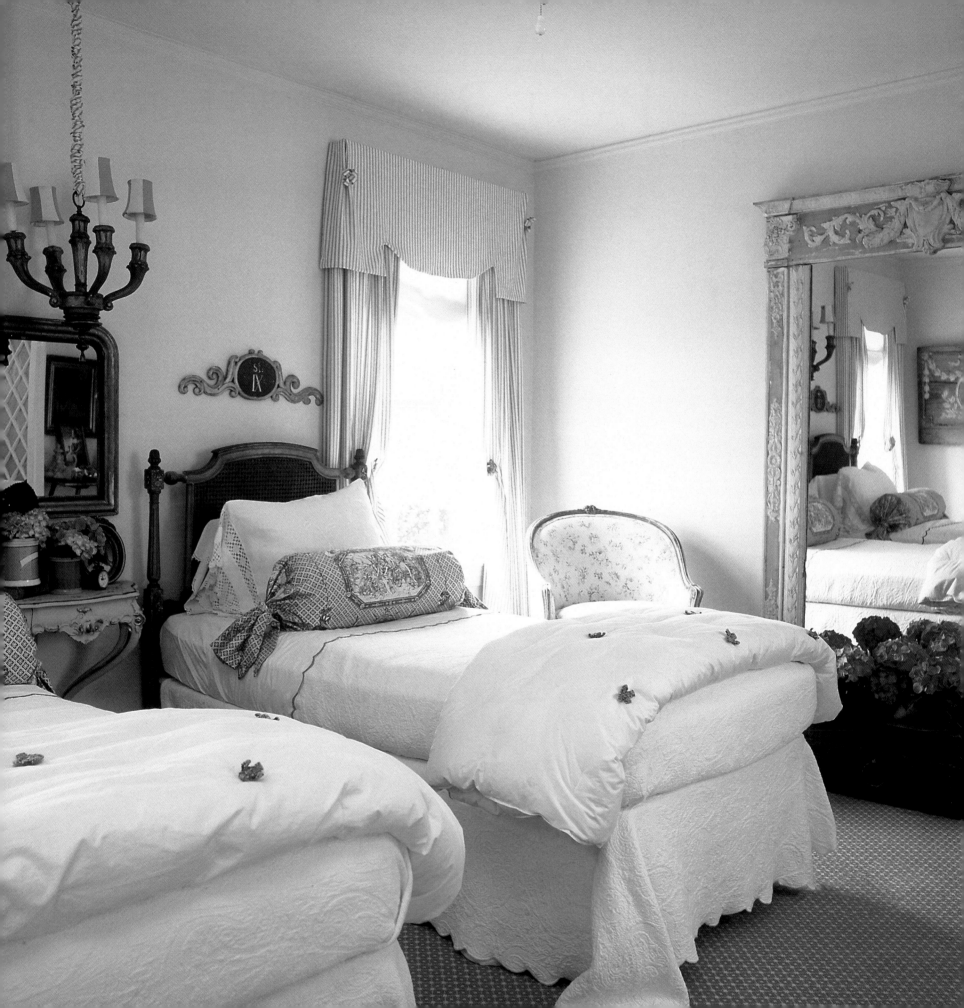

KATHRYN CLINTON

Kathryn Clinton Interiors
3320 Greenbrier
Dallas, Texas 75225
214-616-1122

Kathryn Clinton is a classic Texan. A member of the Daughters of the Republic of Texas, Kathryn has a can-do attitude that won't quit. She once installed a three-log structure, 28-bed Colorado home in seven days. She loves to tell the story about meeting the former Brooklyn, New York, police chief turned elite firefighter during the job when she and her crew were evacuated during a mountain forest fire that was getting too close for comfort.

A graduate of Texas Tech University, Kathryn still manages her business by words of wisdom gleaned during an internship with a world-class designer who studied in France. He taught her to "buy sparingly but good." She took that lesson to heart, and always takes the time and does the research to purchase timeless objects with intrinsic value for clients.

Kathryn takes pride in her ability to "get into her clients' heads" so she can better communicate with them and excel at her work. If it's not reciprocal, she thinks nothing of giving them assignments so they can get with the program.

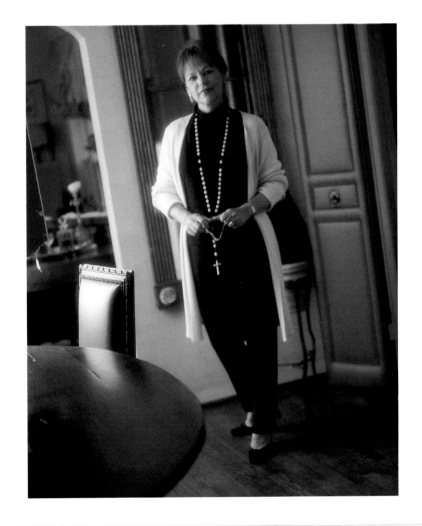

Left: With its cool, crisp coloration, Kathryn's guest bedroom inspires relaxation. She creates a gentle ambiance with elements ranging from a simple carpet to charming vintage cottons and linens.

Right: Kathryn Clinton.

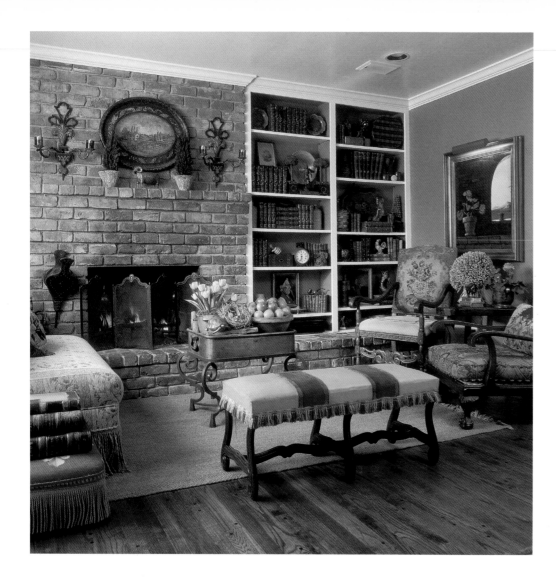
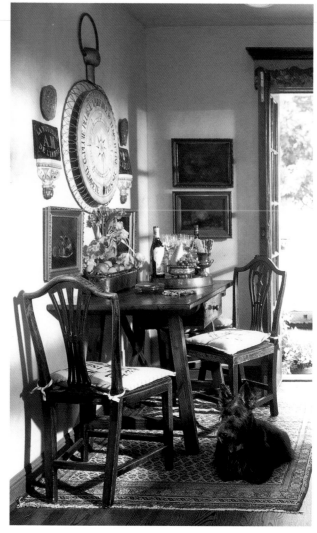

An artist since childhood, Kathryn sketched with her mother, a fashion designer who created Kathryn's wedding gown and the gowns of her bridesmaids. From that incredible inspiration grew Kathryn's confidence in her artistic abilities. In addition to interior design, she gravitates toward other three-dimensional art – sculpting, and casting and fabricating jewelry. A member of a Dallas art studio, she frequently accompanies the group on plein air painting sessions in Texas' Big Bend area or Hill Country.

Trained in all aspects of design, Kathryn can switch gears from stark contemporary to comfortable traditional in a flash. She likes to incorporate shades of red into interiors because they are vibrant and passionate. Kathryn also is a voracious reader and has an extensive library covering subjects from architecture and history to the decorative arts, which she often references on the job.

Her work for clients frequently goes above and beyond the routine. Once she even purchased a painting on the wall in a four-star restaurant with a particular client in mind. Kathryn, who has a great eye, later discovered the painting was signed by a listed New Mexico artist.

Kathryn's always setting new goals for herself, looking to expand her thinking and professional abilities. Her dream is to earn a degree in architecture and become an urban planner, ultimately aiming to develop a semi-rural retreat on the rolling prairie near Dallas/Fort Worth.

Kathryn is blessed to live with her family in the Dallas Park Cities home where her husband was reared, and treasures the memories and tradition that rare privilege brings.

Far Left: In Kathryn's multifunctional den, a fireplace and art and furnishings from the 17th, 18th, 19th and 20th centuries create a welcoming atmosphere.

Left: The Clinton family's Scottie, Ellie, models in the kitchen's dining area. Vintage copperware and French tulips welcome guests, along with some wine and cheese.

Right: In the Clinton dining room, Italian leather chairs flank a custom drop-leaf dining table. The banquette, leather doors and antique hunt paintings are reminiscent of a cozy European restaurant.

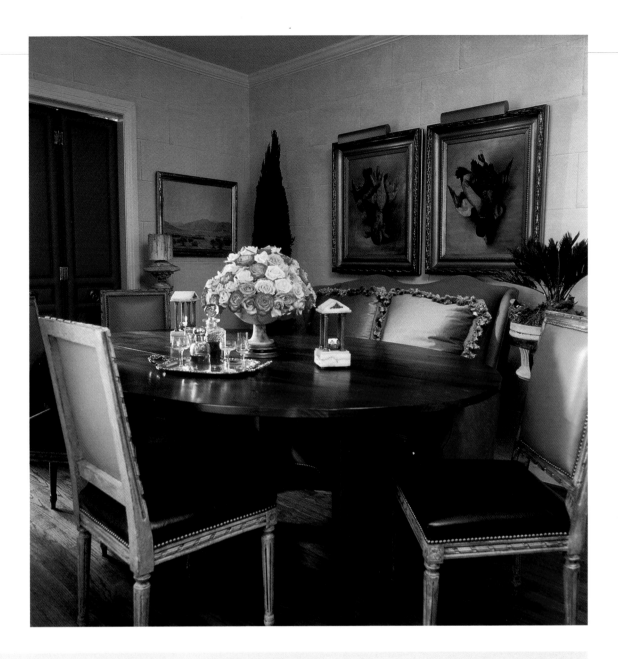

MORE ABOUT KATHRYN. . .

What are some of Kathryn's interests outside the design world?
Kathryn and her husband are gourmet cooks and have visited California's Napa and Sonoma Valleys to pursue their interest in wines; they also attend cooking schools. According to Kathryn, she'll "pecan smoke" anything! The Clintons are known as a "tennis family," spending many enjoyable hours competing on the courts and attending matches.

What are some of her favorite projects?
Ranches in East and West Texas. Another is an exquisite home in the hills of Austin. Prior to construction, she walked the rolling property with her client of more than 30 years ("he's an unbelievable visionary," says Kathryn) – the ultimate in planning.

If Kathryn could eliminate any design elements from the world, what would they be?
The gaudiness of today's home furnishings market, which she likens to the extreme decadent decoration of the late Victorian era. Kathryn also dislikes today's mixing of architectural periods and wishes for an enlightened return to classic, pure styles.

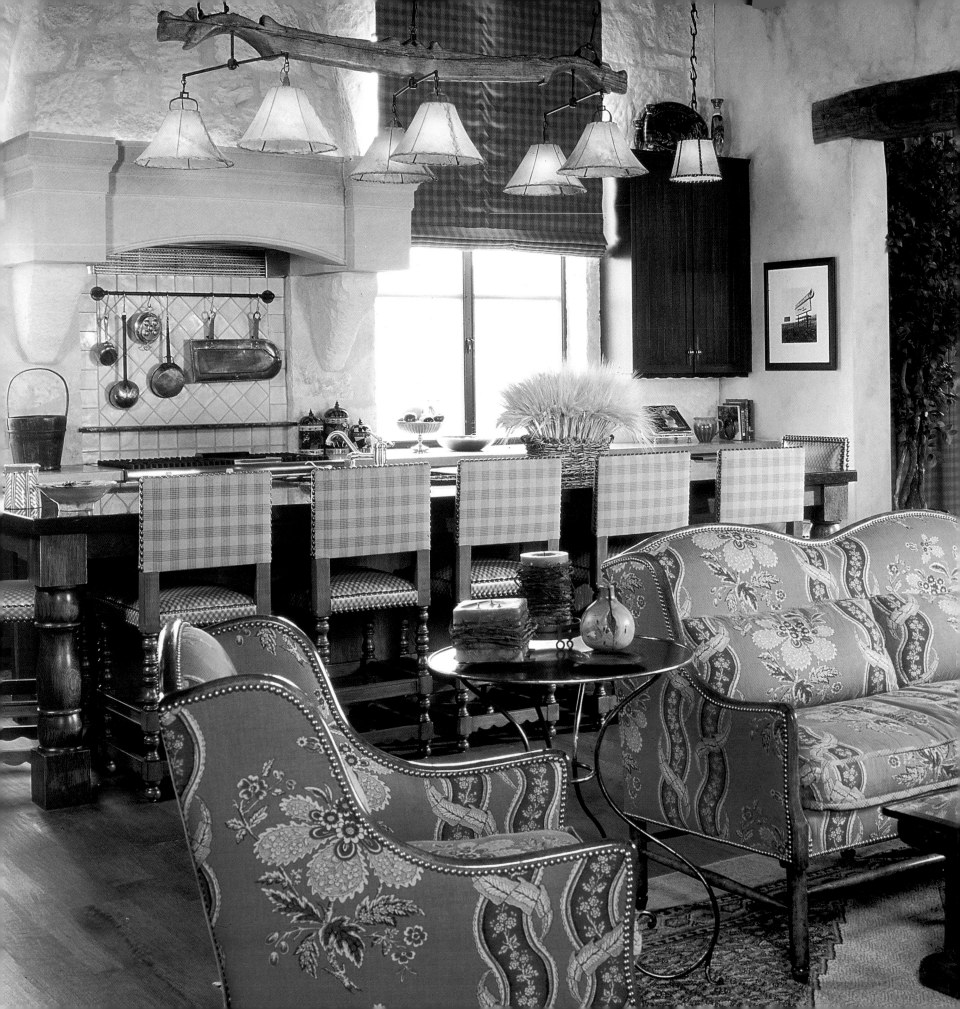

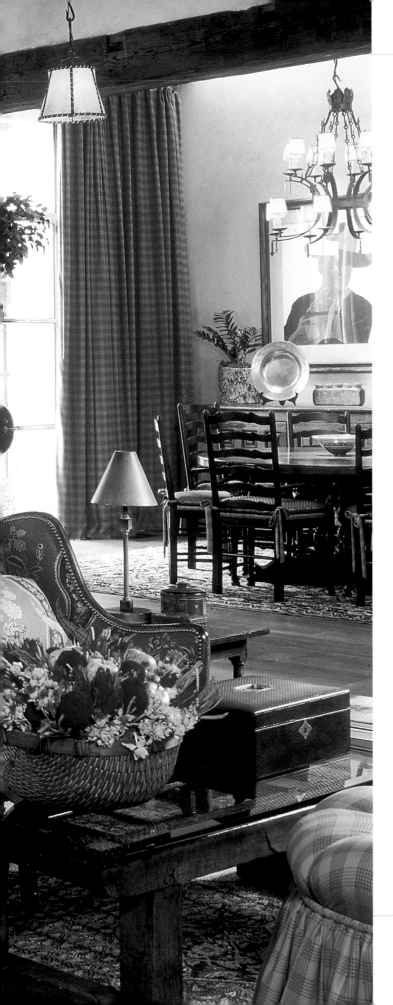

DAVID CORLEY

David Corley, ASID
David Corley Interior Design
909 Dragon Street
Dallas, Texas 75207
214-742-6767

Modest about his achievements, David Corley is highly respected among fellow designers for his integrity, talent and consistency. You'd never know he routinely has rubbed shoulders with the crème de la crème of design.

David took the direct route to the world of design, receiving a bachelor's degree in commercial art from Southern Methodist University. He opened a design department for an office equipment company when that organization began to create office interiors.

In those days, executives were lucky to have a cubicle and a gray metal desk, but soon David was part of the industrywide revolution when contemporary wood and steel furniture transformed offices into pleasant environments in which to work. He was part of the move to give offices — especially executive suites — a more residential look and feel, complete with fabric on walls and drapes on windows.

Eventually, David formed a partnership with a Fort Worth client for whom he had designed an office and launched a full-time residential practice. They had a ready-made list of clientele — the individuals for whom David had designed executive offices. Now he was decorating their primary and secondary homes as well. The twosome also established the Minton-Corley Collection furniture line.

Left: This Texas ranch residence has an expansive kitchen and breakfast area with country French furnishings, concrete countertops and camel hair rugs. Cheerful Lee Jofa fabric covers the sofa and chairs. Custom lighting, including a chandelier fashioned from an oxen yoke, was designed by architect Turner Boaz Stocker.

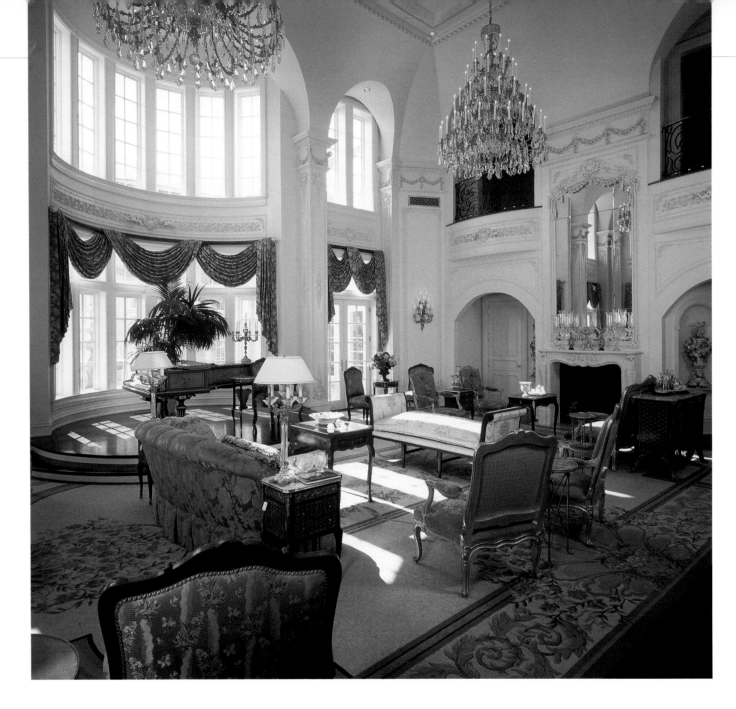

David, who has a great fashion sense and surpasses most business executives in appearance and demeanor, understands the value of strong client relationships. For him, they're more important than anything else. Also vital to success, he says, are experience and the knowledge of what's available and where.

David doesn't have a signature look but rather tries to determine a client's lifestyle and taste, and lets those guide the outcome. He's adamant about shunning anything trendy. His career includes a few of what David calls "hard" contemporary interiors. But he prefers a more traditional, comfortable approach, with a fluid blending of European antiques, reproductions and ageless fabrics.

David's accomplishments run the gamut from city residences, ranch houses, mountain cabins and beach retreats to private offices of successful business executives and occasionally their jets or yachts.

Left: Priceless French antiques, including a rare salon set with original tapestry, decorate this exquisite formal living area. A built-in mirror hangs above the marble mantel. Custom-made rugs from Martin Patrick Evan are based on antique Aubusson designs. Moldings are by J. P. Weaver of California.

Top right: A sophisticated two-story library features a 19th century Louis XV desk with leather top, tufted navy leather sofas by Edward Ferrell and an Arcadia custom rug with swan motif.

Bottom right: This grand entry's pièce de résistance is Jerusalem gold limestone. The graceful iron work is by Iron Craft Studio, Dallas. A mural by Eyecon accents the stairway that leads to a third-floor ballroom.

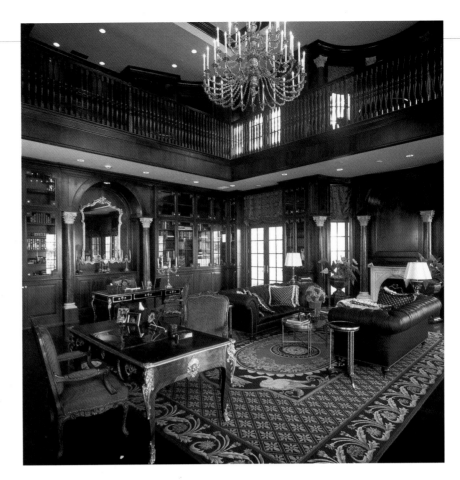

Today, David lives two lives. Part of the week he lives in Fort Worth where he and wife Mary spend time with their family; David commutes quickly and easily to his Dallas studio. On weekends, you can find the Corleys in Santa Fe, New Mexico, where they have a second home and an antique shop just off the square.

MORE ABOUT DAVID. . .

What accomplishments is David most proud of?
David participated in a collector's engagement calendar for the Winterthur Museum and Gardens. He and other renowned designers commented on their favorite Winterthur antiques in the calendar. He was thrilled with the ready access to priceless antiquities, which he still considers a great privilege and career highlight. He also participated in group shows in New York (sponsored by Billy Baldwin) and Atlanta that featured the work of top U.S. designers such as Mark Hampton, Bill Blass and Mimi London.

What is the single thing he would do to a room to bring it to life?
True to form, David would add people. Client relationships are all important to David, who believes the foundation of the interior design business is relationships.

How does David relax from his hectic schedule?
David is always on the job. He enjoys mixing business with pleasure (it's all pleasure to him!), even on frequent trips to Europe where he enjoys making the rounds, buying for clients and establishing new business contacts.

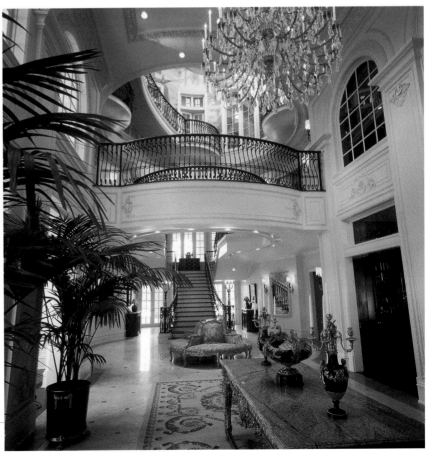

ADRIENNE FAULKNER-CHALKLEY

Faulkner Design Group
3232 McKinney Avenue, Suite 170
Dallas, Texas 75204
214-389-3304

When Adrienne Faulkner-Chalkley was a child, she rearranged her bedroom furniture about every six months – her first clue she wanted to be an interior designer. Taking time out to earn a bachelor's degree in business administration, Adrienne followed her bliss and pursued a design career.

Adrienne never has regretted a moment spent with her nose in an accounting textbook or analyzing European equity offerings because she realized early on that solid business judgment often determines success. She supplemented her business education with design studies and finally indulged her passion, first as an intern for a well-known Dallas interior designer and later as a designer for a successful architectural firm.

Then Adrienne was offered the opportunity to design former Dallas Cowboy Troy Aikman's residence, which spurred her to launch a practice on a shoestring from her home's second bedroom.

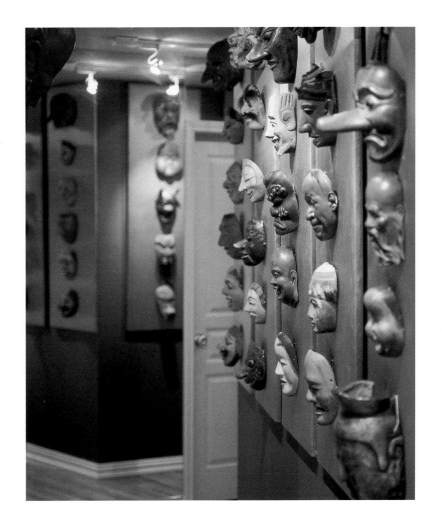

Left: Among the treasures in the living and dining rooms of the Faulkner-Chalkley residence are those collected by Adrienne's grandfather, noted Dallas architect George L. Dahl. They include an Italian street scene mural he purchased in New York in the early 1950s. Open bookshelves and silk portieres separate the formal living space from the informal den and open kitchen area.

Right: Adrienne hangs her grandfather's mask collection in her home's hallway. The masks are reflected in a facing mirrored wall. She says the décor follows the precepts of feng shui, which advocate hallways represent ancestry.

Since then Adrienne has built the Faulkner Design Group into an award-winning, full-service design enterprise that specializes in high-end residential projects, as well as multifamily, hospitality, corporate, senior living and student housing developments. She has more than 400 projects in the United States and Canada to her credit and today employs about 15 architects and designers whose team spirit and incomparable creativity energize her.

Adrienne believes versatility makes a designer desirable. From traditional to contemporary, modern to rustic Texas ranch, she creates a variety of looks with aplomb. Her 'round-the-world travels, which she began as a teenager, imprint her designs. She sometimes punctuates rooms with elements from different countries and cultures, creating a distinctive theme or one-of-a-kind eye catchers. Whatever the approach, Adrienne aims to tweak her clients' sensibilities with the unconventional and help them "think outside the box." Her objective is to produce spaces that affirm how they live and work.

Adrienne is driven by her clientele's emotional response to ideas and the relatively rapid turnaround time some projects demand. And because she operates across two countries, she is intrigued by regional market characteristics and integrates them into her custom settings.

Left: In the Faulkner-Chalkley master bath, large corner windows bring the outside in. The shower walls are comprised of oversized slabs of Chinese slate, and the floor is chipped travertine with a tumbled marble mosaic design. The custom-designed vanity easily accommodates two.

Top right: A custom-designed water wall adds drama to a sleek, contemporary entry hall.

Bottom right: Timeless art by Adedio Costantini provides a stunning backdrop for a casual contemporary Italian living area. Soft ambient lighting reflects the warm amber hues of bamboo floors and maple veneers.

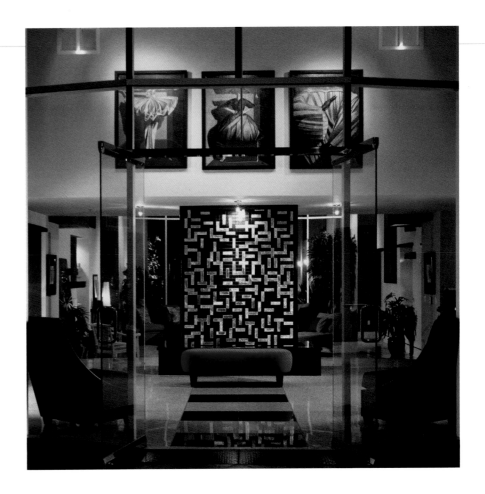

Adrienne's grandfather was George L. Dahl, renowned architect of Dallas' Fair Park. Following in his footsteps as an international traveler, collector, art connoisseur and entrepreneur, Adrienne admires her grandfather's business acumen and artistry. She has established a Web site, www.architectural-images.com, where she shares his renderings as giclée reproductions.

Adrienne finds peace away from the design and business worlds by simply relaxing at home under majestic oak trees or by the pool with her three sons and husband and soul-mate Nigel, who keep her grounded and balanced.

MORE ABOUT ADRIENNE. . .

What would Adrienne do to a room to bring it to life?
Add color. It's the simplest, easiest and most cost-effective tool a designer can use to evoke emotion.

What objects has she had for years that remain in style today?
Her grandfather's priceless mask collection, which he acquired during his travels because he was fascinated by faces. Adrienne has added masks from Mexico and Bali since she became the grateful caretaker of these treasures, hanging them in her home's hallway.

How would Adrienne's friends describe her?
She's focused on lifelong relationships, both personally and professionally. She is responsive, client oriented, loyal, honest and a visionary.

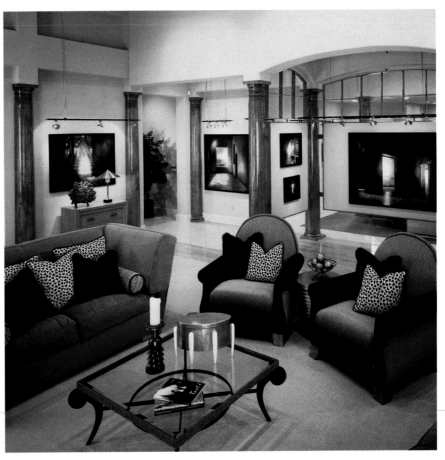

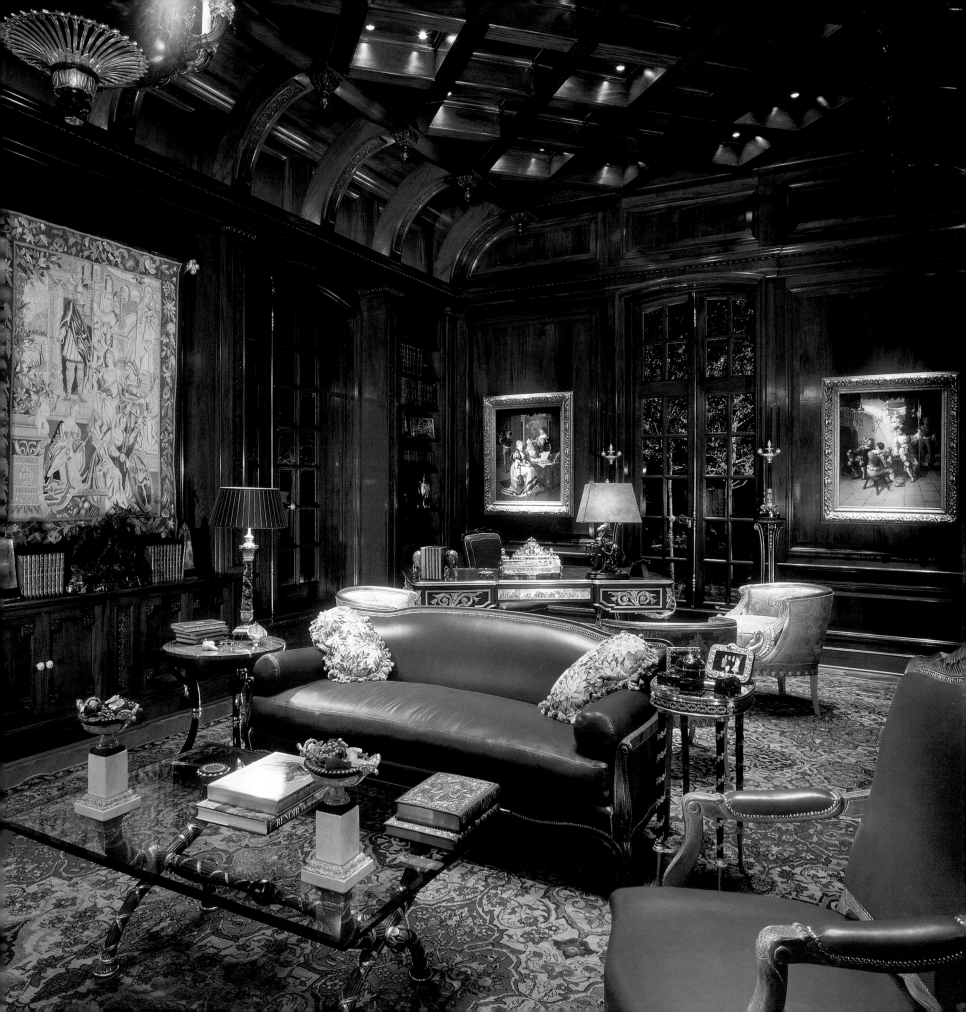

SHERRY HAYSLIP

Sherry Hayslip, ASID, IIDA
2604 Fairmount
Dallas, Texas 75201
214-871-9106

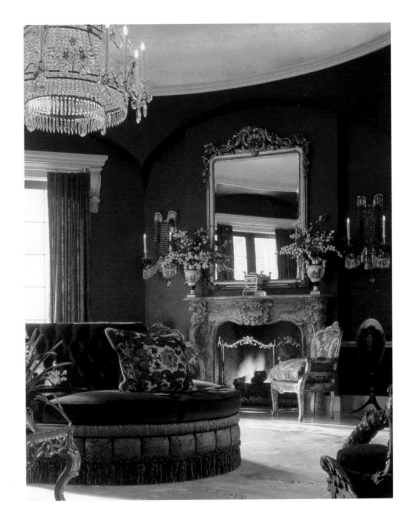

Sherry Hayslip's approach to interior design has a philosophical edge. A self-professed rationalist, Sherry successfully juxtaposes reason with art, enriching clients' lives with beauty and meaning.

One of the premier interior designers in Texas, Sherry is owner and principal designer of Hayslip Design Associates, which she founded more than 25 years ago. Her firm, one of the largest interior design organizations in Dallas, has earned a reputation for sound design, practical project management and client satisfaction.

Sherry's business comprises a complementary mix of high-profile residential projects and executive commercial work. Her diverse portfolio includes projects ranging from a grand 44,000-square-foot classically inspired home to a .5-square-foot tree trunk residence for an imaginary bunny.

National and regional plaudits attest to the quality of Sherry's work. Honors include national ASID Interior Design Project first-place awards for residences over and under 3,500 square feet, as well as *Dallas Home Design* Silver Style awards for Best Home Design over 5,000 square feet and Best Contemporary Design. Her work has been featured extensively in national and international news and trade media.

Left: With its French polished mahogany paneling and ceiling, this French Directoire-style library adds richness to a grand, historically accurate chateau.

Right: The centerpiece of this shimmering raisin and ochre living room is a large oval borne, or confidante. Designed by Sherry, it provides seating with substance.

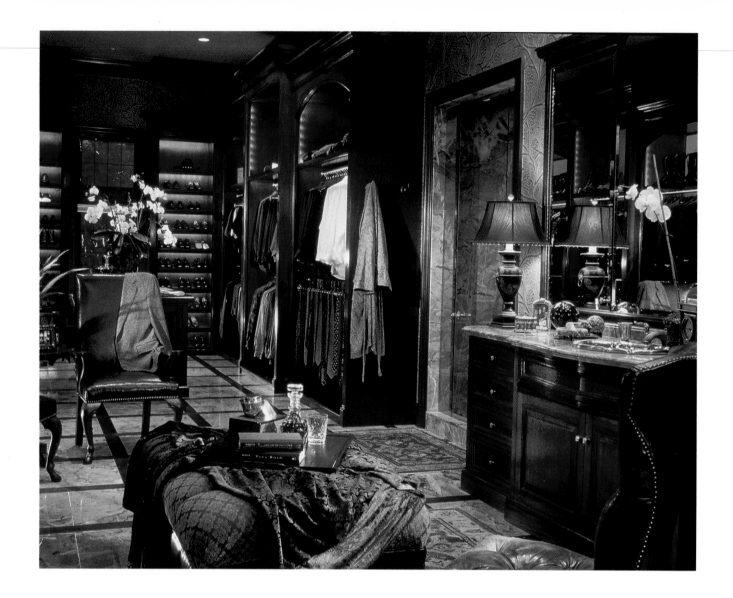

Sherry earned a bachelor of fine arts degree with honors in comparative studies from Southern Methodist University where she also has pursued liberal arts graduate studies. Her undergraduate work ran the gamut from art history to literature to aesthetic philosophy – a broad background that has served her design career well, enhancing her creativity and strengthening client communications.

Additionally, Sherry has participated in several advanced programs in the decorative arts, architecture and business, including seminars sponsored by the Parsons School of Design, Harvard University, and the Bard Graduate Center for Studies in the Decorative Arts. During sojourns in Europe, particularly England, France and Italy, she has studied art and architecture.

A stalwart proponent of continuing education, Sherry hosts European study trips for her staff, so they, too, can experience the "source material" of great design.

Sherry takes education beyond the classroom and applies learning to every design project, encouraging clients to become students of the art as well. She researches style histories, as well as the origins of clients' private collections so she may better incorporate them into personalized settings.

Above: With silver wallcovering, dark mahogany molding and inlaid marble, this gentleman's bath combines a sitting area, complete bath and haberdashery-style closet and dressing room.

Right: A built-in banquette enhances seating in an English baroque great hall, providing a cozy retreat.

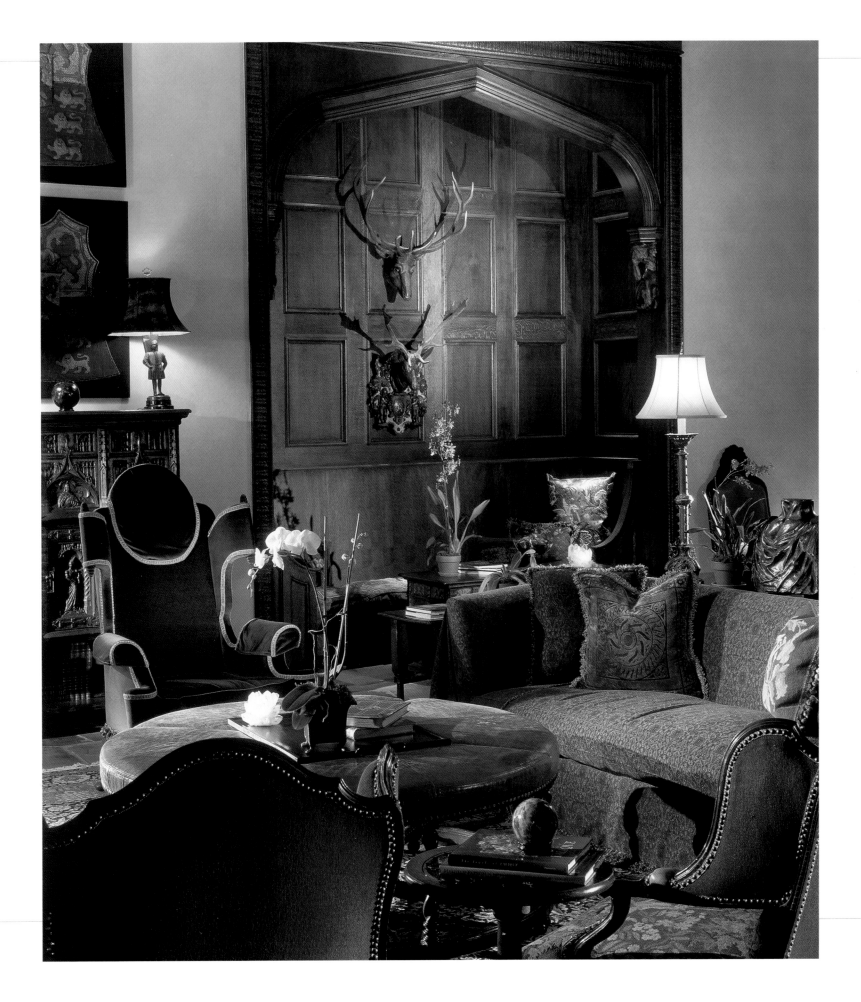

Left: As light enters this foyer, it bathes the oyster-colored walls and floors in a golden haze, bringing warmth and comfort to this contemporary home.

Right: A smooth black river rock hearth and sleek maple bookcases hidden behind closed doors add an understated elegance to this library.

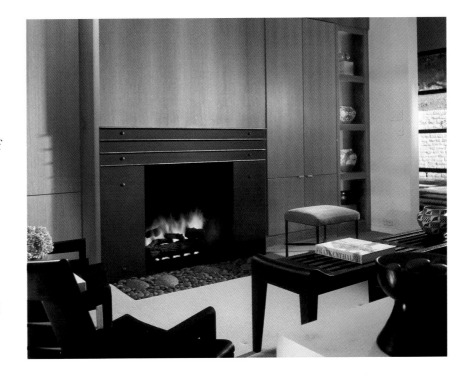

A thoughtful designer, Sherry creates interiors that work within the parameters of a space's architectural integrity and a client's tastes and desires. The anchor of Sherry's work is classicism, whether the style is period, modern or contemporary. Focusing on simplicity, symmetry, proportion and balance, she aims to create "something beyond decorating," bringing multidimensional personal meaning to clients' everyday surroundings.

One of Sherry's passions is designing rooms for clients' children. Ideally, she involves each child in the design process, hoping to give him or her a meaningful experience and lifelong memory. If children help create their personal space, she believes, they grow up feeling loved, respected and important.

For Sherry, an interior is a composition, with each element part of a bigger picture and the whole more beautiful than the parts. For inspiration, she calls on the totality of life – particularly nature, history, revered manmade objects and forms, and respected, revolutionary creative thinkers such as Michelangelo, Thomas Jefferson and Edith Wharton.

Occasionally, Sherry escapes from her practice by writing (she keeps a personal journal, writes articles about design and is working on a couple of books) and reading (she enjoys philosophy, contemporary fiction and nonfiction). Travel is her absolute getaway. And though Italy is her favorite destination, Sherry finds beauty everywhere she goes.

MORE ABOUT SHERRY. . .

What design element has Sherry used for years that remains in style today?
Fortuny fabric.

Who has had the biggest influence on Sherry's career?
Her husband, architect Cole Smith, Sr. Sherry says Cole is a phenomenally gifted classical architect who is "fully present," savoring every aspect of life. She has learned to view the world through his eyes, more critically but with more joy.

Why does she like doing business in Texas?
Because the people are friendly, warm and gracious in both their personal and business relationships.

What does Sherry like best about being an interior designer?
Helping people improve their lives by bringing beauty into their homes.

What is one of Sherry's personal indulgences?
Sherry has more than 100 pairs of designer shoes. She owns lots of black, brown and gray shoes for basic business and evening wear. But she also splurges on "fun" colorful pairs to brighten somber outfits or for casual wear ("red shoes are an essential part of any woman's wardrobe," she says). "I love looking down at my pretty shoes and secretly feeling good about this finishing touch, even if it is primarily just for me," says Sherry.

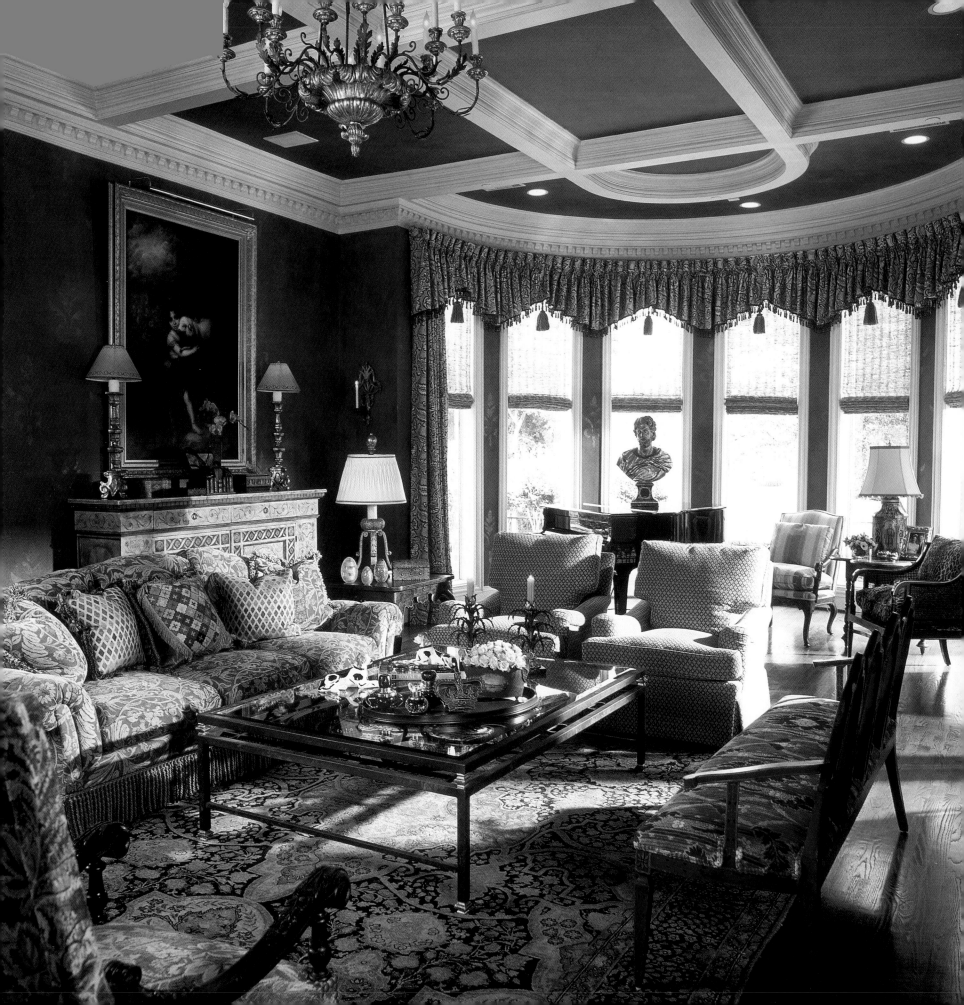

JOHN HOLSTEAD

John Holstead, ASID
John Holstead Interior Design
2050 Stemmons Freeway, Suite 126
Dallas, Texas 75207
214-698-0922

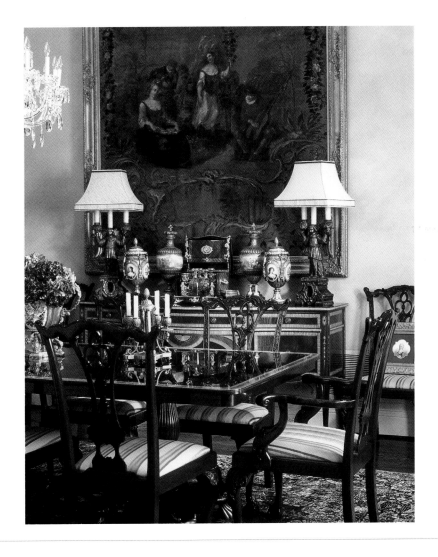

John Holstead's thriving design business is testimony to his exceptional vision and versatility. His keen ability to view objects and settings three dimensionally enables him to take a virtual tour during the design process. John has an innate ability to produce distinct design environments in a variety of styles to meet clients' personal expectations. He can create a chic mid-century modern milieu, a traditional 18th century setting filled with priceless art and porcelain, or a casual low-country look with equal dexterity.

John earned a bachelor's degree in interior design from the University of North Texas and acquired management savvy while assisting with his family's business. He has ventured to England, France and Italy to further his study of art, architecture and the decorative arts. He has practiced design for 20 years.

Left: Sumptuous color and rich textiles make this family area the ideal setting for relaxing in style.

Right: A rare porcelain collection and French antique canvas are the perfect accents in this formal dining room.

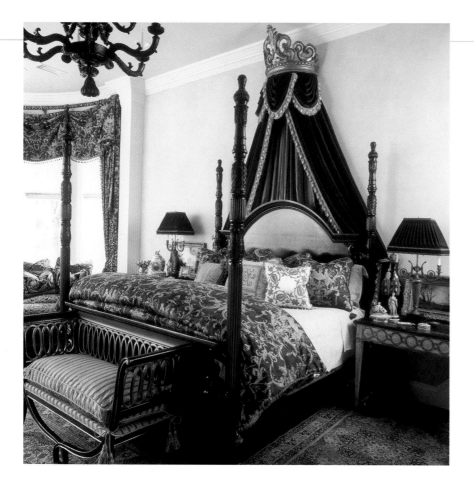

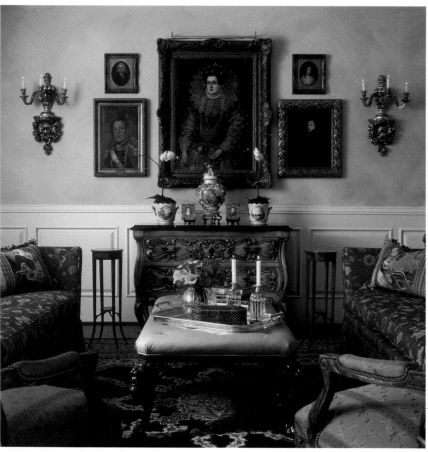

Top left: A four-poster Italian bed with corona transforms this bedroom into a royal retreat.

Bottom left: Antique portraits add a personal touch to a traditional conversation area.

Right: Lavish drapery treatments soften this paneled English gentleman's study.

John primarily caters to residential clients. He likes nothing better than to take on new construction ventures, preferably as a charter member of the design team, along with the project architect and builder. He also handles major renovation work. A third design niche, vacation homes, has taken him from Carmel, California, and Cordillera, Colorado, to the Florida Keys.

John believes his ability to establish intimate communications with clients during the programming process is vital to every project's success. As part of the regimen, he assigns them homework, so they can discard preconceived notions and become aware of their design preferences. With this solid foundation, John and his clients proceed with projects on common ground.

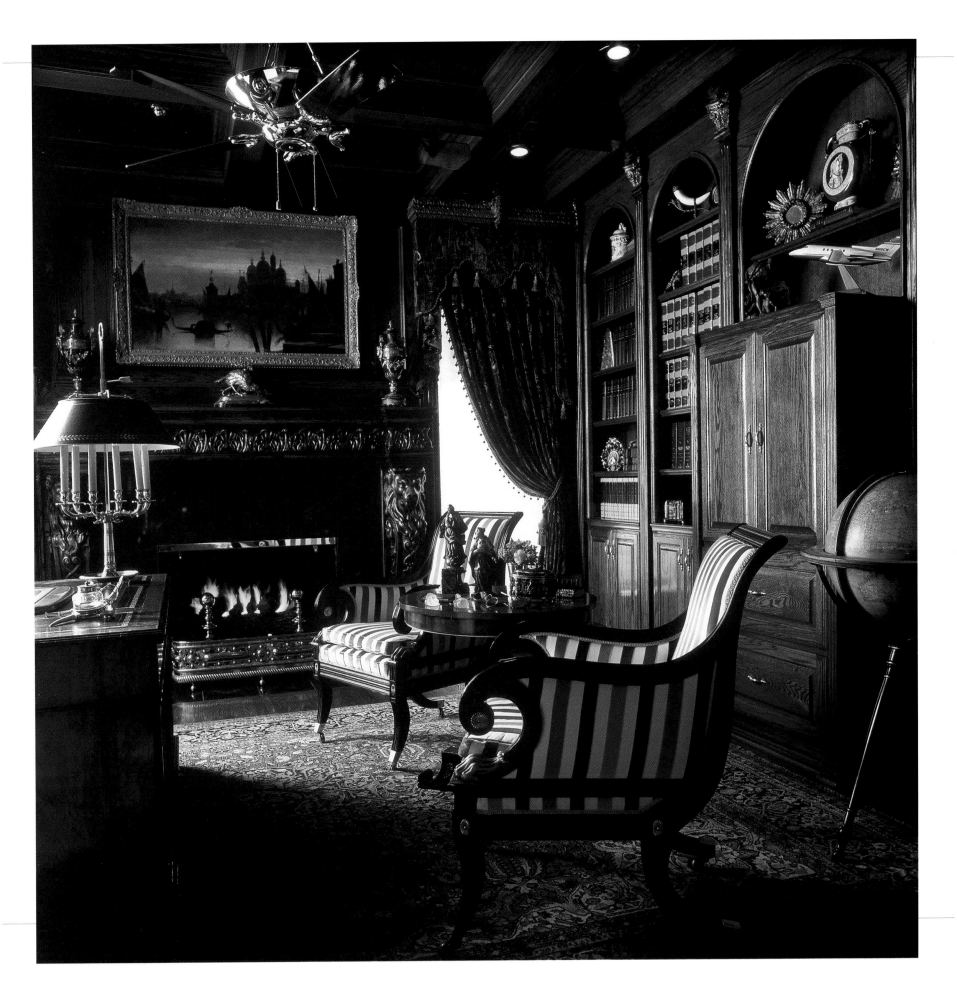

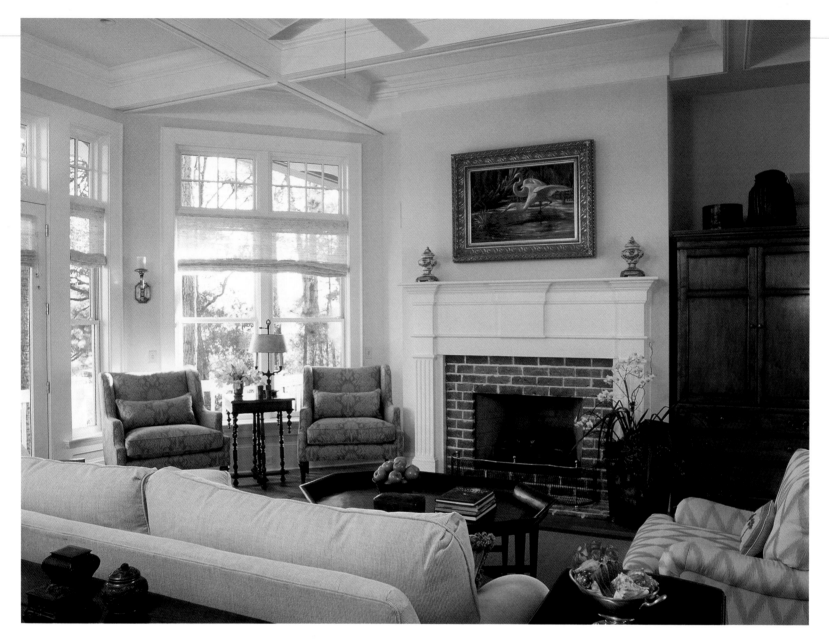

John's love of antiques, fine textiles and delicately beautiful china mirrors his family's passion for elegance. His personal home is brimming with favorite vintage objets d'art, and he is inspired by his surroundings – nature, art, fashion and textiles.

John relaxes by doing what he loves best – antiquing with friends or clients, searching for the perfect object that will render a space fulfilled. Always the visionary, John invariably makes invaluable discoveries.

Above: Unadorned windows and a neutral palette create a light-filled retreat.

Top right: This charming low-country dining room creates the perfect backdrop for intimate dining.

Bottom right: John arranges a pleasing tableau by mixing different periods with some of his client's favorite keepsakes.

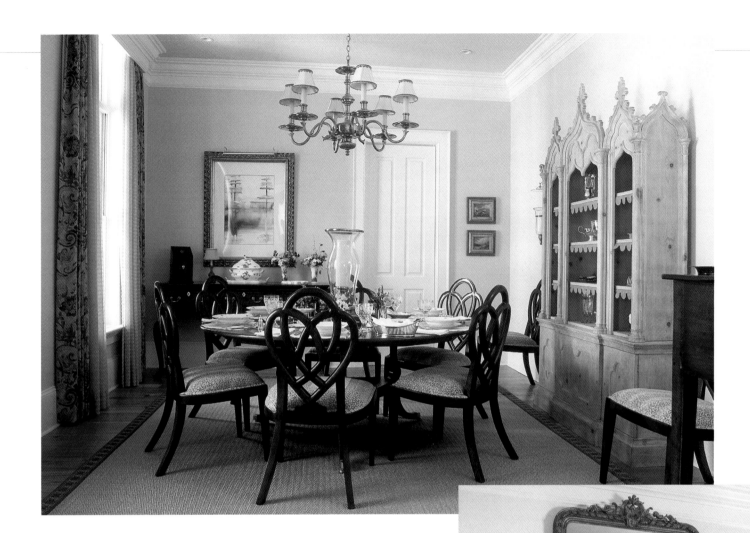

MORE ABOUT JOHN. . .

What is the single thing John would do to a room to bring it to life?
Add color. According to John, color is one of the most influential tools a designer can use. It expands a room or makes it more intimate. He encourages clients to embrace color and use it to their advantage.

What object has he had for years that remains in style today?
An 18th century original-surface French trumeau mirror that hangs in his hallway. The creamy beige beauty is painted with water-gilded accents in a decorative gold motif. A versatile piece, it's always held a place of honor in John's abodes.

Who has made the biggest influence on his career?
A college art professor who taught John to study how objects relate in space, a valuable lesson he continually applies in his design practice.

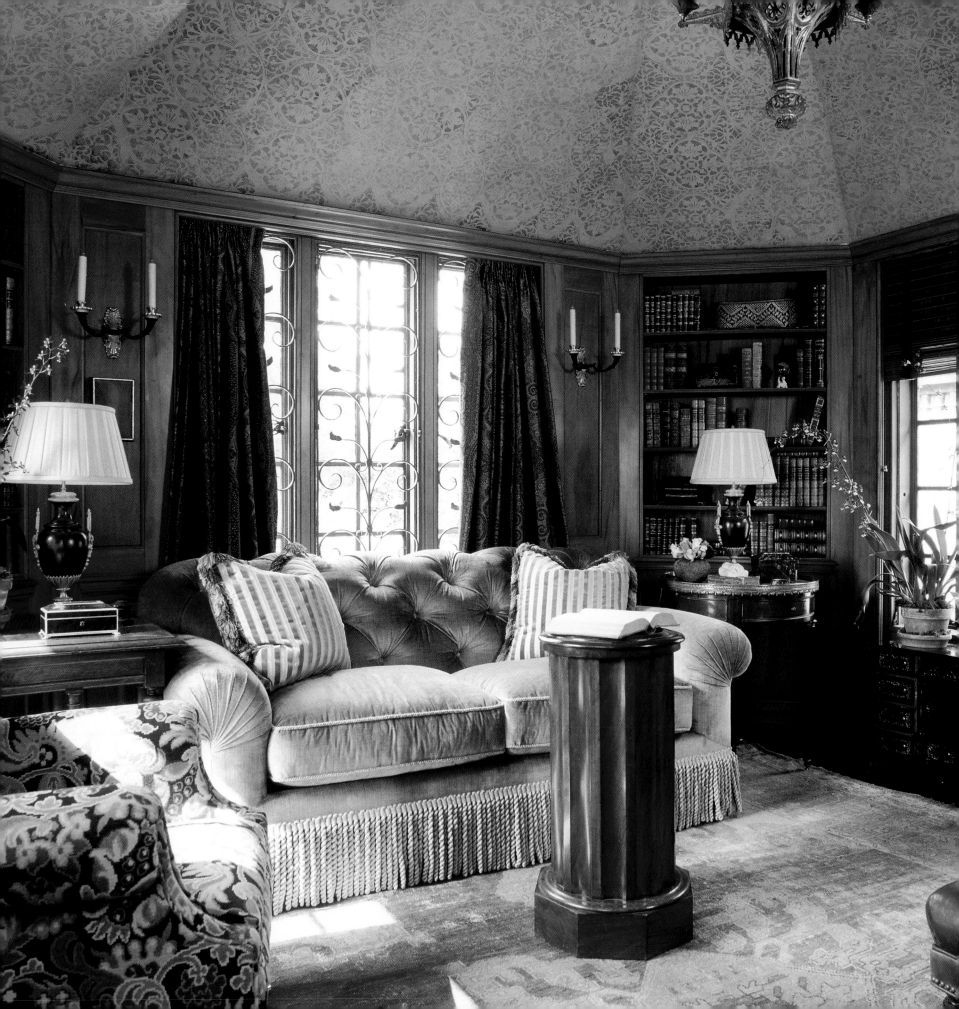

KIM JOHNSON, KIM MILAM & JUSTIN SEITZ

Johnson • Milam • Seitz Ltd.
710 Carroll
Fort Worth, Texas 76107
817-338-0738

Kim Johnson, Kim Milam and Justin Seitz – three Fort Worth designers who can't say no – and don't want to. This trio tackles every job with unbridled enthusiasm – from residential to commercial, from interior and landscape design to architecture. Sometimes they've even served as general contractor.

With complementary talents and skills, the threesome creates groundbreaking designs. Classic proportions and symmetry are the basis for their work. As a result, they craft rooms permeated with peace, comfort and order.

Kim, Kim and Justin are chameleons, quick-change artists whose strength is versatility. They adopt style and color preferences compatible with a client's personal needs, tastes and lifestyle. And they develop a custom palette for each project, preferring to work with warm, rich colors or neutrals.

The primary goal of these design experts is to create refreshing and pleasing environments that ultimately may alter lives. They're not just changing the way things look. They're creating well-being, stability and happiness for their clients.

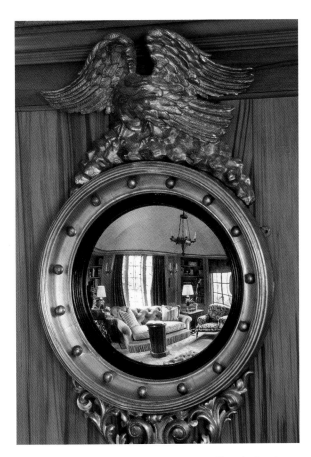

Left: Inspired by the original 1929 window grillwork, the plaster ceiling is hand-stenciled in muted colors that are accented by the luminous cherry paneling.

Above: An American federal convex mirror reflects the sofa upholstered in silk velvet with custom-colored trim. The antique Turkish rug adds another luxurious layer.

ALLAN KNIGHT

Allan Knight & Associates
1400 Hi Line Drive
Dallas, Texas 75207
214-741-2227

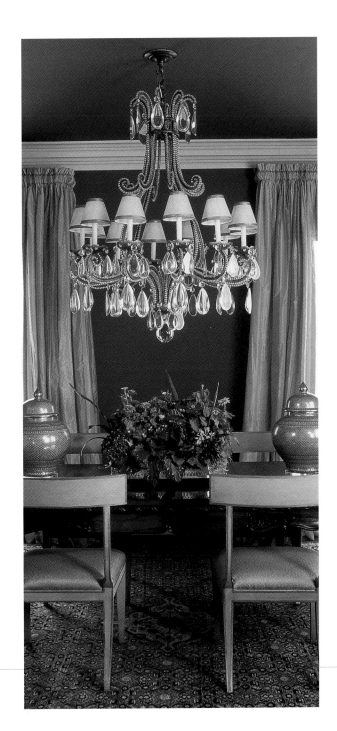

Allan Knight's mother encouraged him to look beyond the boundaries of where he lives. Allan's latest endeavor, a 35,000-square-foot Dallas showroom, is the quintessential escape where designers find themselves on a 'round-the-world tour amid a compendium of one-of-a-kind art, artifacts and antiques.

With a wealth of global resources, Allan has amassed incomparable treasures from other countries, cultures and eras. He has discriminatingly rescued precious items from salvage yards or demolition and played an important role in preserving them for future generations.

Allan's showroom, renowned for its size and diversity and quality of merchandise, enables him to share his love of design, his appreciation for the past and his innate ability to juxtapose the old with the new. Many of his possessions, which date back to the 8th and 9th centuries, comprise valuable objects from Asia. They include 8th century Cambodian offering bowls, 18th century Burmese temple fragments, 18th century Laotian wooden sculpted Buddhas, 18th century tiles from a Chinese temple and a 19th century hand-carved naga, or dragon, that guarded a Thai temple. He also displays breathtakingly unusual delights from other countries as well, such as India, Pakistan, France and Nigeria.

Left: In Allan's showroom there are no barriers. It houses a variety of styles and objects that exist in harmony.

Right: Luxurious textures enrich a client's dining room where French, Persian, English, Thai and American elements meld into a delicious whole.

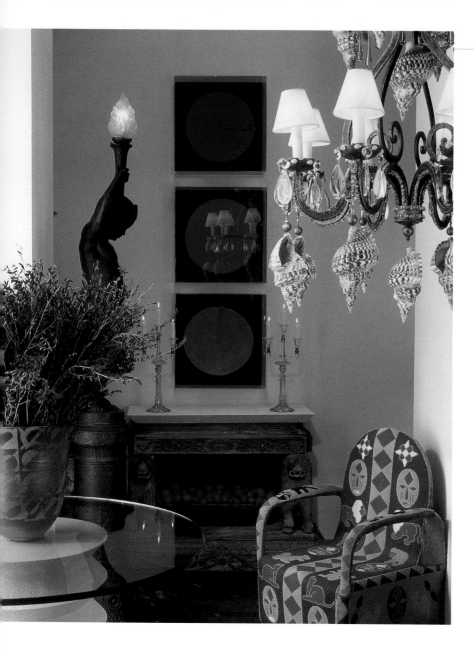

In the late 1990s, Allan collaborated with business partner Ben Goldfarb. The twosome opened the current showroom, which at the outset occupied 6,500 square feet. In late 2002, they increased the space more than fivefold, allowing for an expanded, airy display of an acrylic furniture line, manufactured by one of Ben's companies, and a new lighting line and lamp workroom. The lamps' trademark style includes nickel-plated hardware (like jewelry, Allan says), acrylic bases resembling crystal and luxurious silk shades.

According to Allan, Ben is a rarity: a business executive who understands creativity. "He is the ultimate facilitator of the showroom," Allan says, "and the reason I'm here."

Allan markets his inventory worldwide from his desk in the midst of the showroom, where he spends most of his time. Other showrooms also represent Allan's inventory in Dallas, Houston, New York, Washington, D.C., Atlanta and Los Angeles.

Allan's primary objective is to provide designers with a diversity of rare and unusual pieces to punctuate their work. Many artifacts in the showroom are carefully mounted on acrylic or are used unconventionally to create exceptional conversation pieces. Allan also offers superior customer service. Every item on the floor is immediately available, a rare convenience in today's home furnishings market, making it easier for designers to furnish or accessorize their clients' homes and businesses.

Allan has been in the design business since he was 13 years old when he assisted his mother, a decorator in Midland. His grandmother and mother fostered his artistic abilities and granted him the necessary freedom from convention to pursue his design endeavors.

Since graduating from the University of Texas at Arlington with a bachelor's degree in architecture, Allan has interspersed his design work with various showroom businesses and a tabletop accessory endeavor.

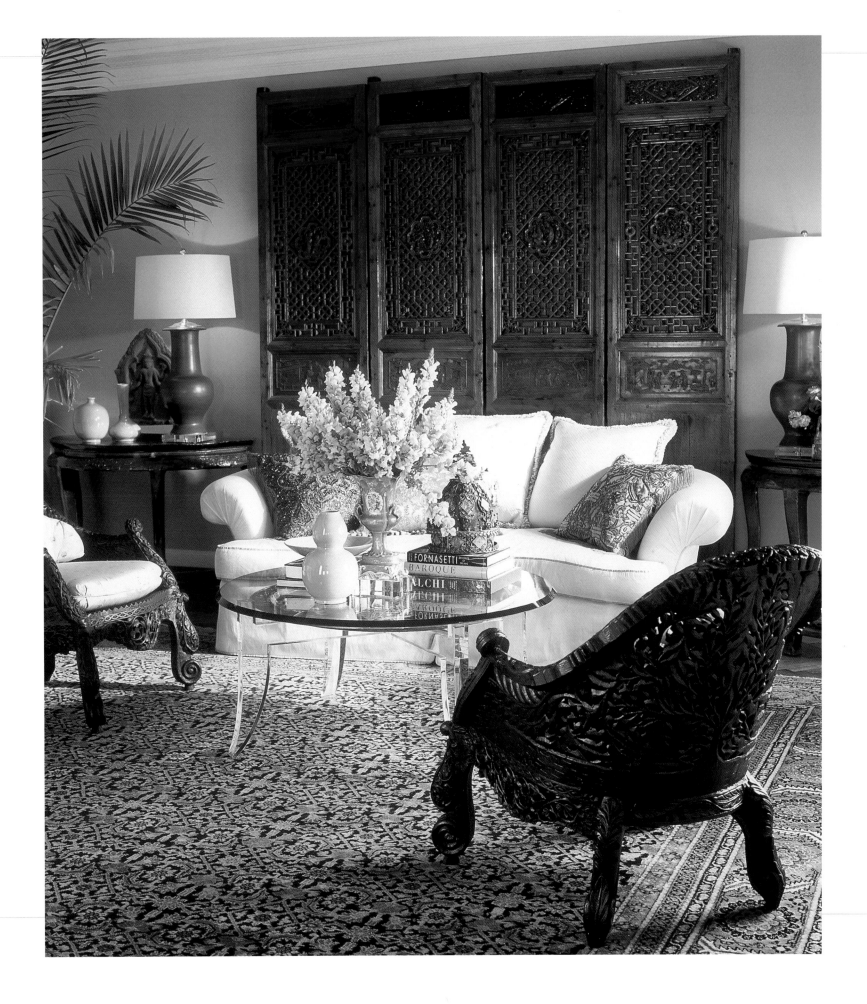

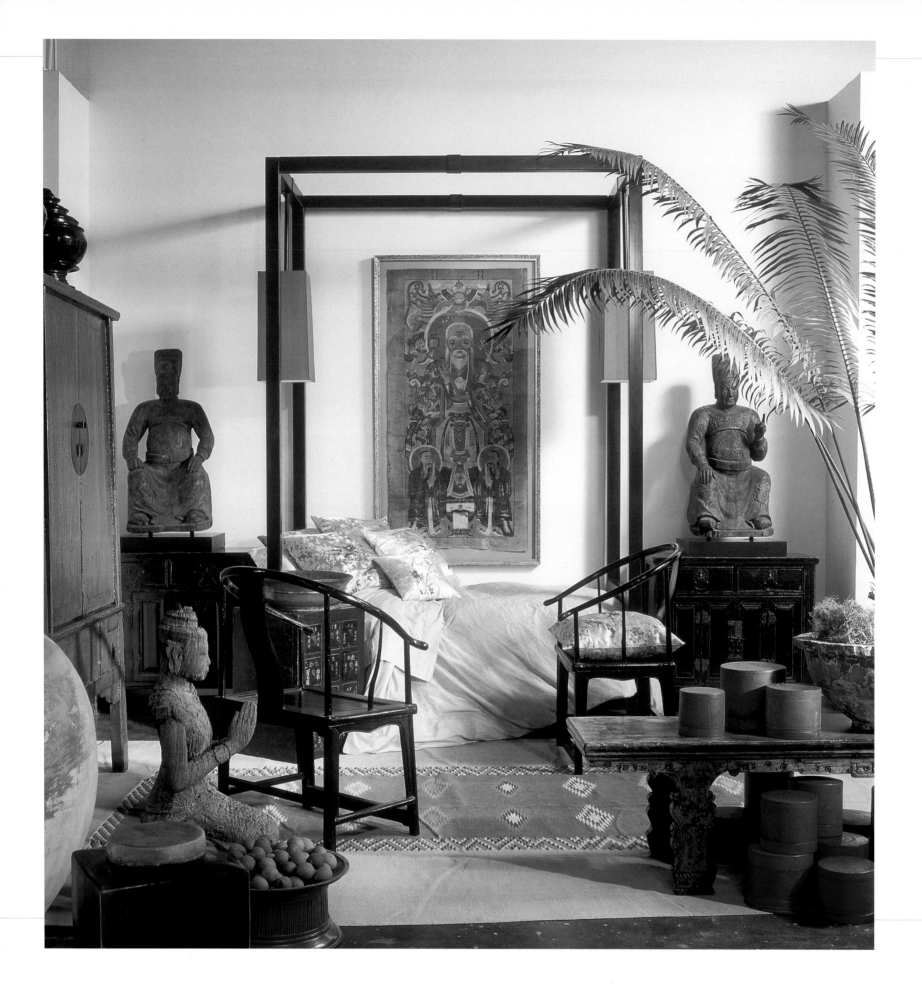

MORE ABOUT ALLAN. . .

What separates Allan from his competitors?
He has a discerning eye and can spot something fantastic or unusual in the trash, or he can detect the finest among the finest.

What is the single thing he would do to a room to bring it to life?
Put a cat in it. Cats can give any room life, especially if a dog is already there.

What object has Allan had for years that remains in style today?
A 16th century Turkish tapestry framed on his bedroom wall that has special meaning for Allan. He purchased the tapestry with the proceeds from the sale of stock in his father's oil company. Today the tapestry is worth more than the stock would have been. Every time Allan looks at the tapestry, it reminds him of his dad's courageous attempt to establish a public company in a tough industry.

Does Allan think his name fits him and why?
Yes. It's a solid name, and he perseveres.

How do Allan's friends describe him?
He's always working, or thinking about work.

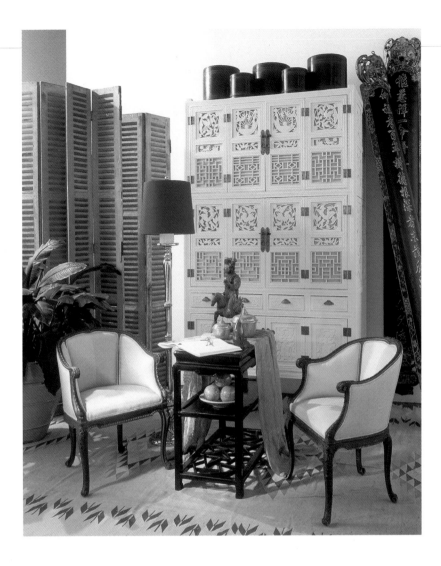

Left: Allan breaks with traditional Asian themes and colors. His interpretation of this Asian-style bedroom is luxurious and comfortable.

Above: Using a fresh contemporary palette, Allan daringly juxtaposes Asian and French elements in this vignette.

Allan undertakes design projects on a limited basis, primarily for residential clients. He believes the essence of creating an exceptional environment is to transcend a client's boundaries with an understanding of his or her philosophy of life and relationships with family, friends and business associates.

It seems Allan has transcended his own boundaries, just like his mother encouraged him to do. A creative entrepreneur loved and respected by fellow designers around the world. A preservationist who sees beauty in all things. A talented designer with fearless panache whose clients have become his best friends. It's apparent Allan will continue to reach for the stars, and delight and surprise.

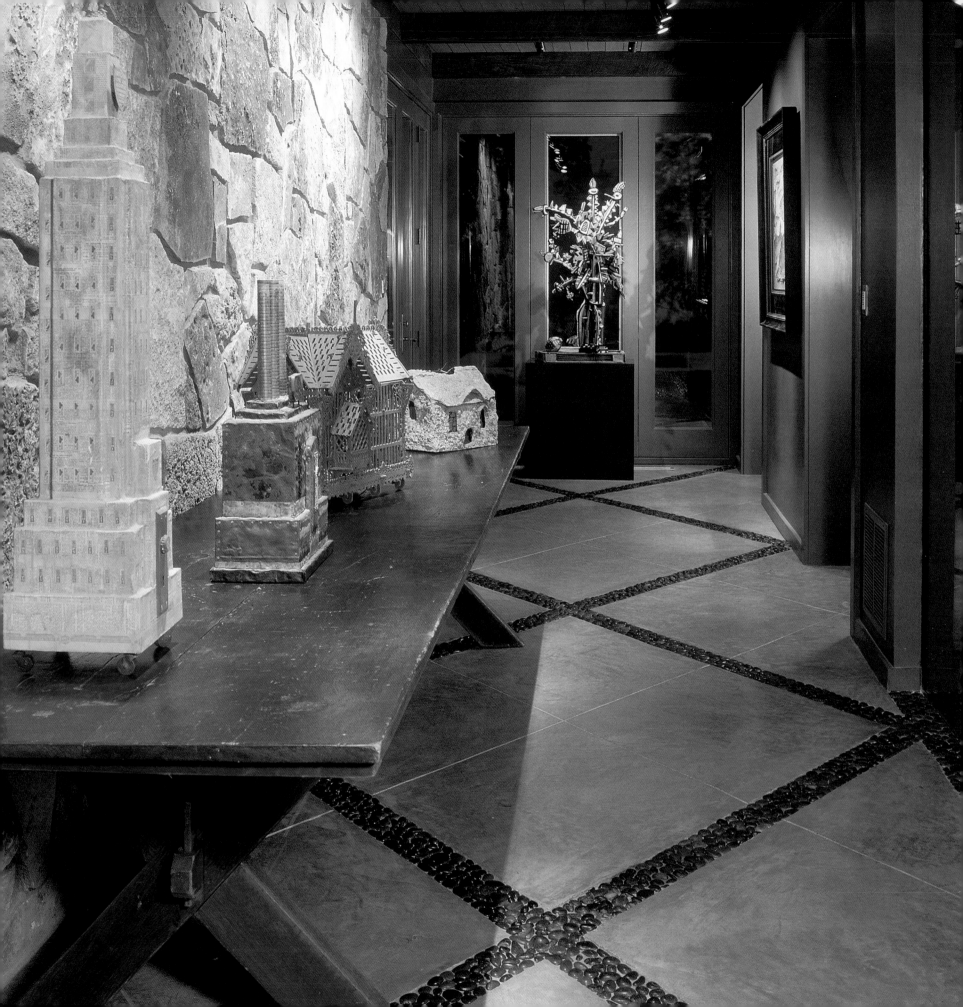

DIANE LINN

Diane Linn, AIA, Professional Affiliate

Linn & Associates Inc.

2728 Welborn, Suite 127

Dallas, Texas 75219

214-521-0878

Diane Linn's grandfather taught her that the ideal space is designed from the interior out. Linn & Associates Inc. is built on this premise, which serves her and her clients well. According to Linn, spatial and interior architectural understanding predicates the creation of the ideal space, which must be beautiful, functional, livable, comfortable and timeless. With good design, there is an automatic collaboration among the designer, architect and the landscape architect.

Linn moved to Dallas from Philadelphia to assist with the space planning for the Plaza of the Americas, at the time, a unique new downtown mixed-use development, and subsequently founded her business in the late 1980s. A graduate of Moore College in Philadelphia, Linn earned her bachelor's degree in interior architectural design, a pursuit that came naturally. Her grandfather was an architect and innovative residential developer in the Philadelphia suburbs. Her brother is also an architect and her father an electrical engineer.

Left: Concrete floors throughout most of this Texas lake house's living spaces were poured, hand troweled and scored. In the main entry hall, Mexican beach pebbles were inlaid in the floor. A David Bates sculpture sits at the end of the hallway.

Right: An antique Indonesian console adds a dramatic touch to a guest room.

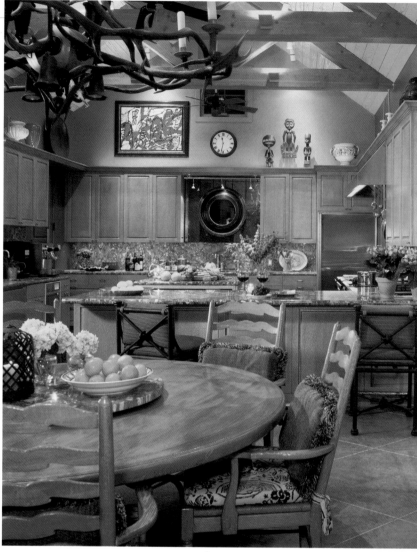

Diane Linn's experience spans a broad spectrum of projects including corporate office interiors, retail and restaurant space, new office building space planning, commercial building renovations, and single and multifamily residences. For Linn, each job is tailored to a client's taste or is site specific.

Her innate abilities to visualize space three dimensionally, to understand architectural elements and to discover the ideal color palette set her apart. Led by carefully introduced natural lighting, Linn's rooms are architecturally sensitive spaces that include interesting textures and a keen sense of color.

As an empathetic observer, she intuitively understands her clients, creating interiors that are infinitely personal. She says exchanging materials, textures and colors between the interior and exterior reinforces the totality of each project and emphasizes its unity as a compatible, single design.

Linn's trademark is a delicate balance of style, as opposed to following trends or fashion. Her work is functional as well as exciting. She incorporates details, finishes and patinas that stand the test of time. And she thrives on the unconventional application of materials and found objects, which add an element of surprise and intrigue.

Far left: A David Bates painting hangs above an early 19th century hand-painted English Regency chest in the open hall between the living and dining areas.

Left: The large open kitchen and dining area is ideal for the owners who love to cook and entertain. The painting above the cabinets is by Jean Dubuffet.

Right: A 19th century cypress wood Japanese door, acquired in London, hangs from an exposed barn-door track and separates a guest bedroom from its dressing area.

Aesthetically oriented study trips to places like England, Italy, France and Mexico and continuing education in various design disciplines add historical and modern influences to her approach. Her study of well-known, diverse architects and designers from Andrea Palladio to Phillippe Starck adds dichotomy. Her love for landscape architecture is reflected in her own urban garden, which is ornamental and smart to her finite tastes and the Dallas climate.

Diane Linn says she's lucky because her work aligns with her passion for living. She gains inspiration from communicating with clients, researching, traveling, reading and visiting friends. So if you call her office at 11 p.m. expecting only to leave a voice mail message, don't be surprised if she answers the phone and is alert! She doesn't believe in wasting a moment when creativity takes hold.

MORE ABOUT DIANE . . .

What colors best describe Diane and why?
Diane wears a lot of black, white and beige because the neutrals act as a noncompetitive backdrop to her presentations. They also connote her ability to stand on "neutral" ground, carefully considering an idea before taking action.

Does Diane think her name fits her?
Yes, it's brief and to the point. And it's timeless, not trendy.

What design element has she used for years that still fits today's style?
Understatement.

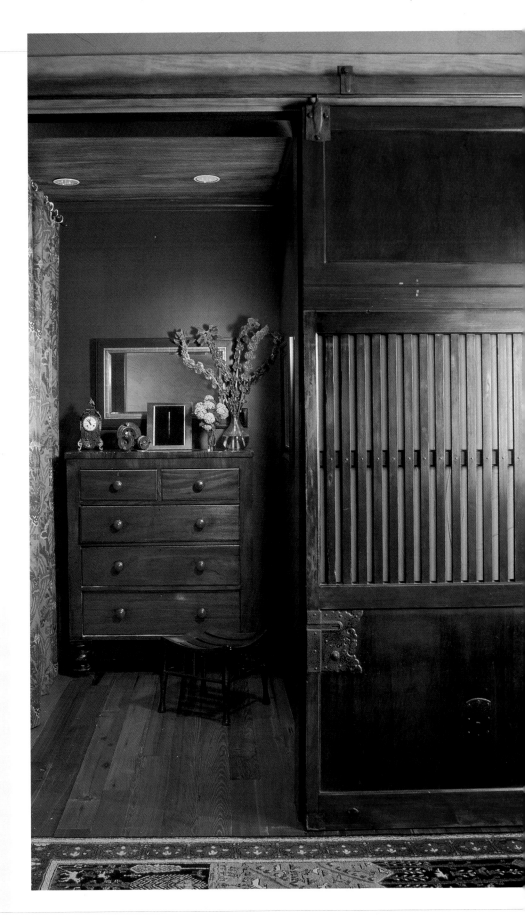

LISA LUBY RYAN

Luby Design Associates, Inc.
At Home with a Past
6712 Snider Plaza
Dallas, Texas 75205
214-696-9991

Friends characterize Lisa Luby Ryan as "driven." She's the first to second that notion, although you'd never guess it by looking at her. Dressed in jeans and frequently cowboy boots, Lisa possesses a casual Texas-style confidence.

Lisa moved to Texas in 1982 and just three years later established her design business, Luby Design Associates, Inc. She got her feet wet by serving as design consultant for a Dallas real estate developer.

With the basics of home construction under her belt and diverse resources at hand, Lisa moved on to expand her clientele. Now that roster is a who's who of Dallas-area influentials, as well as out-of-state notables.

Lisa is known for a look that blends eclectic European ideas with Hill Country comfort and a splash of sophistication. Hers is a cheerful layered blend of patterns, textures and styles. But don't be deceived by the comfortable ambiance. There's precision built into all of Lisa's work where her eye for detail will keep her work as fresh 10 years from now as it is today.

And Lisa incorporates the unexpected in her designs. She favors English and French antiques and vintage textiles but gives them a twist by mixing in contemporary touches. She also creates custom accessories — iron wall sconces and chandeliers, faux-finished case goods, furniture upholstered in vintage textiles and pillows crafted from antique needlework.

Left: Lisa replicates the old English look with a twist. In her home's foyer, recycled vintage slate roof tiles discovered in New England contrast with chairs upholstered in animal-print fabric.

Right: Lisa Luby Ryan.

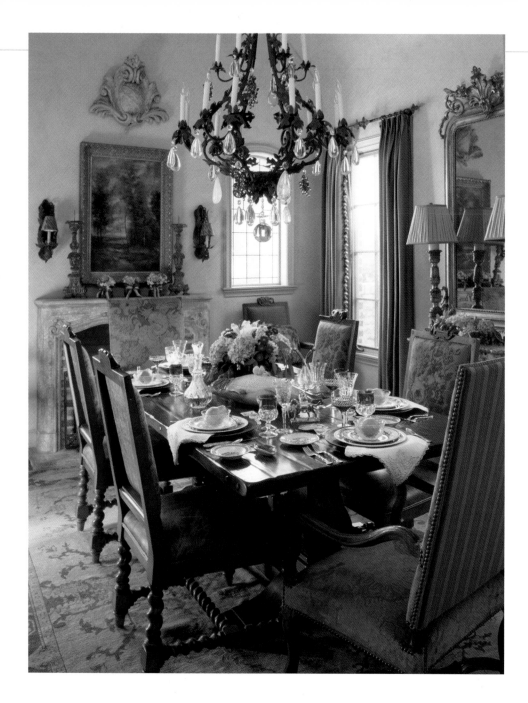

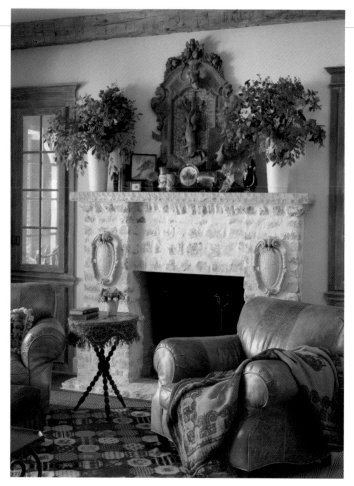

Above: In the Ryan dining room, the graceful curves of an iron chandelier are hung with large crystal tear drops and clusters of vintage glass grapes for extra interest and evening shimmer. The planked table is set with selections from Lisa's antique china collection.

Above right: Lisa lends a comfortable aura to any setting with elements such as old barn beams and butter-soft leather chairs.

Far right: Lisa easily achieves a layered look with style. In her family room, the sofa, upholstered in vintage Swedish quilts and French textiles, rests on a needlepoint patchwork rug. Her brown-and-white transferware collection adds charm in the background.

She takes the time to find fabulous antiques, perfect one-of-a-kind accessories for her clients' homes. She strongly believes that there should be a treasure at every turn, something in each room that's unforgettable.

Lisa most values the personal relationships she develops with her clients — and it shows. She incorporates clients' collections or accommodates their existing pieces into her designs whenever possible. Lisa frequently travels abroad with clients to search for just the right accessories.

Her passion for design spills over into her shop, At Home with a Past, in Dallas' Snider Plaza. Established in 2002, the shop has a distinct English cottage flavor. It appeals to everyone from college students at nearby Southern Methodist

University to Park Cities residents whose appreciation for the past matches Lisa's and travelers taking a break from hectic schedules.

Despite building two successful businesses, this entrepreneur makes time for her top priorities – faith and family. Lisa believes it's important to keep her work in perspective and not take herself too seriously.

What's her next design venture? For now, Lisa's not talking. But you can bet it will be trend setting.

MORE ABOUT LISA. . .

What color best describes Lisa and why?
Pink because it's fresh and happy. From a design standpoint, it complements everything.

What does Lisa like best about being in the design business?
The personal relationships she develops with clients and the influence they have on each other's lives. Also, when she's completed an installation, she believes it's rewarding to step back and see something tangible she's created.

What object has Lisa had for years that remains in style today?
The maple secretary in her entry that belonged to her mother. It was her first piece of furniture and has great sentimental value. Right now it's red with a black and gold motif to fit the look of her home. Lisa believes it's important for clients' homes to have these special pieces, too, because they are what make a "house" a "home."

JAMES MCINROE

James McInroe, Inc.
4301 Vandelia
Dallas, Texas 75219
214-526-8078

James McInroe views all design with a keen architectural eye. His passion for the clean lines of Modernism and instinctive placement savvy were honed while he worked in the 1980s with the late minimalist designer Tonny Foy of Fort Worth.

In the ensuing years, James' tastes have broadened to include a blend of styles from many periods. His work surprises with fearless contrast, which both inspires and bemuses. His easy blending of a Paul T. Frankl coffee table with a Louis XVI chair upholstered in cowhide delights his clients.

Lamps make or break the ambiance of a room and are an important part of James' decorating. To augment his growing inventory of vintage lamps, he has designed his own line that lends the Modernist look to any setting. The lamps' clean sculptural bases, which rest on clear acrylic, are created from diverse materials including animal hides, petrified wood and vintage mirror veneer.

James is at home in Dallas where he lives in an historic apartment in the Argyle, one of the oldest multistory residential buildings in the city. It is a haven for writers, artists and other creative people who also appreciate this architectural treasure. He and his business partner, Marcia Curtis-Hornsby, have purchased a graciously scaled 1920s duplex in Perry Heights, a fitting location for his evolving collection of furniture and objets d'art from the 18th, 19th and 20th centuries.

James' idiosyncratic approach to collecting and decorating ensures his clients a change in outlook toward their homes and lives. The architectural integrity of their homes and the value of their collections will be honored in the process. James feels strongly that possessions are borrowed, and we are merely their caretakers.

Left: In James' dining room at the historic Argyle apartment his affinity for clean lines is apparent. He combines a 1950s Robsjohn-Gibbings table and Daystrom chairs, also circa 1950s, with a James McInroe, Inc. custom sycamore-framed mirror.

Right: A Directoire daybed and Barcelona coffee table are at home in James' living room at the Argyle.

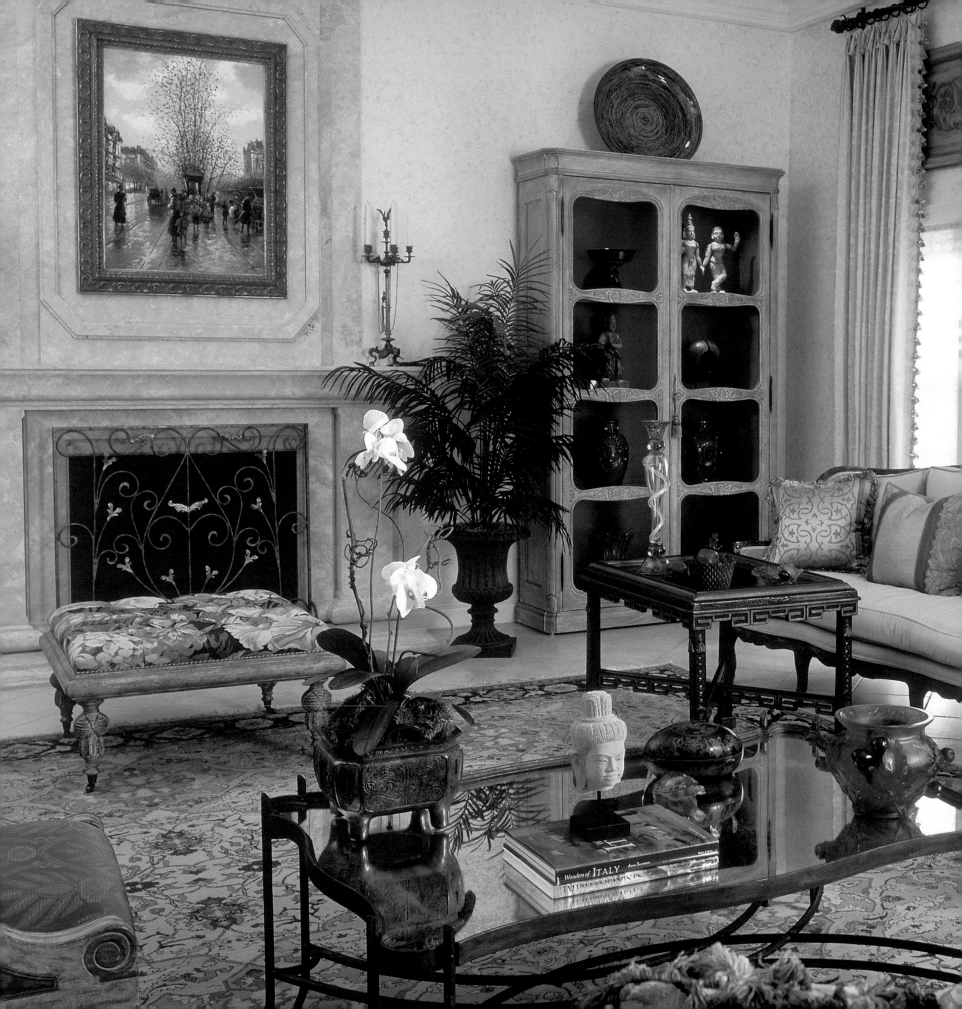

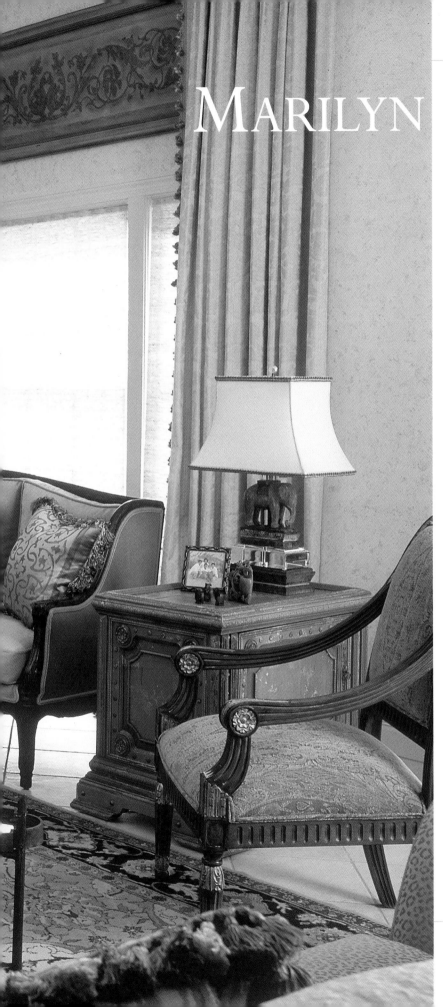

MARILYN ROLNICK TONKON

Marilyn Rolnick Tonkon, ASID

Marilyn Rolnick Design Associates, Inc.

2501 Oak Lawn Avenue

Dallas, Texas 75219

214-528-4488

In a profession she calls an art, not a science, interior designer Marilyn Rolnick Tonkon is a quick study and an instant decision maker. She does whatever it takes to get the job done, and then some. But Marilyn's real trademark is providing that extra special service her clients need, and deserve. Every job gets done with a lot of TLC – tender loving care.

Marilyn immerses herself in every project by listening closely to her clients, thoroughly understanding their lifestyle and design desires. And then she makes it happen according to schedule. The process sounds simple, but those who understand the design business, and are acquainted with her, know better.

Left: Marilyn's eye for detail is evident in this elegant, comfortable living room. Display cabinets flank the fireplace and house a collection of Asian treasures. The coffee table has an antique mirrored top, which reflects light and favorite objects. The black lacquered and gold tea table is by Terrence Sweeney Designs.

Marilyn manages every project determinedly and rarely takes no for an answer, handling details with aplomb. She is driven by the pieces of the project puzzle, which appear to come together effortlessly. One of Marilyn's secrets is her associate Richard Gordon, who has worked with her for several years. She and Richard make a great team because they think alike and are equally responsive to clients' needs. Also, Marilyn surrounds herself with subcontractors and fabricators who are responsible, talented and care as much about the success of the job as she does. She is diligent about watching the budgets of clients, who expect and deserve value.

Marilyn works in styles that range from traditional to contemporary, with the requisites of quality, comfort, continuity and timelessness taking priority. She never met a color she didn't like but, if pressed, is partial to coral because it's warm, flattering and easy to work with.

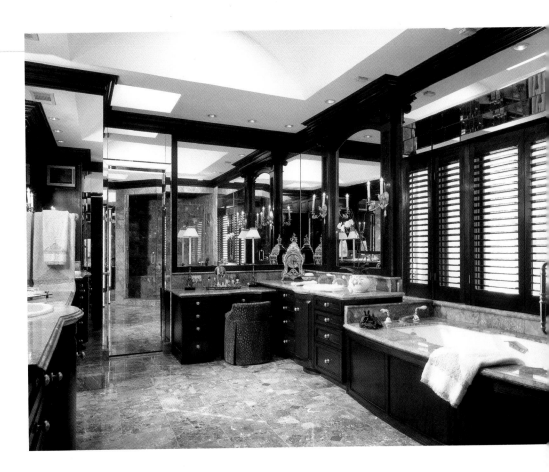

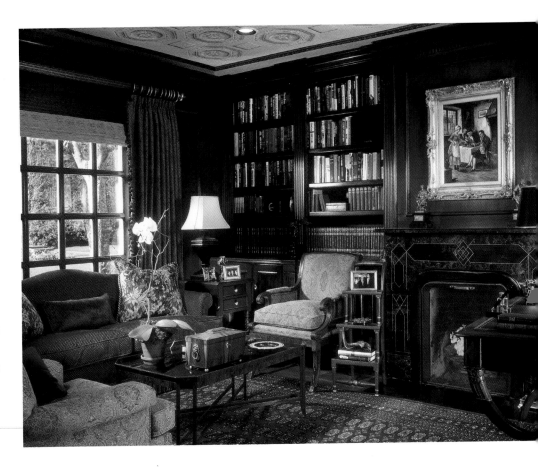

Left: The tapestry-covered chair and ottoman create a cozy bedroom corner while a dramatic torchiere by Corbin Bronze adds height. The soft peach tones of the walls and Bergamo draperies complement the tapestry greens.

Top right: Mirrors surround and expand the space of this exquisitely detailed bath, reflecting the Breccia Pernice marble, custom mahogany cabinetry and vanity mirror frames. Plumbing fixtures and sconces are by Sherle Wagner.

Bottom right: Bookcases span these library walls producing a warm, inviting space for relaxing with a book or working at the desk. The trompe l'oeil coffered ceiling adds height and interest. The room is wrapped in lustrous hand-polished mahogany paneling.

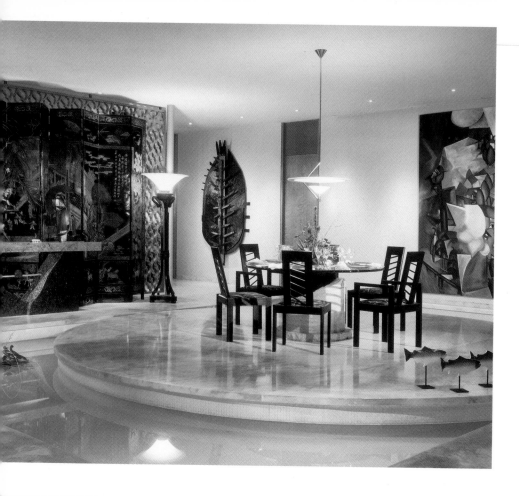

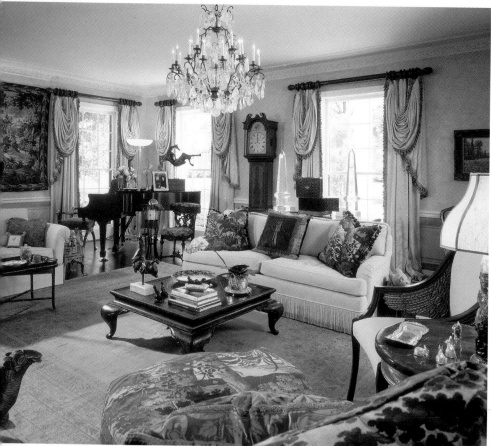

A timeless item Marilyn always has enjoyed incorporating into a room is bookcases. From a personal standpoint, she is passionate about books and says reading is a way of growing. When she and her husband combined households after their marriage, the first thing they did was unpack his 40 boxes of books. And she expertly found space for all of them.

Growing up in Dallas, as a child Marilyn had creative instincts, which were unconsciously fostered by her mother, who had the most exquisite taste of anyone Marilyn has ever known. Later, she majored in psychology at the University of Texas, and then moved on to raising a family. When her youngest child was in high school, it was time for Marilyn to make her move. She launched her design business, taking advantage of her inherent artistic bent, as well as her studies in psychology, which she's applied to her color sense and business relationships.

Marilyn rarely takes a break from her Dallas design business. But when she does, she likes to spend time with family and play competitive tennis with her sister and friends. According to Marilyn, she plays to win, just like she does everything else in her life.

Top left: This dramatic dining room floats on a marble island, setting the tone for the residence's clean lines and bold architecture. The black frame chairs, stone table base and marble floors provide a stunning background for the electric colors of the art and accessories.

Bottom Left: An antique Mahal rug anchors marbleized walls, an elegant country French coffee table by Ruseau and a grand piano in this living space.

MORE ABOUT MARILYN...

What does Marilyn like best about being an interior designer?
The people she works with, who keep her moving and offer opportunities to learn. She also takes great satisfaction in bringing quality and comfort into everyday living.

What is the best compliment Marilyn has received about her work?
Clients have told Marilyn that her work is never dated. Was it done yesterday or 20 years ago?

If she could eliminate one design element from the world, what would it be?
Synthetic fabrics.

What is the single thing she would do to a room to bring it to life?
Add color – a rug, art or simply wall paint.

How do Marilyn's friends describe her?
They say she's a great listener.

Right: The elegant mirror over the Burton Ching console reflects the living room's vibrant palette and Venetian plastered walls. A peek into the dining room reveals a glass-topped dining table with an antique base. The fabric on the Minton Spidell chairs echo the rich coral of the living room.

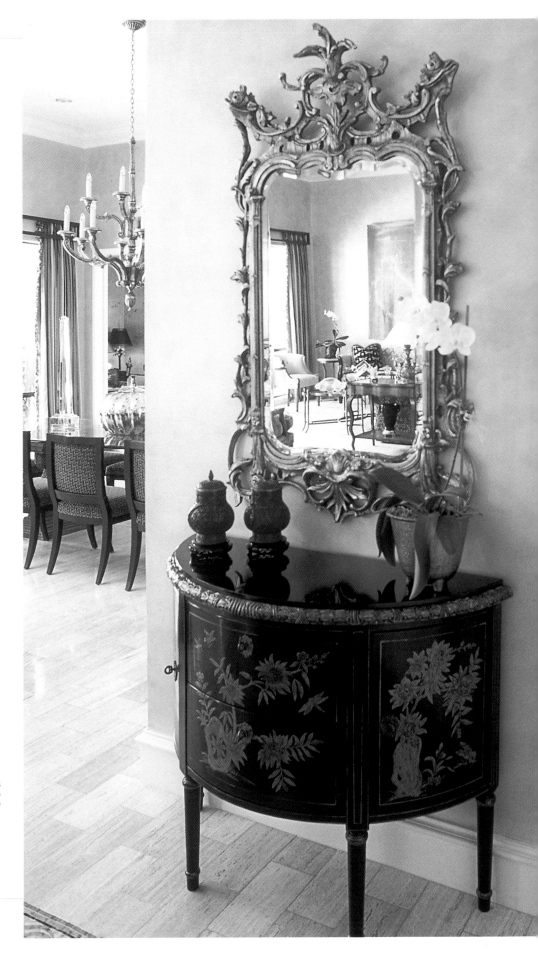

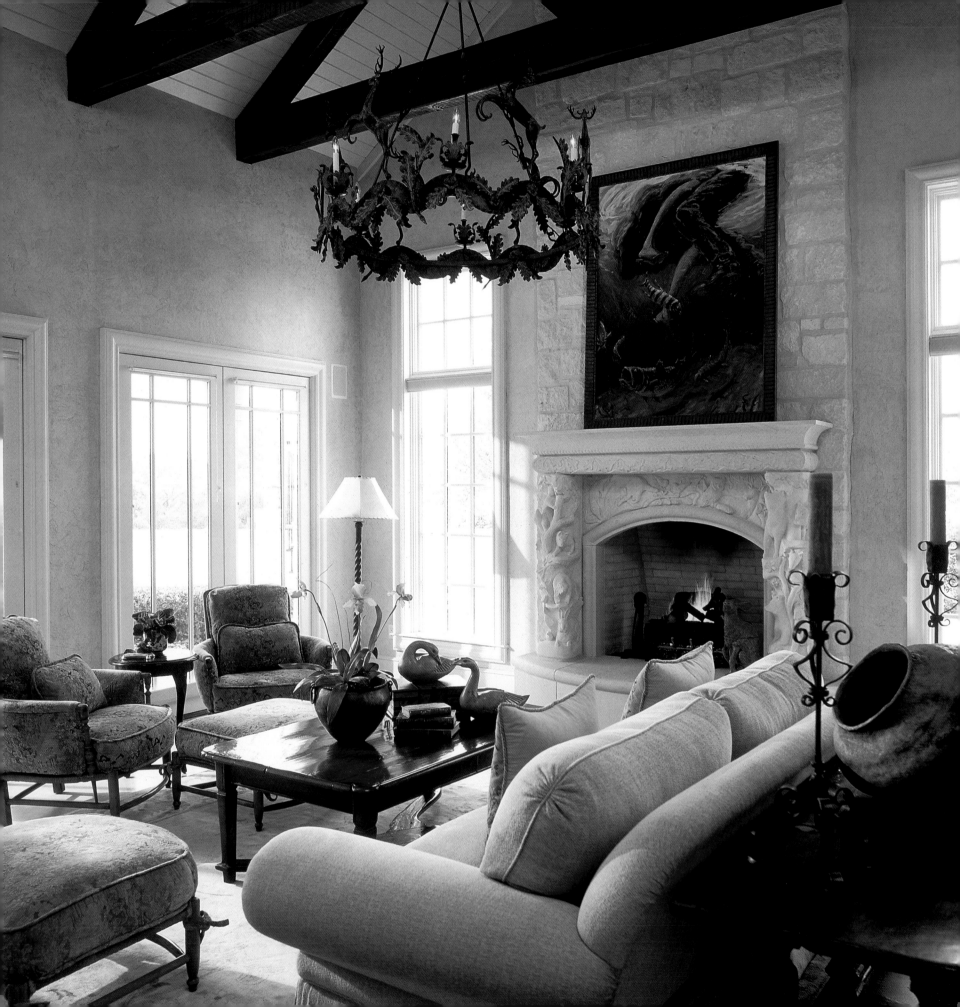

DAVID SALEM & LOLLY LUPTON

David Salem, ASID

Salem & Associates

4600 Southern Avenue

Dallas, Texas 75209

214-351-1592

For David Salem and Lolly Lupton, their partnership is a match made in heaven.

Their Dallas-based business is successful because their personalities and talents complement each other. Their collective strength is visualizing and communicating a coherent design concept to clients. Both enjoy coordinating furniture and fabrics, selecting colors and creating custom finishes. Even though David uses a type A approach to life and Lolly is more laid back, from a business perspective both are sticklers for detail.

David earned a bachelor of arts degree in photography from New York's Fashion Institute of Technology. After graduating, he apprenticed with a legendary Manhattan design firm, Sarah Hunter Kelly Interiors. Lolly studied at the New York School of Interior Design and then moved to Mexico where she studied for two years at the Instituto de Allende in San Miguel de Allende.

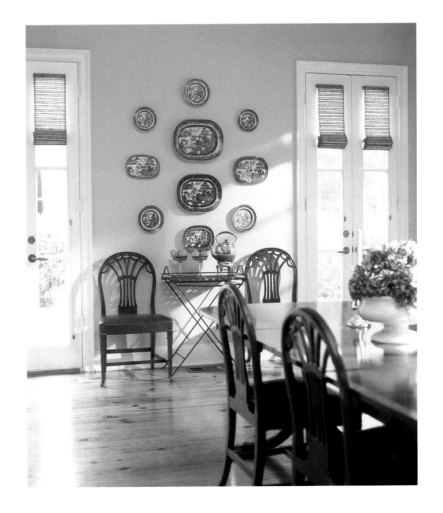

Left: Hand-hewn cedar beams punctuate a Lake Waco great room. A painting entitled "Gulf Coast Tango" by Jim Gingerich hangs above a hard-carved limestone fireplace that depicts indigenous Texas wildlife by stone artist Mike Cunningham.

Right: Longleaf pine flooring salvaged from a 19th century Hearne, Texas, cotton compress complements antique George III mahogany chairs and a blue willow platter collection.

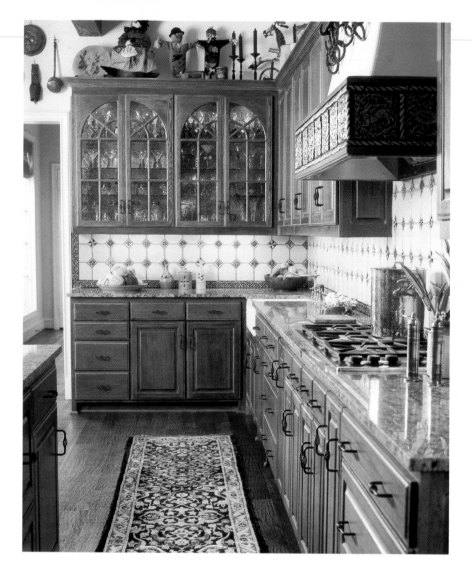

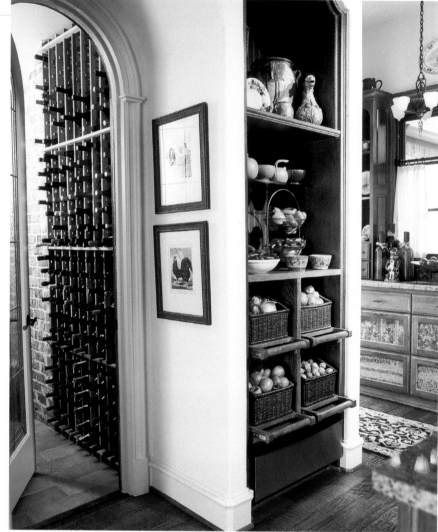

David and Lolly first crossed paths when he moved to Dallas and was a frequent customer in her showroom. A little later they became neighbors in the same apartment building, which cemented their friendship, as well as their professional partnership.

Experienced in residential construction, the twosome prefers to be involved in all phases of a project from finalizing blueprints to managing the installation of the interiors. They enjoy immersing themselves in the details of selecting the materials and elements used in the finish-out construction and coordinating them with the final interior selections.

David and Lolly often incorporate antique furnishings and rugs in their interiors for warmth and texture. They use eclectic objects that lean toward the ethnic and exotic to create a focal point or mood. They also appreciate contemporary projects but insist on no gimmickry. The duo admires legends Billy Baldwin and Mark Hampton because they used classic elements in fresh ways, creating timeless settings.

David and Lolly share design projects but also maintain their independence on other work. Theirs is a balancing act of the best kind.

Pictured at left: Stained and glazed oak cabinets and hand-scraped floors create the perfect ambiance in this stylish gourmet cook's kitchen. The cooktop vent surround is decorated with hand-painted tiles embossed with an animal motif. The kitchen houses the ultimate in convenience — wine and root vegetable storage areas.

Top right: A hand-carved Mexican Cantera stone fireplace highlights a family room warmed by an old pine ceiling and floor.

Bottom right: An arched doorway and window frame an entertainment area. The classic upholstered chairs encircle a tufted leather ottoman that doubles as a "drinks table." East Asian antiques are subtle accents.

MORE ABOUT DAVID AND LOLLY. . .

How do David and Lolly relax from their hectic schedule?
They both love nature and are passionate about animals, often rescuing stray dogs. Lolly says gardening is her respite and loves the time and effort she spends on it. David prefers hiking or bike riding for his "nature fix." David and Lolly also enjoy traveling. Recent destinations have included Mexico, Argentina, Spain, London, South Africa and Thailand.

If David and Lolly could eliminate one design element from the world, what would it be?
Shiny brass.

What have David and Lolly used in their designs over the years that remains in style today?
Sterling silver, both old and new, which they believe is timeless and blends with everything from traditional to contemporary.

BETH SPECKELS

Beth Speckels, ABT

Muse on Dragon

1444 Oak Lawn, Suite 460

Dallas, Texas 75207

214-744-3664

Beth Speckels has taken the art world by storm, and her clients are reaping the rewards. In her show room in the Dallas design district, Beth features the work of about 30 high-caliber artisans from across the country. Beth uses their original art – paintings, sculpture, wood carvings and ceramics – in her work, giving clients not only the diversified architectural and design expertise they seek, but also the personal artistic touch each job requires. Plus, Beth is supporting the art community by granting these artists the ideal venue for displaying their work.

Thinking outside the box is nothing new for gregarious Beth, who is always ready to seize new opportunities. When a client wants something that's one of a kind, it propels her to new creative heights. Beth, who is not locked in to trends but is aware of them, travels extensively in the United States, Mexico and Europe to stay abreast of the latest design work. Then she advises her clients, helping to shape their dreams and enliven their imaginations with current trends or classic styles.

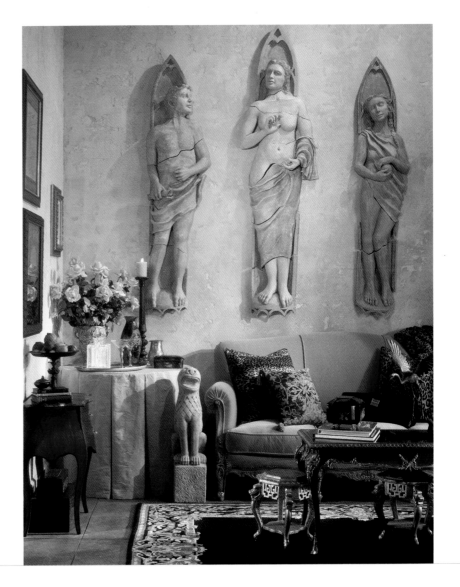

Left: One of Beth's Texas clients said he would prefer living in Santa Fe. So Beth brought Santa Fe to him with rustic furnishings and surfaces in his Texas abode.

Right: Nan Martin's gothic-inspired sculptures are reflected in the verre églomisé mirrors on the side wall created by Frances Binnington of San Francisco.

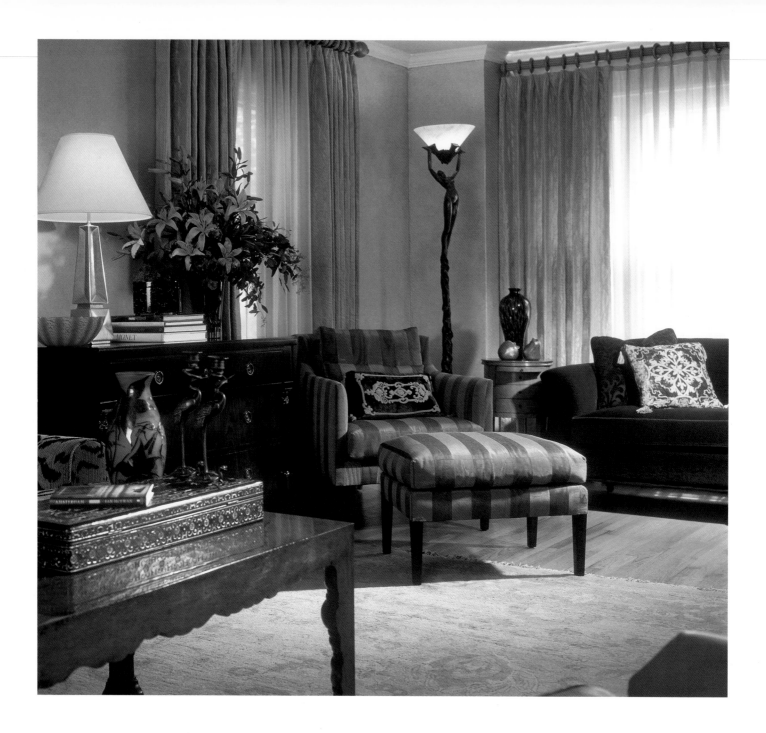

Aided by partner Jayne Davis, Beth tackles a myriad of residential and commercial projects from remodeling to new construction. She often works with architects from the initial design stage through completion, which can include perfect accessories and even fresh flowers. Beth guides her clients toward designs that will stand the test of time.

Some say the basis for great design is exposure. If that's the case, Beth has most designers beat, hands down. Born in Georgia, she grew up in a military family and, as a child, moved 12 times in as many years. She says she "just knew" she wanted to be a designer in the third grade. Beth's mother patiently indulged her creativity, encouraging her to rearrange the living room furniture whenever she felt the urge. Beth moved on to earn a degree in fine arts specializing in interior design.

Also influencing Beth's career choice were her prosperous, generous aunt and uncle. As a child, she visited their island home off the Georgia coast where she always felt special and pampered. One of Beth's fondest memories is her aunt's dreamy boudoir where sherbet green draperies floated in the evening breeze.

Her clients and industry peers alike respect Beth for her creativity, professionalism, integrity and personal attention to detail. It's no wonder she's also known for taking the time to help clients discover their style and, in doing so, discover themselves.

MORE ABOUT BETH. . .

Why does Beth like doing business in Texas?
Because Texas is a melting pot of progressives who have a great independent spirit and are more than willing to try anything when it comes to design.

What is the most unusual piece that she has placed in an installation?
A window treatment for a summer house – a carved snake draped with Balinese fabrics.

How does Beth get away from it all?
When Beth is burned out, she "goes outside." This could mean traveling with her husband Bill to northern California or Puerto Vallarta, taking a buying trip to New York or San Francisco with partner Jayne, or simply strolling around the backyard garden and smelling the roses with her bichons, China and Nikki.

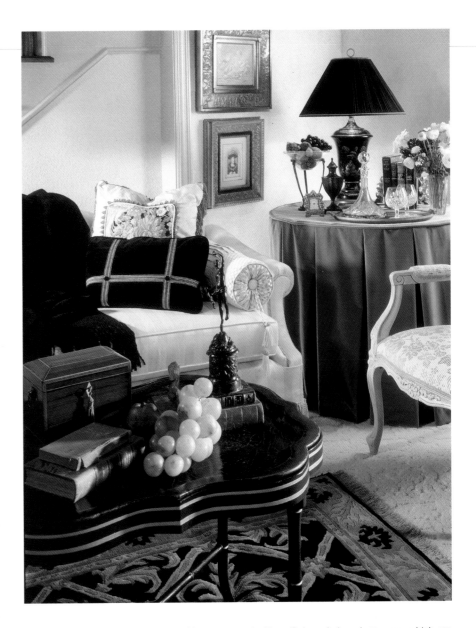

Left: Artist Tom Corbin's bronze torchiere accents the Rose Tarlow chair and ottoman, which are flanked by an aubergine mohair settee.

Above: Beth uses a monochromatic palette to update a small sitting area. The client's patterned floor covering anchors the space and provides notable interest.

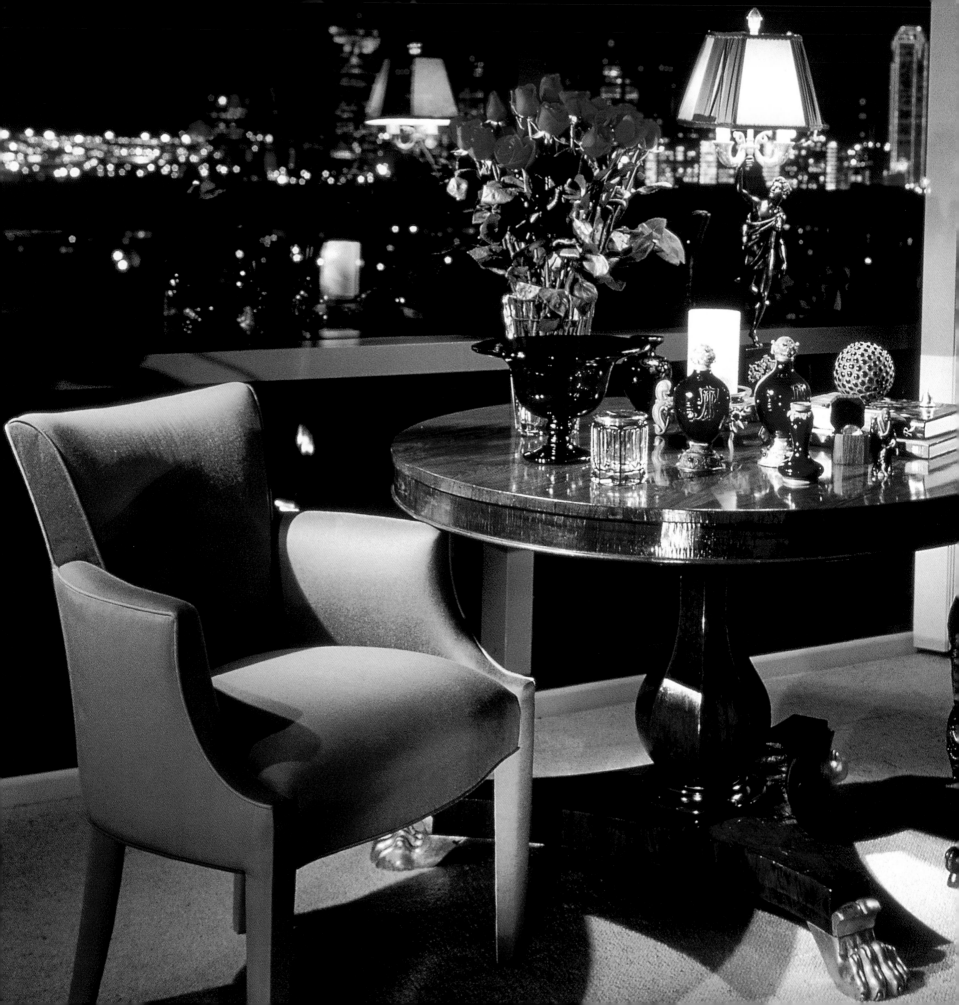

NEAL STEWART & DOUG HORTON

Neal Stewart Design Associates
1025 North Stemmons Freeway, Suite 320
Dallas, Texas 75207
214-748-6541

If you ask clients to describe what it's like to work with designers Neal Stewart and Doug Horton, phrases like "versatile creatives," "total professionals" and "good listeners" might easily pop into the conversation.

Neal and Doug believe the client, and their relationship with him or her, is the most important part of what they do. They are strong believers that the client should be a key member of the project team because, after all, it's the client's personality, desires and lifestyle that provide their design inspiration. Neal and Doug consider it their responsibility to listen and then educate their clients. They know they've done their job well when they've created one-of-a-kind rooms that help their clients enjoy life a little more and sometimes change their lives.

Left: An eclectic sitting room overlooks the Dallas skyline.

Top left: Behind the bed's headboard Neal and Doug ingeniously designed an upholstered moving panel that either exposes a window or ensures darkness for a good night's sleep. The lamps are murano glass.

Bottom left: Neal and Doug created this living area for clients who appreciate the arts.

Right: Neal and Doug juxtapose furniture with a traditional flair and contemporary art in this Houston high-rise apartment. A neutral palette sets the mood.

Neal moved to Dallas some 25 years ago and started his design business primarily because of the transportation advantages provided by the Dallas/Fort Worth International Airport. A few years later, Doug and Neal joined forces. Their client base extends from Dallas and most major metropolitan areas across the country to London and the Caribbean. They also have an office in Honolulu where they are developing an expansive client roster. Most of their work comprises residential new construction or renovations.

Neal and Doug have similar educational backgrounds and career experiences, making for a solid business partnership that allows them to focus on design. The twosome has strong project management abilities and keen organizational skills. They run a tight ship, collaborating on each design project to ensure superior quality and top-notch service. They establish goals for each project and accomplish them according to schedule and within the parameters of a client's budget. And when it comes to architects and contractors, they work with the best of the best.

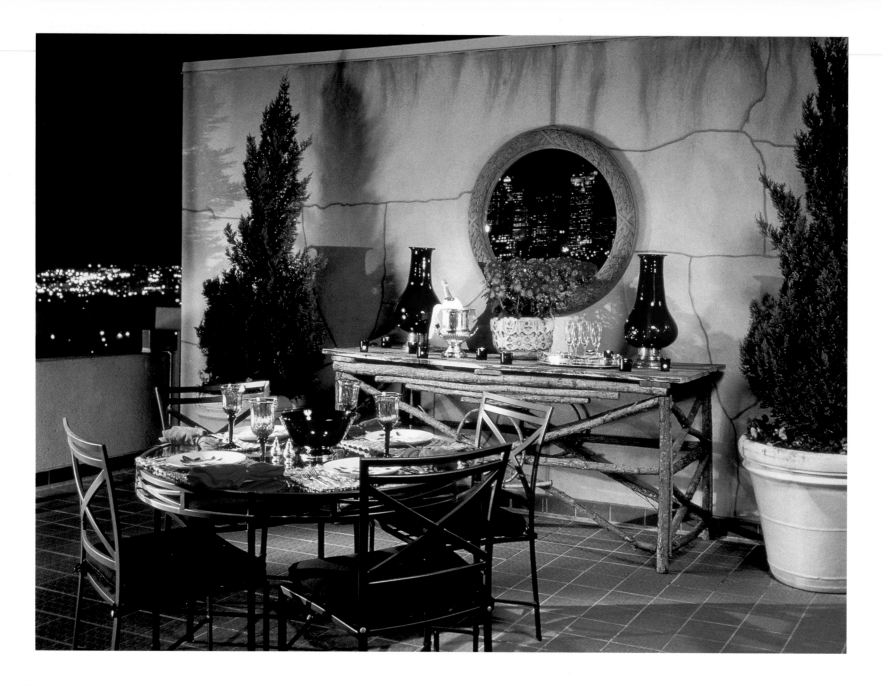

From a design standpoint, Neal and Doug are well known for their versatility, and their wide-ranging creative abilities allow them to tackle any design style. For instance, in a high-rise apartment building in Dallas' tony Turtle Creek area, they completed five projects (talk about building business by referrals!), each with a different design theme – French, Tuscan, Californian, and hard and soft contemporary. They are particularly sought after for their soft contemporary look, which they accent easily with a client's traditional antiques, perhaps even adding an Oriental objet

d'art or family heirloom. They enjoy working with a variety of color, preferring not to be tied down to a particular palette.

If you ask this twosome what motivates them, most likely they will simultaneously respond, "Our clients!" Neal and Doug are inspired by a client's unpredictability and enthusiasm. Most of all, they derive great satisfaction from helping people transition into different stages of their lives.

Left: A rustic serving piece adds an unexpected touch of nature to this terrace on the 16th floor of a Houston apartment building.

Top right: This small sophisticated space is complemented by a multi-functional contemporary table on wheels with etched glass top – ideal for dining, entertaining or working. The silk checked pillows carry out the motif in the Edward Fields area rug. The sofa is upholstered in black wool.

Bottom right: A custom-made oversized black leather sofa and ottomans define elegance and comfort in this living area. The chrome cylindrical tables have blue mirrored tops, and the floors comprise unusually wide maple planks for a sleek open look.

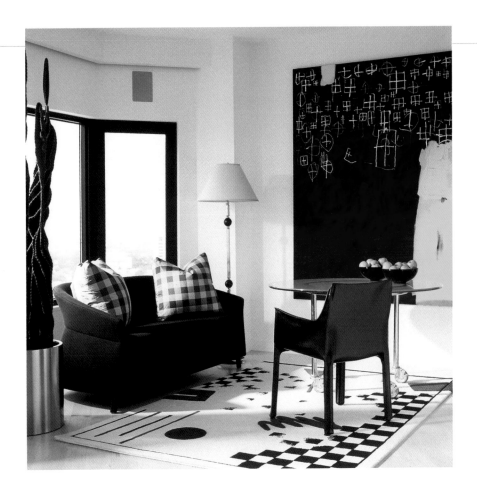

MORE ABOUT NEAL AND DOUG. . .

Why do Neal and Doug like doing business in Texas?
Because most of the people who live in Texas have diverse backgrounds. They are well educated and well traveled.

What do they like best about designing?
Neal: Every day, job and client are different.
Doug: Meeting new people.

How do friends describe Neal and Doug?
They say Neal is always in a hurry, and Doug has a great sense of humor.

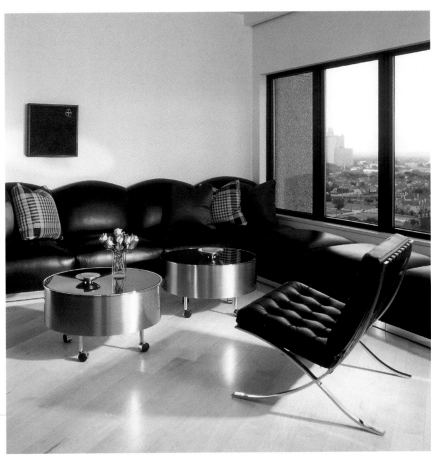

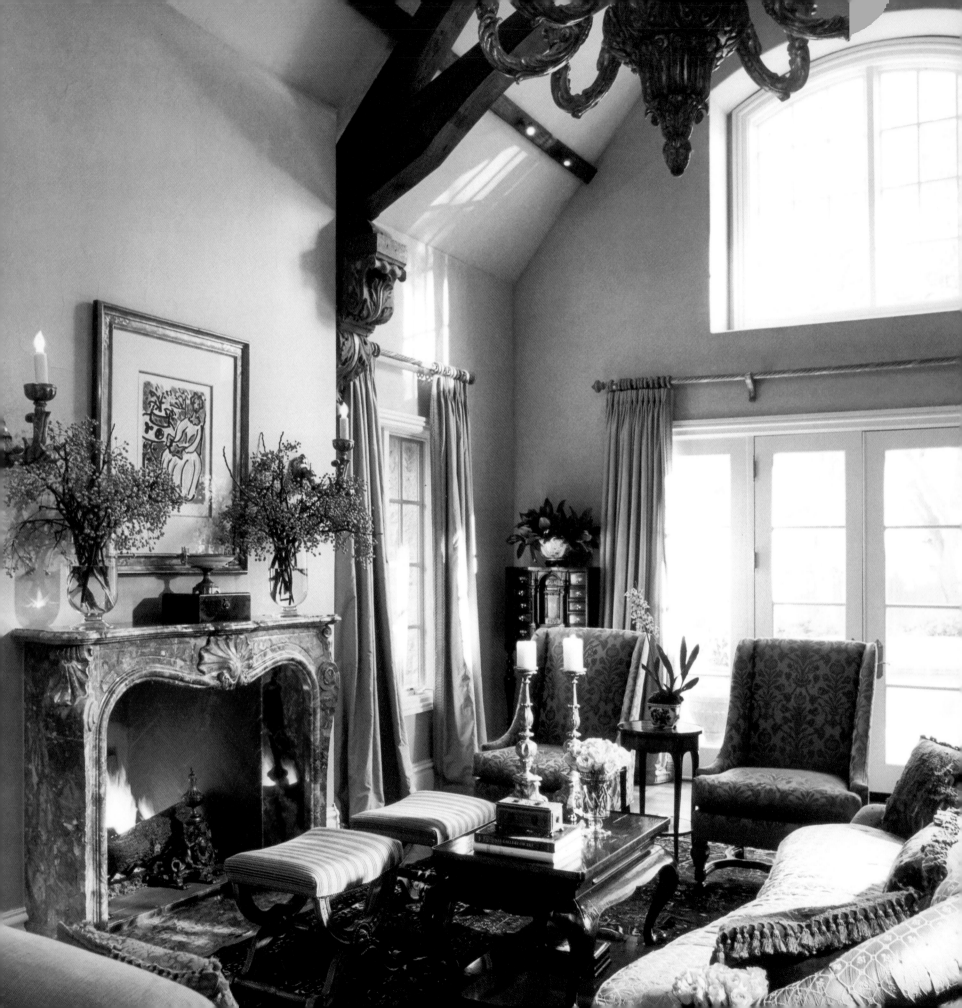

RICHARD TRIMBLE

Richard Trimble, ASID
Richard Trimble and Associates, Inc.
3617 Fairmount Street, Suite 121
Dallas, Texas 75219
214-526-5200

Richard Trimble has a reputation for designing with timeless elegance. His firm is recognized for mixing period antiques with comfortable, custom upholstered pieces for an uncluttered look. Projects encompass a variety of large-to-moderate scale residential work, as well as commercial installations.

Richard has retained many clients for more than 20 years. He's met their needs during different phases of their lives by designing successive residences. An observer by nature, he initially visits clients in their homes, evaluating how they function in their environment. He values their input in order to best match their design requirements with their lifestyles.

Since founding his Dallas firm in 1976, Richard has believed in the hands-on approach to design management. He is deeply involved in the details of each project so clients can communicate quickly and directly with him.

Left: In this inviting living room, a Matisse has a place of honor above the Louis XV fireplace purchased in France. The Italian ceiling corbels circa 1700s attract the eye. An Italian ebonized chest with intarsia marble panels adds charm to the space. The furnishings are covered in fine imported silks.

Right: A Louis XVI parquetry desk and bench warm this niche, which has a pleasant mix of antiques and contemporary art. A rosewood box decanter sits atop the desk.

Left: A colorful Venetian glass collection is displayed on an 18th century Regence server. A French painting of Bacchus accentuates the room, and gold-leaf moldings highlight the French-washed paneling.

Right: In this dining room, a custom-made pedestal table with gold-leaf accents is surrounded by pomegranate silk Venetian-style chairs. A French Boulle wall clock with matching stand and Chinese Famille Rose porcelain bowl are notable accents on a painted Italian console.

Richard gained in-depth business experience before entering the interior design profession. At Texas A&M University he earned a bachelor's degree in marketing with a minor in finance and a master's degree in psychology specializing in personnel management. After working briefly in the corporate world, Richard studied further, earning a bachelor's degree in interior design from the University of North Texas. He also has completed extension seminars at Worcester College, Oxford University.

In addition to being a talented, creative designer and astute business executive, Richard has made a valuable contribution to the Dallas community through leadership roles in many arts and civic organizations. Currently, he is a member of the Dallas Historical Society's Board of Trustees. His community involvement résumé also includes serving as a board member, chairman and president of the Dallas Symphony Orchestra Guild; an ex officio board member, Dallas Symphony Orchestra Association; a member, French Heritage Society; a member, Dallas Museum of Art Associates; and an ex officio board member, Dallas Museum of Art.

Richard also is a past president and former board member of the Texas chapter of the American Society of Interior Designers (ASID) and has served as a member of various ASID national committees.

MORE ABOUT RICHARD. . .

Who has had the most influence on Richard's career?
Richard's wife Pat, who is the operations manager of Richard Trimble and Associates, Inc., encouraged him to return to college to study interior design.

What design element has he used over the years that's always in style?
Chinese porcelain.

What is the most unusual piece that Richard has placed in an installation?
A French cheese-drying rack he used as a towel stand in a cabana.

What is the single thing he would do to a room to bring it to life?
Add fresh flowers.

How does Richard like to spend his free time?
Richard and his wife Pat travel extensively, particularly in Europe, where they frequently mix business with pleasure.

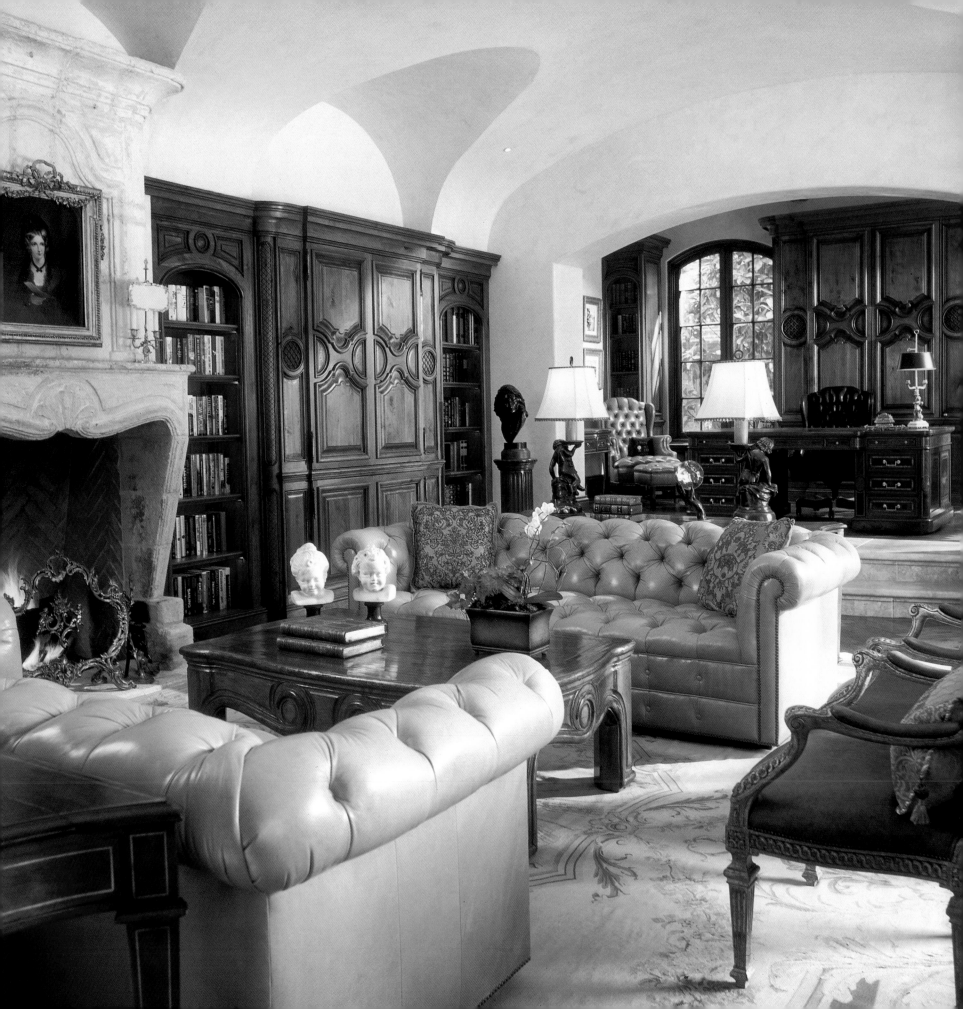

CHERYL VAN DUYNE

Cheryl Van Duyne, ASID
14999 Preston Road
D-212 PMB 253
Dallas, Texas 75254
972-387-3070

For Cheryl Van Duyne, the best part about being an interior designer are the moments when clients tell her how much they enjoy their beautiful, new environment and how she's changed their lives.

Cheryl, who readily admits to a perfectionist streak, has based her design business in Dallas for more than 20 years. Her clients, many of whom she's had since starting her firm, appreciate her precision, confidence and creativity. They trust her instincts for developing the perfect design solutions to improve their homes and offices, both aesthetically and functionally.

Cheryl has followed clients from first home to country getaway, frequently designing long distance. After visiting a design site, she measures meticulously and takes reference photographs. That's when the ideas start to flow. A strong visual type, she's been redoing rooms in her mind for as long as she can remember, a trait she laughingly refers to as an "affliction."

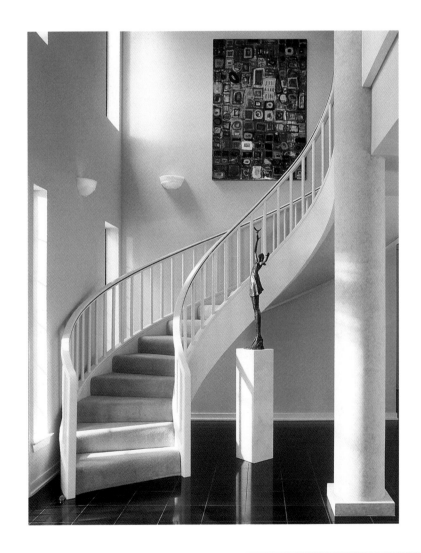

Left: An Aubusson rug circa 1870 anchors this elegantly detailed library. Cheryl custom designed the sofas to accommodate the room's size and scale.

Right: The dramatic, colorful painting by Susan Sales and bronze sculpture by world-famous sculptor Tom Corbin complement the contemporary stairway perfectly.

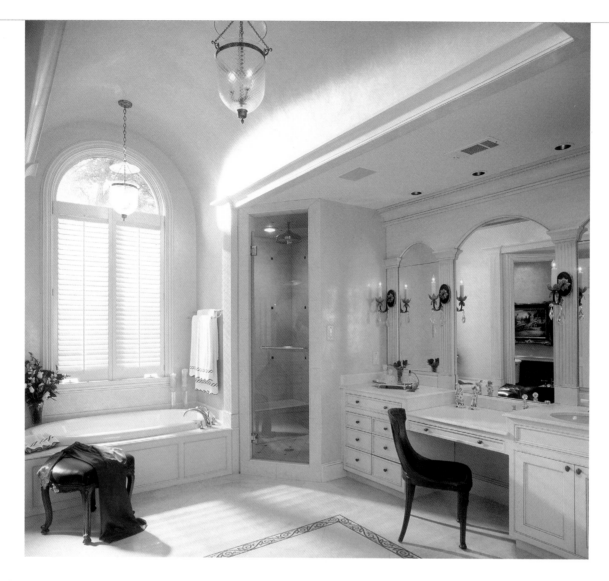

If Cheryl had only one design element to work with, she would choose color. It's powerful and creates mood, even changing a room's visual shape when applied properly. While her own home is a mix of styles, Cheryl leans toward contemporary with traditional influences. She says she enjoys all styles, as long as they are well done.

Cheryl has continued her studies in France and England, spending weeks visiting countryside castles, museums and art galleries on study trips, learning about architecture and ancient interiors.

Cheryl approaches her work with humility and gratitude. She has great respect for her professional peers, as well as those who assist with merchandise, and the artisans and craftsmen who work on her projects. Texans are helpful, can-do people, she says.

Her work has garnered local ASID Design Ovation awards and the Silver Style award given by *Dallas Home Design* magazine. Her work also has been featured in the media, including *D* magazine, *Southern Living* magazine, national design books *Southern Rooms*, *Showcase of Interior Design* and *Porches and Outdoor Spaces*, as well as Home & Garden Television. She is an active ASID member, and has served as chair of Dallas Association Public Relations, and is on the Texas Chapter ASID board and serves on several advisory boards.

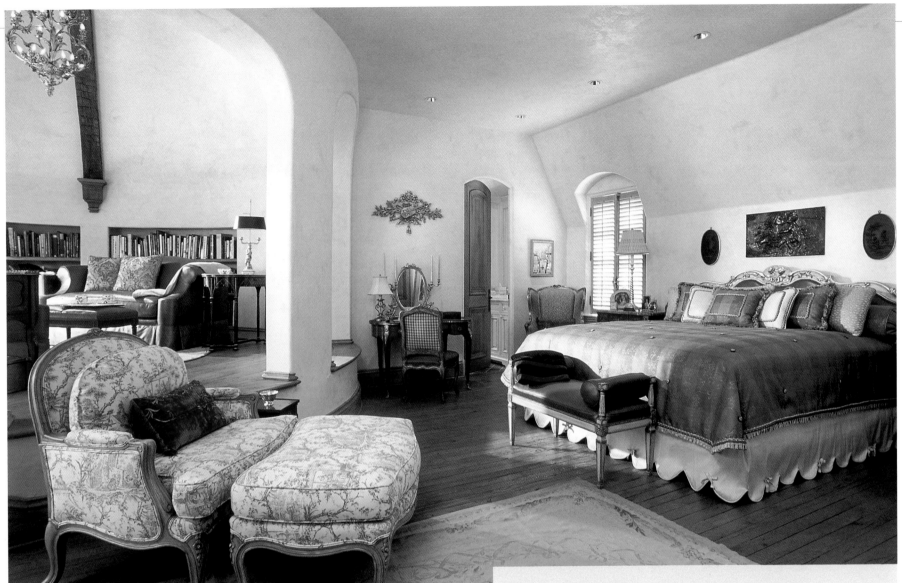

Cheryl is proud of her family, especially her grandchildren. Even during busy weeks filled with client meetings and deadlines, she finds time to squeeze in a grandchild's talent show or dance recital.

Left: Special touches make this bathroom a luxurious, relaxing space. Cheryl designed the cabinetry, millwork and barrel-vaulted ceiling, which ends with an arched window at one end and a mural at the other. Mosaic tile provides a colorful accent, and the lighting highlights the sparkle of the walls' venetian plaster, as well as the ceiling.

Above: This guest bedroom suite is ready for the most important visitor. Cheryl combines exquisite antique French furniture from her client's collection, soft leather sofas, antique textural silks and an Aubusson rug in this sumptuous setting.

MORE ABOUT CHERYL. . .

If Cheryl could eliminate any design elements from the world, what would they be?
Light switches and electrical outlets on walls.

What design element has she used over the years that's always in style?
A well-designed chair is versatile and can be used anywhere, says Cheryl. A fine antique or great painting also is universal, and great lighting is essential.

What CD is playing in Cheryl's car?
Cheryl enjoys classical and jazz music, but she's usually on her car phone working — using a hands-free microphone, of course!

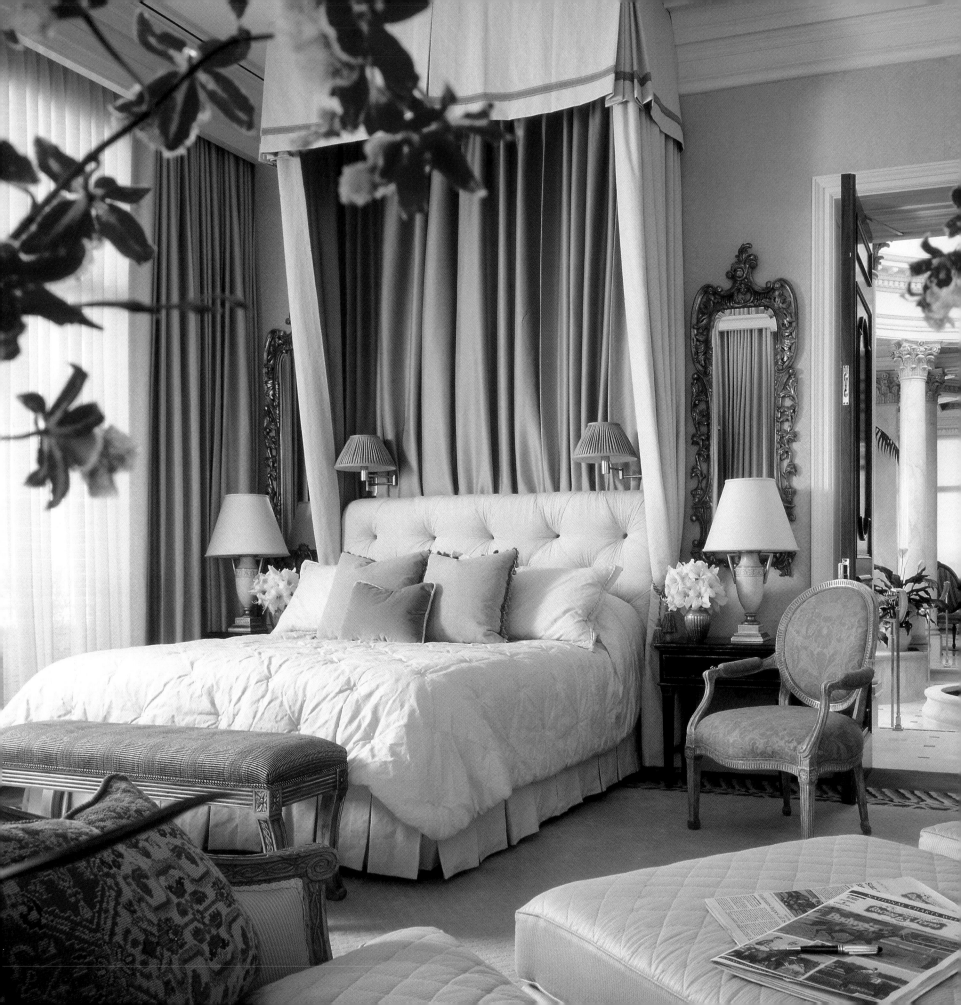

TRISHA WILSON

Trisha Wilson, ASID
Wilson & Associates
3811 Turtle Creek Blvd., 15th Floor
Dallas, Texas 75219
214-521-6753

Trisha Wilson's first home was a hotel in Augusta, Georgia, where her father was manager and she was born. Little did she know that her destiny already was written in the stars. Today Trisha is a world-renown hotel designer and truly a legend in her own time, thanks to her extraordinary creativity, exceptional business savvy and a lot of hard work, as well as two commercial developers who were Renaissance thinkers.

After graduating from the University of Texas with a bachelor's degree in interior design, Trisha began her career as a residential interior designer, and then took on restaurant design as a new challenge. With these venues under her belt, she held her breath and took a giant leap forward into the world of hotel design.

During the past 25 years, she has built her firm, Wilson & Associates, from the ground up. Now with about 200 employees, her company is headquartered in Dallas with offices in five additional cities — New York, Los Angeles, Singapore, Shanghai and Johannesburg. Trisha's firm routinely has 40 to 50 projects simultaneously under way around the globe.

Left: Classical architecture abounds in this master bedroom with French-style furnishings, a canopied bed and silk brocade fabrics.

Above: Trisha Wilson at the Venetian.

Even though the majority of Trisha's interior architectural design business is hotel focused, her firm also does residential and restaurant work, with some offices specializing in these niches. With about 50 registered architects on staff, Trisha emphasizes architecture in all her designs, which are driven by clients' visions and budgets. Personally, she has no signature look but enjoys combining periods and styles, and particularly likes the contrast between traditional furnishings and contemporary art.

Trisha admits she's had some lucky breaks, along with a little chutzpah for good measure. Famous developer Trammel Crow, Sr. gave her the opportunity of a lifetime that catapulted her into the world of hospitality: the chance to design her first hotel, the Loew's Anatole Hotel in Dallas (now the Wyndham Anatole). At the time, the grand Anatole was the premier hotel of its kind, especially in Big D, with plenty of restaurants, too, just to keep Trisha on her toes.

With her reputation preceding her, Trisha defined the phrase "going global" in the early '90s when she was invited by visionary developer Sol Kerzner to design The Palace of the Lost City. Ranked as one of the world's extraordinarily breathtaking hotels, The Palace is part of the Sun City resort just outside Johannesburg, South Africa.

Forever guileless, Trisha always accomplishes what seems to be the impossible. No matter whether it's a splendid residence in Dallas, a funky in-crowd restaurant in Bangkok or a luxurious five-star resort hotel in Cairo, her philosophy is simple: She tackles every design project one room at a time.

Top Left: The clean, simple design of this contemporary townhouse is refreshing. A sea grass-covered staircase leads to a collection of books and African artifacts.

Top right: The living room of a Mediterranean-inspired villa shows off Tuscan furnishings with silk brocade upholstery.

Right: This living room offers opulent comfort and luxury. An eclectic combination of leather and silk upholstery, Mexican silver treasures and hand-stenciled ceiling embody the setting's Spanish-Mediterranean motif.

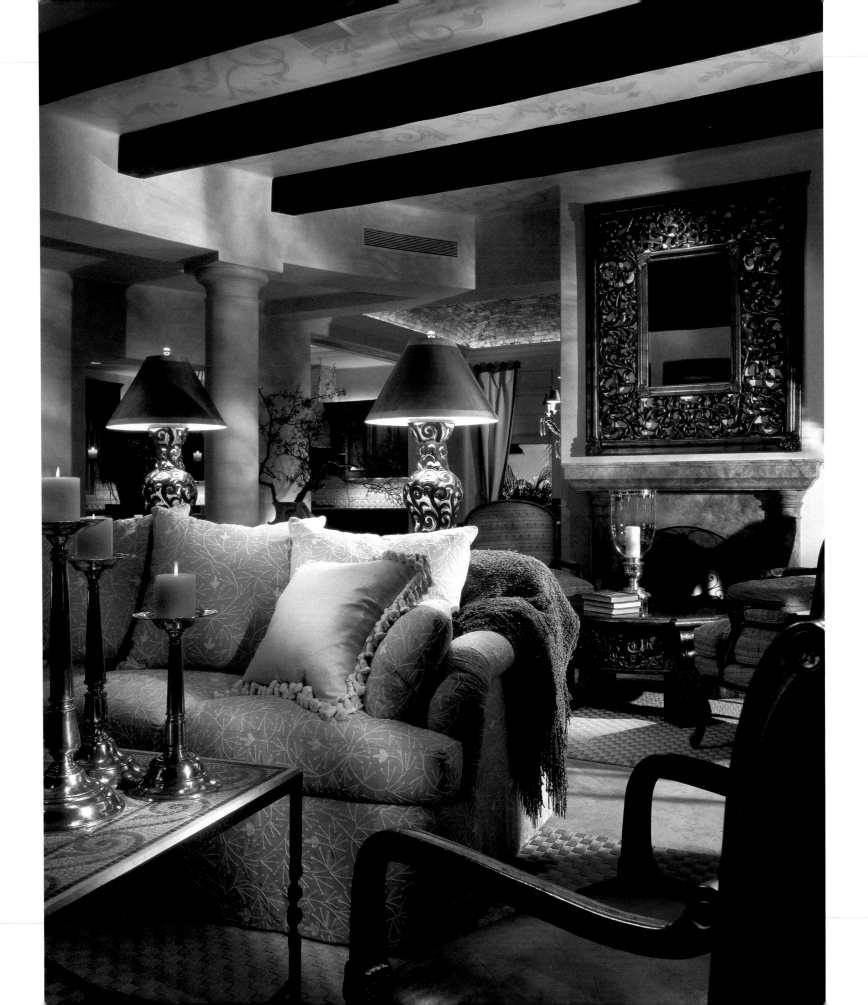

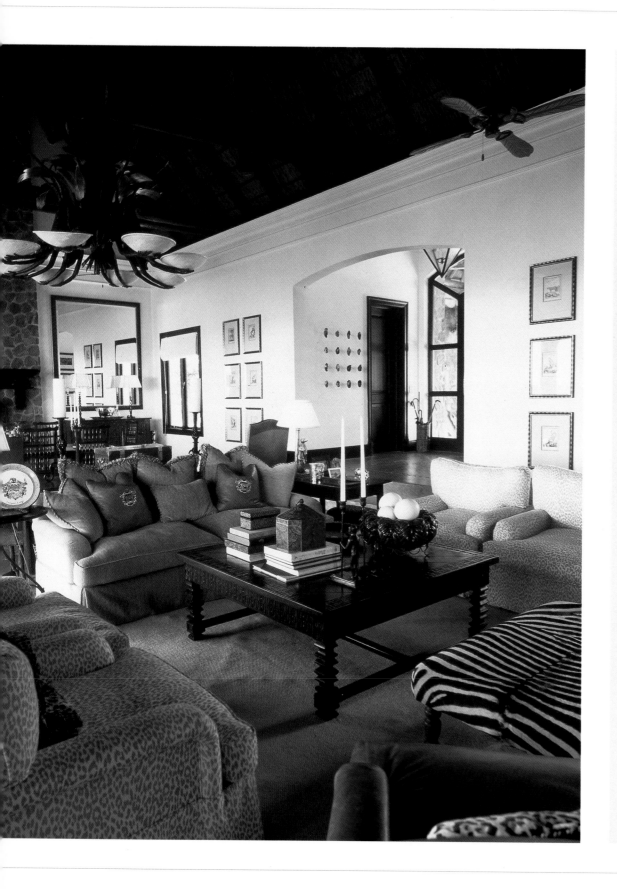

MORE ABOUT TRISHA. . .

What is the best compliment Trisha has received during her career?
Having an endowed scholarship established in her name at the School of Architecture, University of Texas at Austin.

What is Trisha passionate about?
Africa and its wildlife. She fell in love with Africa and her future husband at the same time – when she was designing The Palace at the Lost City outside Johannesburg. Trisha also enjoys sketching and photographing the African countryside.

What objects has she had for years that remain in style today?
In Trisha's homes in Dallas and near Johannesburg, she values her collections, including contemporary art, antique silver, ethnic necklaces, and blue and white porcelain.

How do Trisha's friends describe her?
Honest. They know she will always say what she thinks.

What is the most unusual piece that she has placed in an installation?
A swimming pool used to bathe Arabian horses in Saudi Arabia.

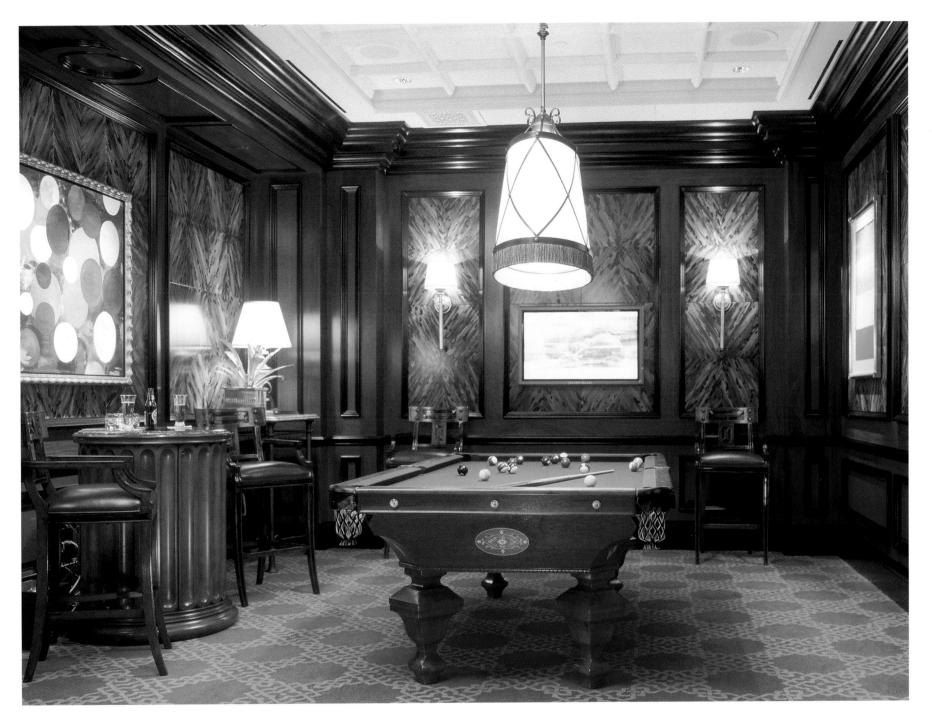

Left: The living room of an elegant British colonial lodge is the ultimate in luxury. African artifacts, including a mask collection in the hall, are ideal accents.

Above: The matchbook marquetry paneled walls help create a decidedly masculine ambiance in this luxurious game room. Contemporary art offers a definitive contrast.

JOANIE WYLL

Joanie Wyll, ASID
Joanie Wyll & Associates
6330 LBJ Freeway, Suite 239
Dallas, Texas 75240
972-380-8770

Joanie Wyll strives for designs with drama. Perfect scale, proportion and balance are the foundation on which she builds her sleek, sophisticated look. Whether the setting is traditional or contemporary, she advocates the tasteful, clean lines of modern classicism.

Then she introduces the pièce de résistance: contrast. Her juxtaposition of diverse styles, finishes, shades and textures allures clients and admirers alike and makes her rooms simply irresistible.

Her elegant, subtle palette comprises chic neutrals accented by bursts of bold color, usually in the form of extraordinary contemporary art that commands a double take, especially when hanging center stage above an antique baroque console or a modern sofa. An art lover, she often commissions well-known artists to create works for her clients.

Joanie provides her clientele with outstanding service from project conception through installation and beyond. She and her long-time associate, designer Marybeth Jones, work one on one with clients, spending quality time with them to ensure their involvement in the design process.

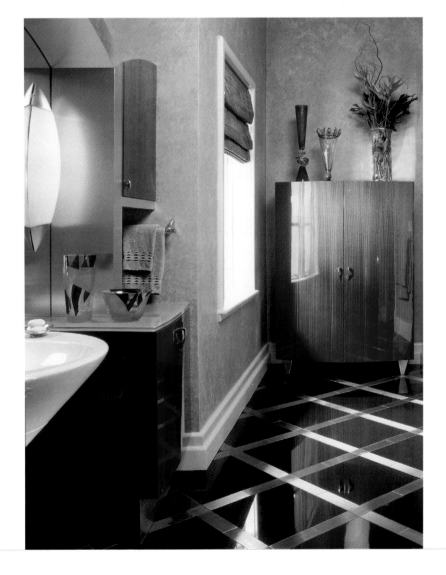

Left: This wine room exemplifies sophisticated city living. Polished nickel adds a contemporary flair to the mahogany chairs. Cabinets are ribbon sapelli mahogany.

Right: This jazzy bathroom shows off a stainless steel floor.

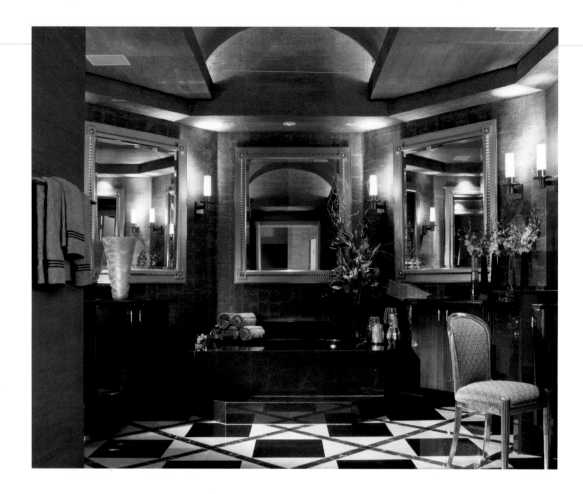

Top left: You might find this glamorous bath and dressing room, outfitted with classy marble and exotic wood, in a luxury hotel.

Bottom left: This lavish art deco media room flashes back to the 1930s and 1940s when movie theaters were grand showplaces.

Right: A round monolithic table and custom lighting that draws attention to a treasured art collection make this a one-of-a-kind dining room.

Joanie prefers to be a charter member of the design team for every project, whether new construction or renovation, residential or commercial. She looks forward to the creative interaction and idea exchange with the client, architect and builder. Her goal is to gain an innate understanding of the space and maintain its integrity by harmoniously placing furniture, art and accessories.

Joanie's affinity for design dates back to childhood. She remembers always having a passion for art, fashion and design. She pursued her lifelong dream and earned a degree in interior design. Shortly thereafter, indefatigable Joanie established her practice while raising a family.

Joanie's perseverance and hard work have paid off. Greatly respected by her peers, she has been honored by the Dallas Association, Texas Chapter of ASID for her innovative work. She has won numerous Design Ovation awards, including

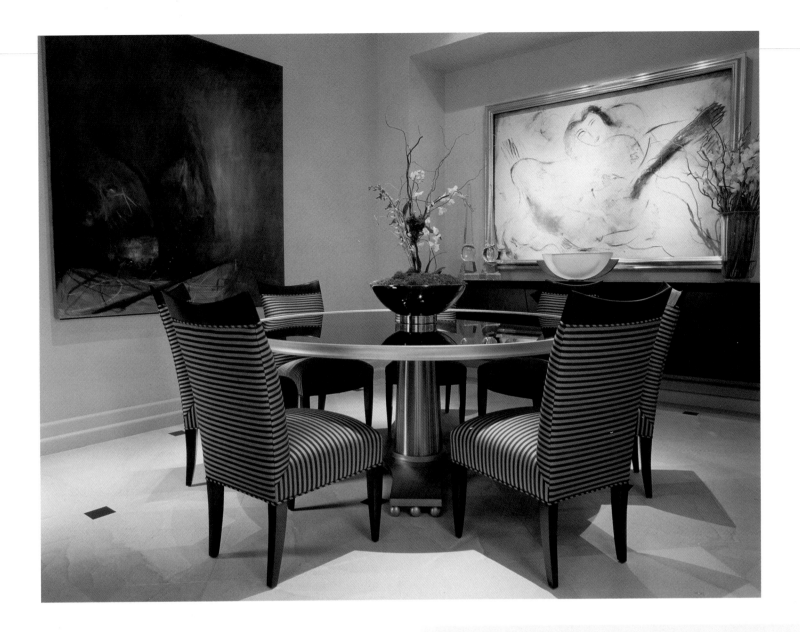

recognition in the Design/Special Detail and One Compelling Space categories. She also has garnered *Dallas Home Design* Silver Style awards for Bath Design and Best Blend of Design and Architecture. Her work also has been featured in Texas news and trade media.

Joanie likens producing a new design solution to solving a puzzle. She lives for the mystery of the game, the visual search for just the right pieces. When a client exclaims "Oh, wow!" she knows she's created the perfect fit.

MORE ABOUT JOANIE. . .

How do Joanie's friends describe her?
They say she's a perfectionist.

What design element has she used for years that remains in style today?
Wonderful original contemporary art exuberant with color and emotion.

Why does Joanie like doing business in Texas?
People are open to new ideas and have a great appreciation for good, innovative design.

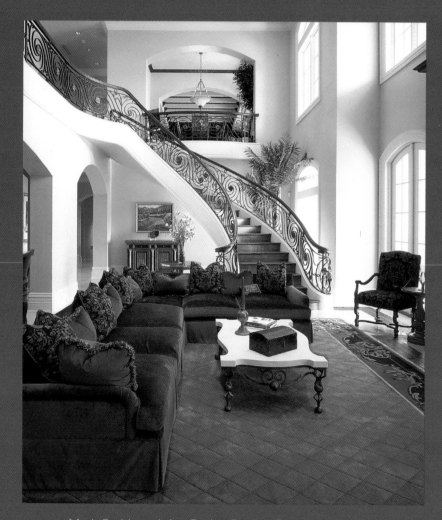

Mark Smith and Joe Burke, Design Center, page 120.

Austin

AUSTIN

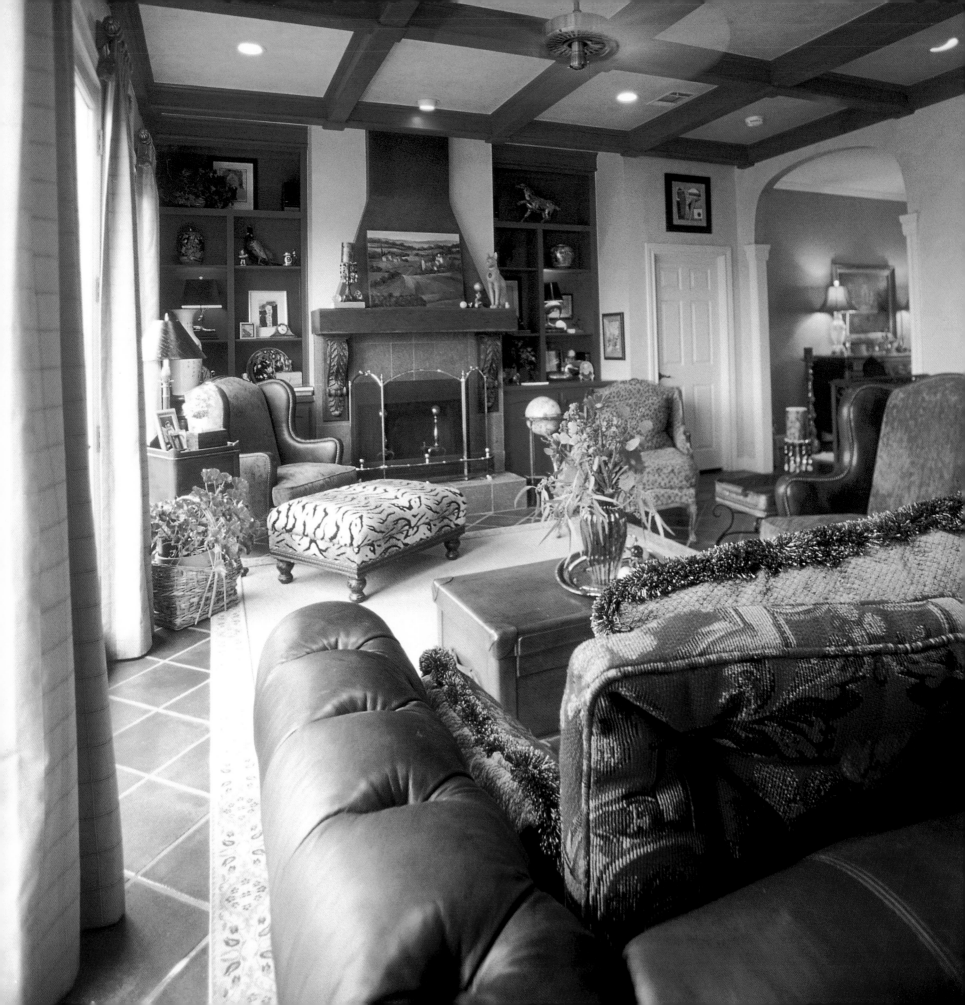

BRYN BUTLER

Bryn Butler, ASID
3803 Jackson Avenue
Austin, Texas 78731
512-787-8812

Bryn Butler is a self-proclaimed design maven. From grand first homes to casual second homes, from ranches to private aircraft to boats – she's designed interiors for them all.

Bryn, who has a background in architecture, threw her hat into the design ring years ago. Her decision has taken her all over the state of Texas, the Southwest and around the world.

Prior to joining the design staff at John William Interiors in Austin, she was an independent designer in the Hill Country for many years.

In Russia, Bryn taught a design class about Texas interiors in Moscow and St. Petersburg with the aid of an interpreter. And she connected with Japanese clients via the Internet. They landed on her Horseshoe Bay doorstep with blueprints in hand for their downtown Yokohama, Japan, four-story home no wider than a two-car garage. With Bryn's help, they selected materials in Texas, New Mexico and Nuevo Laredo, Mexico, for the interior of their Southwest-style abode, which were shipped via container to Japan. When her clients' residence was completed, Bryn and her mother were invited to visit. They hung art work as a finishing touch and enjoyed being guests in an all-American home in a traditional Japanese neighborhood.

In 2003, Bryn was a winner of the Austin ASID chapter's first-place Design Excellence Award and an Award of Merit. She was a finalist for the Texas Association of Builders Star Award for Best Interior Merchandising of her work in Austin's Lakeway area.

What motivates Bryn? "There are so many homes with beige carpet and beige walls!" She is thrilled to hold clients' hands and lead them into the "deep end of the pool" to help them discover their sense of style.

Left: Bryn creates a country club ambiance in her clients' award-winning family room with punches of color and plenty of opportunities for displaying their art collection.

Above: Longleaf pine reclaimed from an old Texas dance hall was used in the flooring of this residence. Aged mesquite ceiling timbers, Austin stone columns and a collection of prized animal trophies contribute to the feeling of a handsome Montana backwoods lodge.

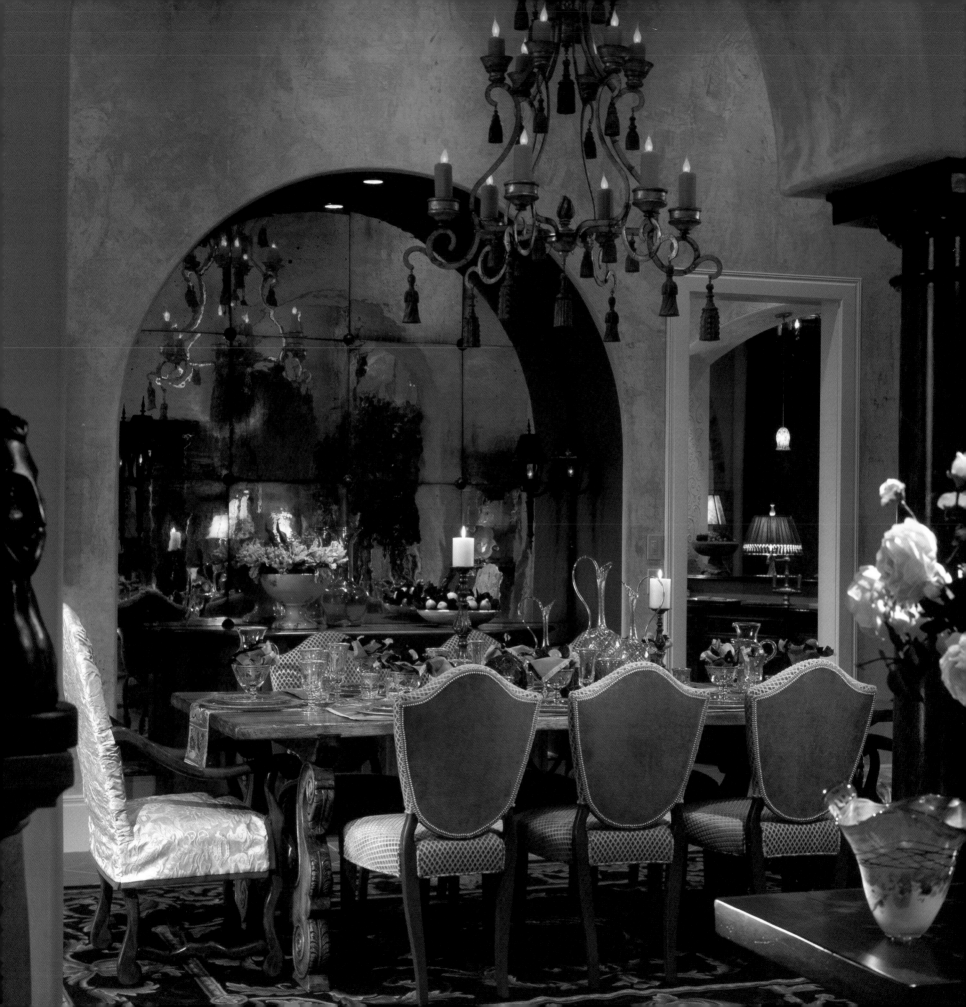

JULIE EVANS

Julie Evans, ASID
Julie Evans Interior Design
2808 Bee Cave Road
Austin, Texas 78746
512-330-9179

As a little girl, Julie Evans was a blossoming interior designer. She just didn't know it. When her family moved into a new home, Julie's mother asked her to draw a picture of the house – just to keep her occupied. Instead of drawing a box with a triangular roof and chimney, Julie produced a crude floor plan. In the seventh grade, Julie gave a speech, choosing "antiques" as her topic. She watched her classmates' eyes glaze over as she outlined the differences between Sheraton and Chippendale instead of delivering the exposé on the Beatles they would have preferred.

After studying interior design at the University of Texas, Julie and husband Jim traveled to Australia, an impulsive lark that lasted nine years. There she touched on design by working in the lighting retail business. Eventually, the Evanses returned to Texas so their children could know their roots and have family memories. That's when Julie began to build her design business, sometimes collaborating with Jim by creating interiors for his home construction projects in Crockett, Texas.

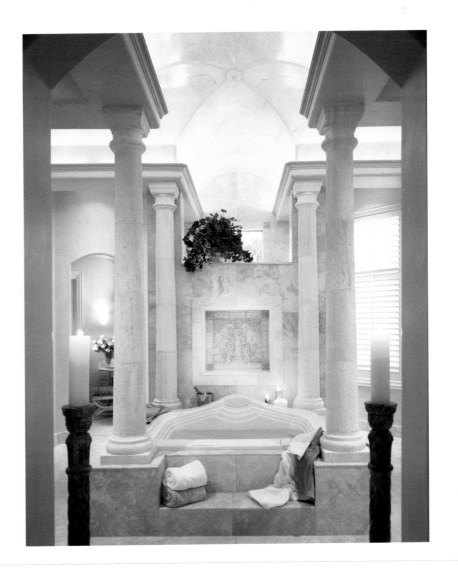

Left: In this new home, Julie creates a rich and deeply textured atmosphere that's sophisticated but not formal. This award-winning dining room contrasts textures, styles and colors.

Above: Julie intentionally keeps the design simple in this master bathroom, which enhances the drama of scale and architectural elements.

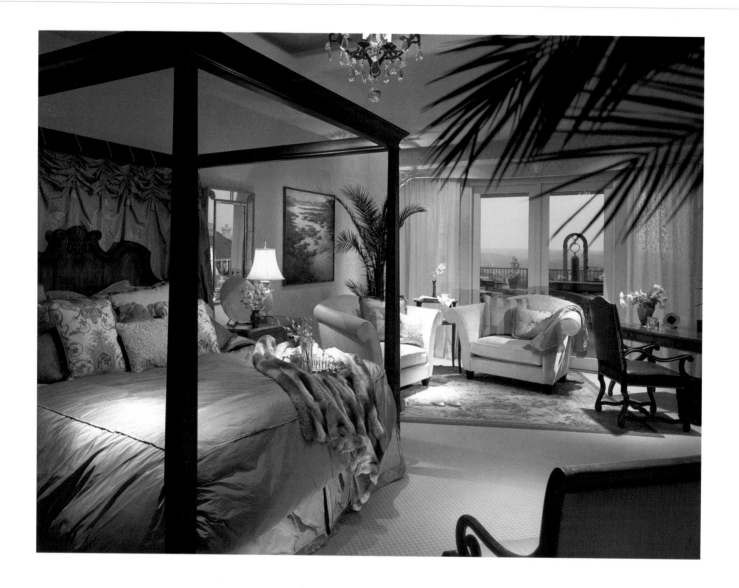

Two days after their last child graduated from high school, the moving van was ready to whisk Julie and Jim to Austin. Julie couldn't wait to return to "the most laid back of cities" where she could spread her artistic wings.

Julie believes interior design is largely an editing task: The critical eye ensures that you will achieve the desired effect. She says a room's axis creates energy, and that's what evokes the appropriate line, scale and balance of a setting. Julie prefers a minimal traditional look, funky but not fussy. And she has an affinity for color because it evokes an immediate emotional response from clients and often serves as the basis for creative decisions.

Julie owes much of her success to two Crockett residents who encouraged and inspired her as she reentered the professional design world. Susie Cook, a fellow designer and close friend, mentored Julie when she started her business. Alma Turner, an interior designer, home builder, artist and bit of a Southern Belle, taught Julie that if she did her best — focusing on the job and not the compensation — success naturally would follow. It is a lesson Julie has taken to heart, practices daily, and has found to be true.

What does Julie like to do when not designing? "I just like to *do*," says Julie. She traverses the nearby Hill Country and treks to New York on buying trips where she easily fits in visits to museums and antique shops. She also practices yoga and Pilates, and has taught dance. Julie enjoys attending live musical performances in Austin, seeing great similarities between music and design, both infused with rhythm and movement.

MORE ABOUT JULIE. . .

What is Julie's favorite color?
She is attracted to all colors, but her favorites are described with more than one word, she says with a chuckle.

Why does Julie like to do business in Texas?
Because there is an independent spirit that permeates the people of Texas. Julie thrives on her clients' individuality from ranches to lofts, and doesn't think any of her clients have wanted the same look — pure inspiration for Julie.

If Julie could eliminate design elements from the world, what would they be?
There are so many! Grout that doesn't match tile; oak cabinets that are too yellow; columns that are not in scale with an elevation; stone and brick combinations that are too busy; and furniture placement that upsets a room's axis, or flow.

Left: In this award-winning master bedroom, French pieces from the 1940s play against more traditional French furnishings and sumptuous silk.

Above: Julie revives an 1850s home to modern playful elegance. She believes historic preservation doesn't have to be stuffy and can still win awards!

MARLA HENDERSON

Henderson Group
702 San Antonio Street
Austin, Texas 78701
512-495-1885

For Marla Henderson, beauty is a tree branch, a sun-washed beach, a polished stone. She brings the art of nature to the interior, producing personal nests for her clients that inspire, nurture and comfort.

Marla grew up on Georgia's St. Simons Island where she first recalls being awed by nature. Her mother's miraculous inventiveness sparked Marla's creativity. She made her a dollhouse out of a cardboard box and stitched dreamy "designer" ensembles for school dances.

Friends in Atlanta encouraged Marla to try her hand at design after college. On a whim she moved to New York, establishing her firm on a lot of courage and a little budget. Forever fascinated with all things Texan, later Marla made another bold move, this time to Austin where she has renewed her relationship with nature.

Left: The nest sculpture by Jennifer Ham of Savannah, Georgia, provides a quiet focus for this simple and serene retreat on Austin's historic Bremond block.

Above: Burnished porcelain rattles by Austin artist Edmund Martinez rest in silver cups Marla discovered on a New Orleans scouting trip.

Marla's settings have a painterly quality, and she uses color selectively. Her palette of preference reflects nature's calm — whites, creams, soft gray-blues and gray-greens, and tobacco — while rich color punctuates her settings. Natural materials such as stone, wood and clay give her designs a sensual appeal. And because Marla often incorporates handcrafted items, she works closely with talented artisans to foster traditional methods of creation. She also advocates collecting original artwork.

Marla and associate Ann Tucker "produce" projects from conception. They help clients assemble the perfect design team, including an architect and a landscape designer, to create the ideal living space. The enterprising twosome also has launched a line of hand-woven rugs from Turkey's Anatolian region. In addition, Marla and Ann host art and design tours and conduct makeovers that rejuvenate clients' spaces.

Marla's idea of a mini-vacation is taking a dip in one of Austin's nearby swimming holes, only 15 minutes from her studio. It's no wonder Marla says becoming a Texan is the best move she ever made.

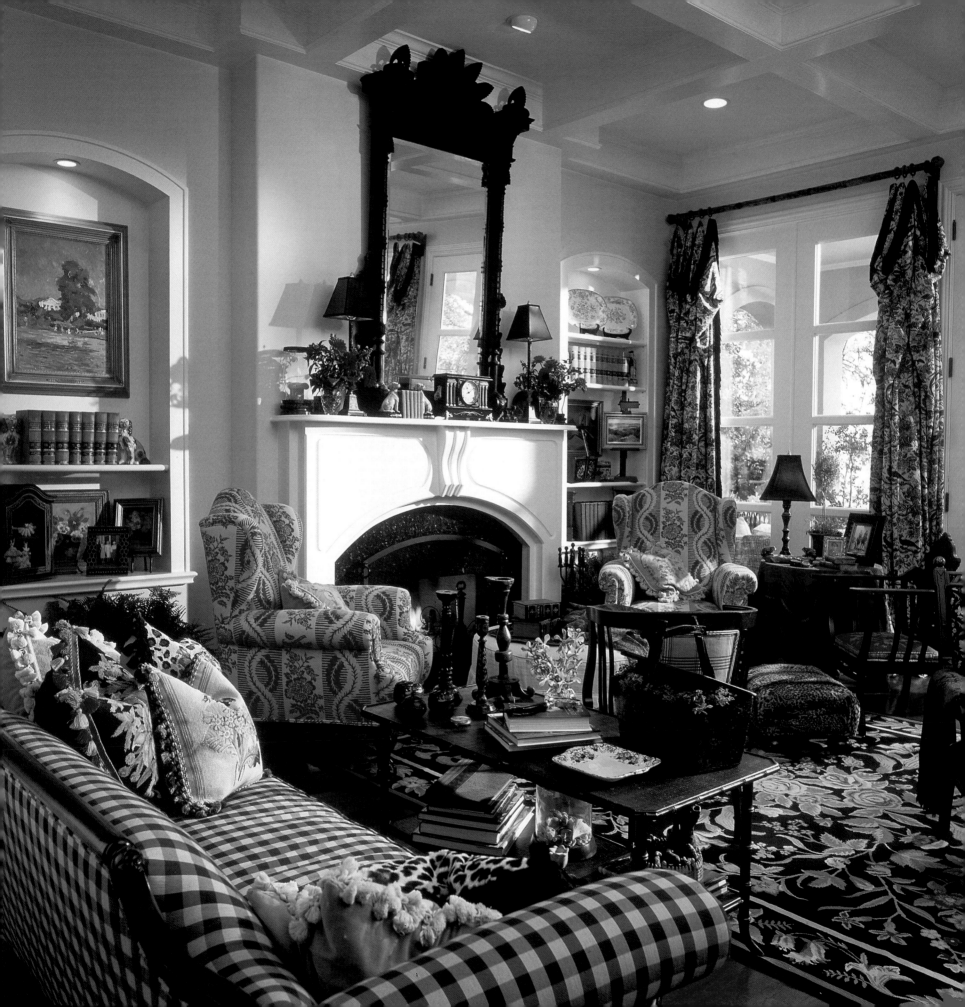

JENNY HEUSNER

4124 Westlake Drive
Austin, Texas 78764
512-327-0830

For unconventional Austin designer Jenny Heusner, opposites attract. Her work possesses a timeless quality that creates an aura of elegance and comfort. But a soupçon of the quirky or whimsical – usually found in clients' attics or basements – anchors her designs, often intriguing the imagination.

Jenny comes by her love of eclecticism honestly. Her mother, a stylish retail buyer of couture, and her father, a commercial photographer with a great sense of the offbeat, celebrated and encouraged her creativity. Jenny studied art and design at the University of Cincinnati and the Cincinnati Art Museum.

An open-minded listener and astute observer, Jenny guides clients down a path of self discovery. She readily incorporates their belongings in her work, possessions that are a part of their personal history and represent who they are. Passionate about life, she says "the future must reflect where we've been," and she covets objects with a patina.

Jenny, who has an exceptional ability to retain color and visualize three dimensionally, believes great design is based on classic proportion and scale. A mother of four, she expertly produces inviting, practical environments that endure and is a proponent of teaching children to appreciate beautiful objects.

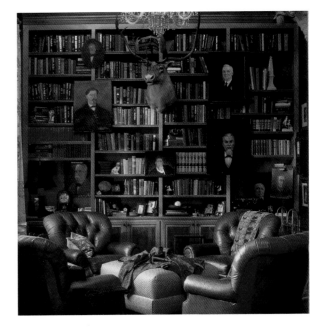

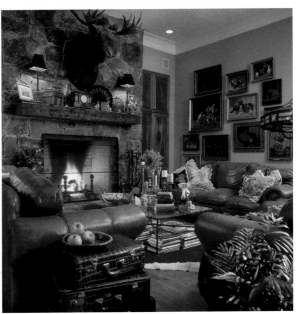

Left: Jenny's eye for whimsy is alive and well in this living room where the antique wingback chairs are upholstered with the fabric's reverse side. The footstool is covered with a cheetah coat that belonged to her mother.

Top right: A collection of male portraits – "adopted" Heusner family members – and a caribou fill Jenny's library with personality. The ottoman, covered in two-tone woven leather, is topped with an antique paisley throw.

Bottom right: "I am a shopper, not a hunter," Jenny says, referring to the moose above the fireplace. She used lumber from an abandoned ice house for the mantel.

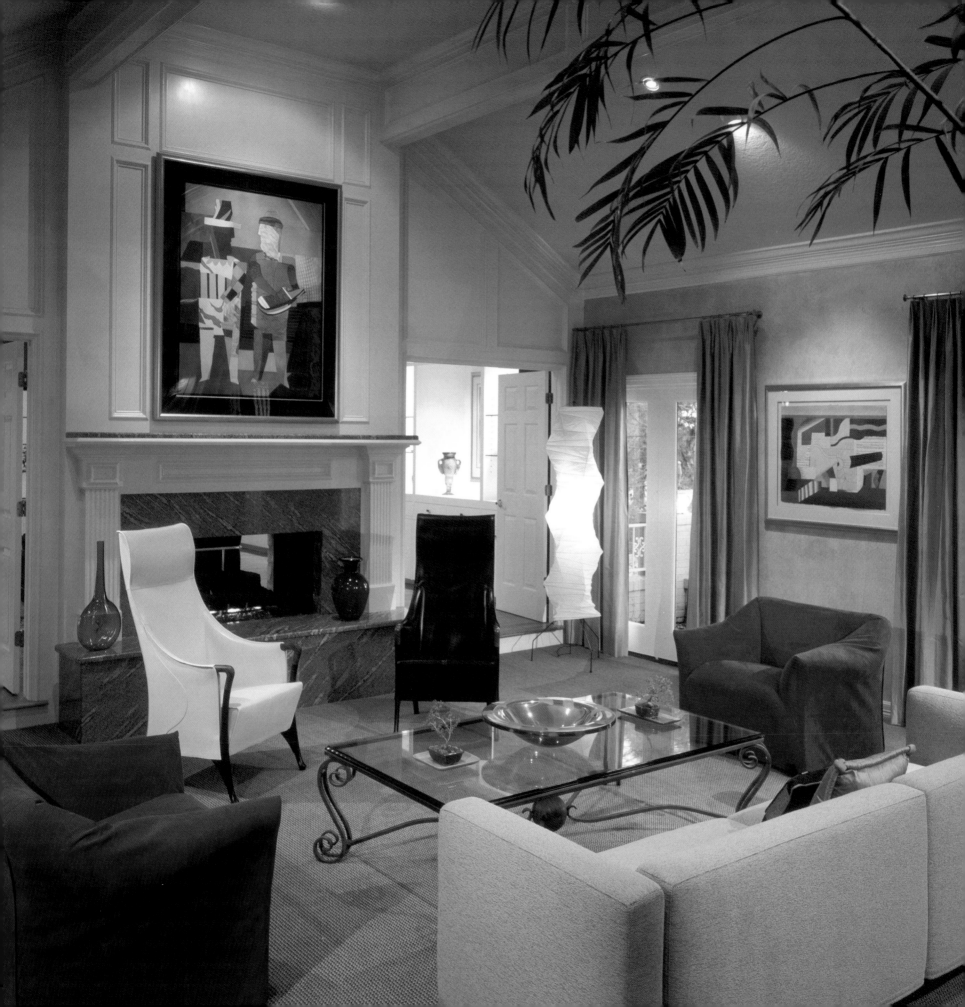

SUSIE JOHNSON

Susie Johnson, ASID

Susie Johnson Interior Design, Inc.

2808 Bee Cave Road

Austin, Texas 78746

512-328-9642

Despite a bachelor's degree in French, it was only a matter of time before Susie Johnson would become an interior designer. Her study of the French language exposed her to the people and culture of the country where art and fashion are revered as part of everyday life. A Francophile since she was 15, Susie is convinced that France has had the most influence on the world of design in general and her creativity in particular.

Other locales have inspired her as well. Susie traveled the globe with her husband during his corporate career. Not only did she visit France several times, but a stay in Iran during the heady days of the shah introduced her to the exotic wonders of Middle Eastern culture and intricate design. In Scottsdale, Arizona, she became enamored of the natural starkness of the desert and minimal, sophisticated southwestern motifs.

After settling in Austin some 25 years ago, Susie found the best of all worlds. With its rugged terrain, warm weather and architectural elements such as tile and adobe, the Hill Country is akin to southern France, making Susie feel right at home.

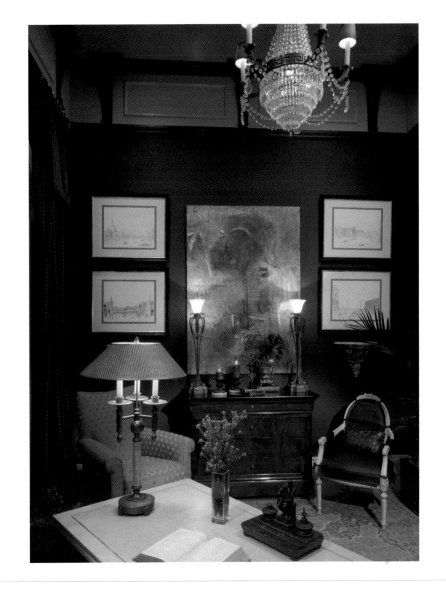

Left: Giorgetti leather chairs and a Noguchi lamp mix with an Italian table and George Papart originals to keep the mood light in this dramatic living room.

Right: In this award-winning showhouse study, deep chocolate walls provide a backdrop for classic references. Susie juxtaposes a 19th century Tuscan chest with abstract art.

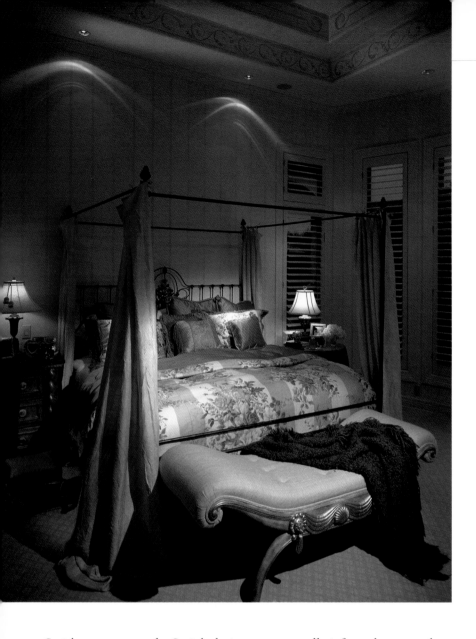

Susie's ability to effectively mix formal with informal, rough with smooth, sophisticated with country emanates from her childhood. She loved playing with her Madame Alexander doll and cherished her favorite aunt for sewing her homemade doll clothes and constructing beautifully detailed miniature furniture. "The best gift I ever had," says Susie, "except for my two children." But Susie didn't hesitate to switch gears, running outside to climb a tree or ride her bicycle.

Multitalented Susie clearly has an affinity for languages. Her favorite, of course, is French, which she says helps tremendously in her design work. She tries to maintain her fluency by listening to tapes in her car between client visits (never a wasted moment!). Susie also speaks a little Spanish, is learning Italian, and even spoke and read Farsi while in Iran.

A self-starter, Susie was a big proponent of eating healthy meals and maintaining an exercise regimen long before they were trendy. She works out almost every day, usually in classes where she has developed lasting friendships. And when it comes to eating, Susie calls herself a "grazer," maintaining a high energy level with fish, nuts and vegetables.

So it's easy to see why Susie's designs are generally informal, accented by the sun-washed colors of Provence and gracefully aged, more formal antiques. She uses timeless classic pieces from the late 18th, early 19th and 20th centuries. The European continental vernacular most appeals to her, with French, Italian and Asian references. And there's nothing Susie likes more than to mix disparate elements. She'll hang a colorful abstract painting over an 18th century sideboard. Or she'll combine a country table with a Louis XVI chair, but give the chair a rustic finish so it blends into the less formal setting.

Susie's clients, who are generally within a two-hour drive from Austin, say that her naturally sunny disposition makes working with her a pleasure. And she follows the golden rule when it comes to client relationships. She treats them the way she would want to be treated if she were a client, solving problems quickly and keeping the lines of communication open. Susie believes her clients are phenomenal, so she thinks nothing of doing little extras for them, something she calls "doing double back flips." She brings them flowers on special occasions or homemade dog biscuits for favorite family pets.

Left: Hand-painted tone-on-tone striped walls add dimension to this master bedroom. The custom iron bed shows off a mélange of luxurious textures.

Right: In a cozy corner of this spacious master bath, the trompe l'oeil ceiling soffit echoes the round tub's Italian mosaic tile seaside motif.

Her service with a smile sometimes extends to the exterior of a client's home when she collaborates with husband Carl, now a landscape designer after retiring from the corporate world.

Go-getter Susie says her name suggests someone who's informal, outgoing and cheerful. What better way to describe Susie, or her work?

MORE ABOUT SUSIE. . .

What is Susie's favorite color?
Yellow-gold, because it is versatile, optimistic and upbeat.

How do Susie's friends describe her?
They say she is exceptionally thoughtful and considerate, remembering birthdays and keeping secrets. They only wish she'd take them shopping in France where she not only knows the language, but the ropes!

If she could eliminate one design element from the world, what would it be?
Contrived, fussy window treatments.

What is the single thing Susie would do to a room to bring it to life?
Paint it a deep, rich color.

What is one of her pet peeves?
Susie dislikes stereotypes, or as she calls it, "putting a tag on something." She's open minded and a strong believer in the adage, "You can't judge a book by its cover." If you do, you might miss something mysterious or exciting that's inside!

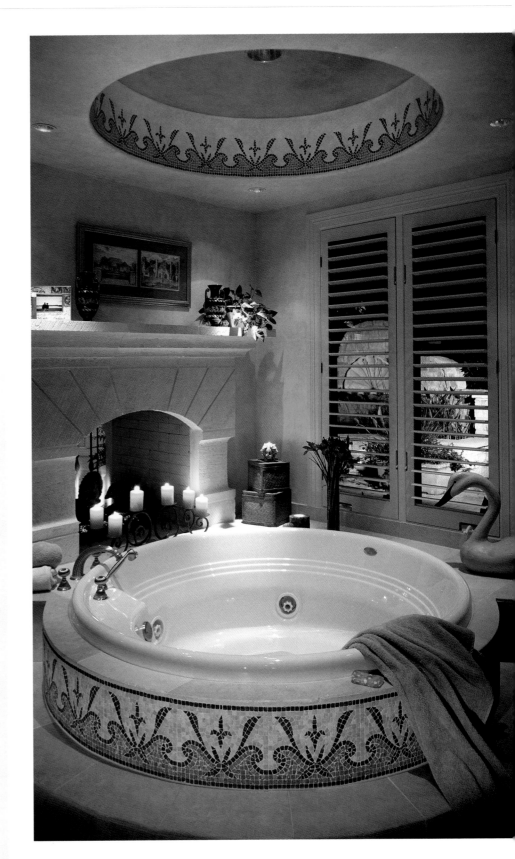

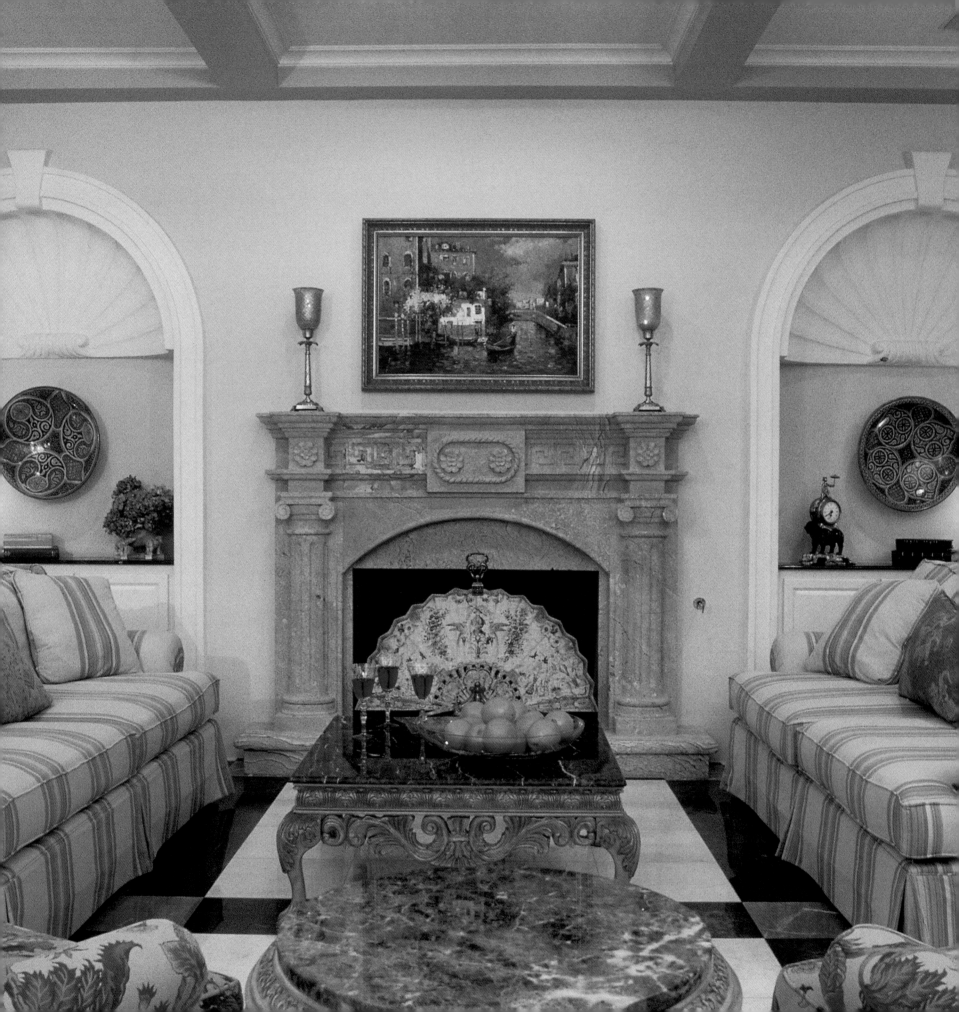

WILLIAM ALEXANDER KINCAID

William A. Kincaid, ASID
William A. Kincaid Interiors
1801 Westlake Drive, Suite 208
Austin, Texas 78746
512-328-3270

William Alexander (Buzz) Kincaid grew up in charming Victorian homes in and around Uvalde and went antiquing with his grandmothers. The die was cast: Buzz was destined for a career in interior design.

Buzz started his decorating business while attending El Centro College in Dallas. After earning a design degree, he eventually moved to Austin, the city that stole his heart, where he's been on his own since the early 1990s.

A descendent of a pioneer family, Buzz celebrates his heritage as a Texas native. Enamored of the state's remarkable cultural diversity and varied architecture, he finds an eclectic mix of classic styles most captivating. Buzz prefers working with subtle color combinations, as well as a monochromatic palette, and many of his interiors reflect nature's artistry.

Buzz produces tailor-made environments, customized according to his clients' idiosyncrasies and approach to life. Above all, he believes a great designer is an even greater listener, forging an intimate bond with clients as he leads them on a journey of creative discovery.

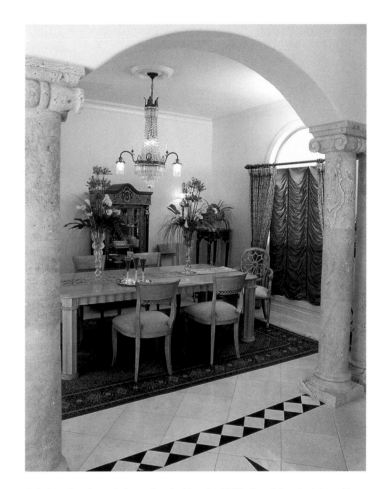

Left: In a San Antonio home inspired by the 1920s Spanish colonial era, Buzz sets the stage for comfort in this informal living room. The gold cantera stone of the fireplace matches interior columns and pilasters throughout the house. The stucco shell niche detail was hand crafted by a Mexican artisan.

Center: William Alexander Kincaid.

Above: The arched entry to this dining room is accentuated by grand gold cantera stone columns. Patterned marble floors, seen throughout the residence, and an Austrian shade framed by Fortuny-style draperies add sophisticated touches. All eyes are on an antique chandelier, while a neutral palette is the ideal background for showcasing seasonal floral color.

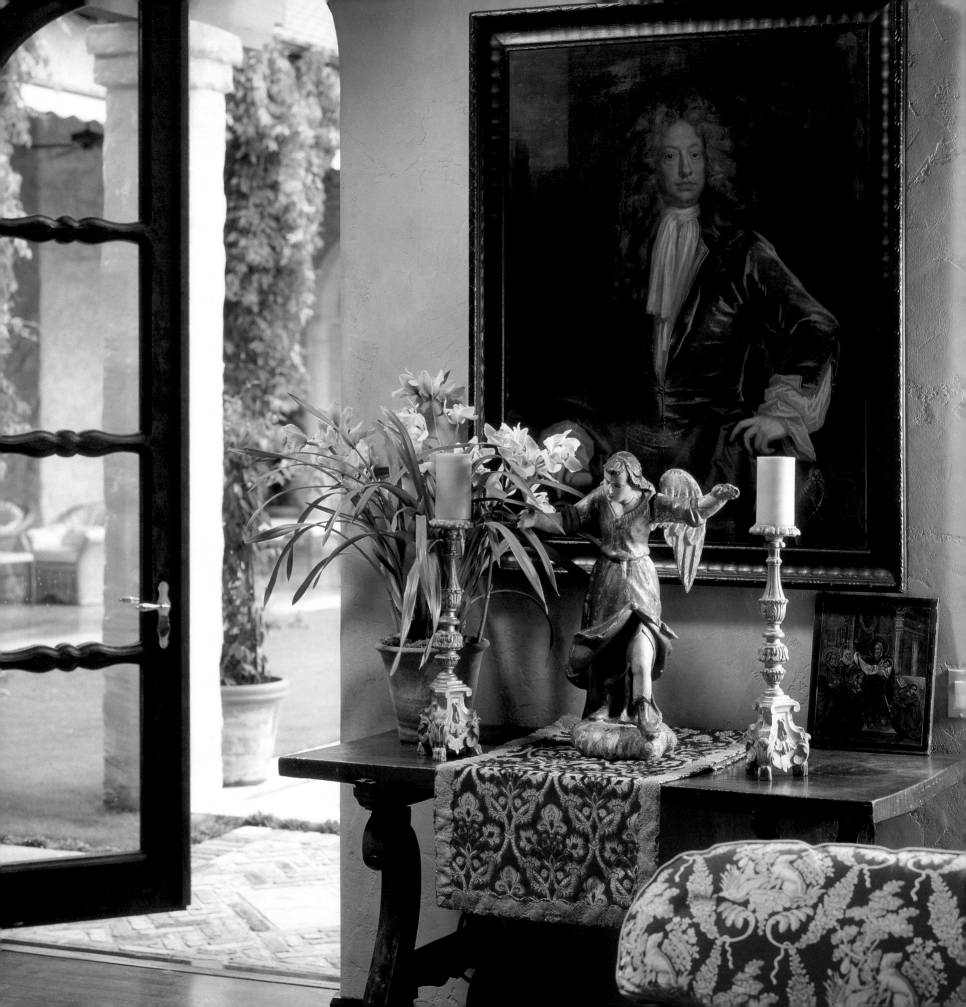

GAY RATLIFF

Gay Ratliff Design
3509 Hampton Road
Austin, Texas 78703
512-476-3831

Gay Ratliff is a classicist who enjoys sharing her love of interior design with others. Possessing a great sense of scale, proportion and shape, she creates rooms that have a soft, lived-in look like they have been around forever.

Her mother and grandmother were passionate about design, too. They had exquisite taste and beautiful homes and possessions. Gay tagged along on their ventures and "played decorator." She traveled frequently with her family, which exposed her to the world's finest architecture and museums.

Gay studied European history and design at the University of Texas. Later, she had the opportunity to study French decorative arts at the Musée des Arts Décoratifs in Paris and English country houses and gardens at Cambridge University. She has an extensive personal library relating to art, architecture and the decorative arts that she uses when researching a project.

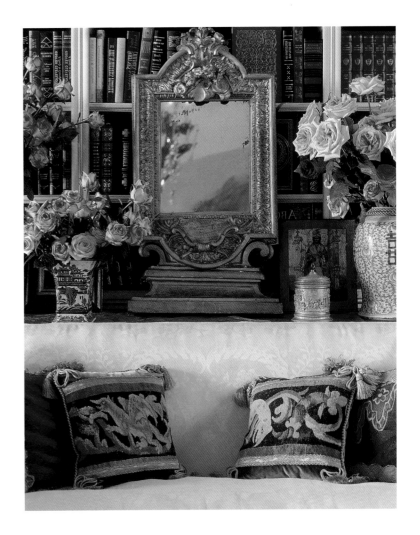

Left: The library in this Tuscan-style villa offers a view of an outdoor living area with pool and fountains. An 18th century painting of a French nobleman overlooks a 17th century Italian trestle table, angel, altar sticks and altar cloth.

Right: Leather-bound volumes offer a subtle backdrop for antiques. A 17th century heavily carved Venetian mirror is flanked by blue porcelain, an 18th century Russian icon and an 18th century round gold box of German origin. Pieces of 17th century tapestry decorate the damask sofa.

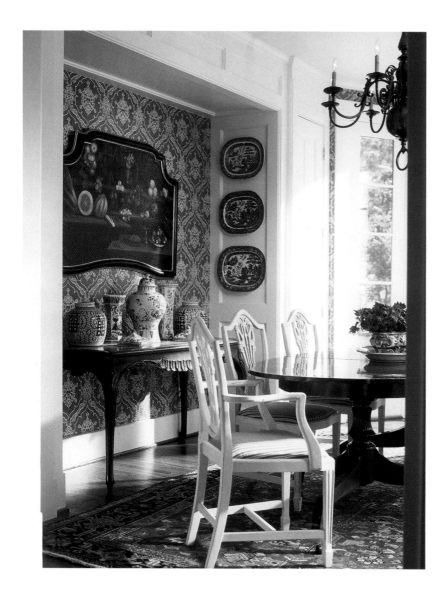

Left: In this light, airy breakfast room, a wonderful combination of 19th century antiques includes an Irish serving table, an English Sheraton dining table and Swedish neoclassical chairs. Gay's arrangement of early blue and white porcelain balances the antique Italian painting above the Irish table. This extraordinary home's architect is John Mayfield.

Right: A pair of comfortable chairs upholstered in refreshing white linen lends an informal air to a sunroom with a marble floor. An antique Louis XVI-style mirror hangs above the 17th century-style hand-carved mantel. A silver and crystal chandelier suspended from the 14-foot ceiling lights this grandly proportioned room.

Good interior design should possess a timeless quality. Gay creates classic settings based on solid lines, appropriate scale and exquisite proportions. Over the years, periodic updating is all that should be necessary for rooms to remain not only beautiful, but also comfortable, inviting and functional, whether English, French, Italian, contemporary, art deco or eclectic.

In her practice, Gay primarily focuses on residential clientele, although she occasionally does commercial work, including specialty retail shops and executive offices. She looks to her clients for inspiration because each person, and each project, is different. She enjoys her clients' participation and enlightens them about the creative process, which heightens their enjoyment as the project comes together.

During her career, Gay has been influenced by architects such as David Adler of Chicago, John Staub of Houston, Neil Reid and Philip Trammell Schutze of Atlanta and Addison Mizner of Palm Beach, who imbued their respective cities with classicism. She also admires numerous contemporary designers such as David Easton for their well-proportioned classic interiors. It follows that Gay has an affinity for classic architecture in general, particularly homes built in the 1920s and 1930s that are recognized today for their incomparable proportion and style.

This Austin designer believes a basic knowledge of history enhances understanding of the important factors that have influenced architecture and design over the centuries, for example, the nobility's patronage of the arts. She also believes that much is learned by observing the best of design and architecture through the ages.

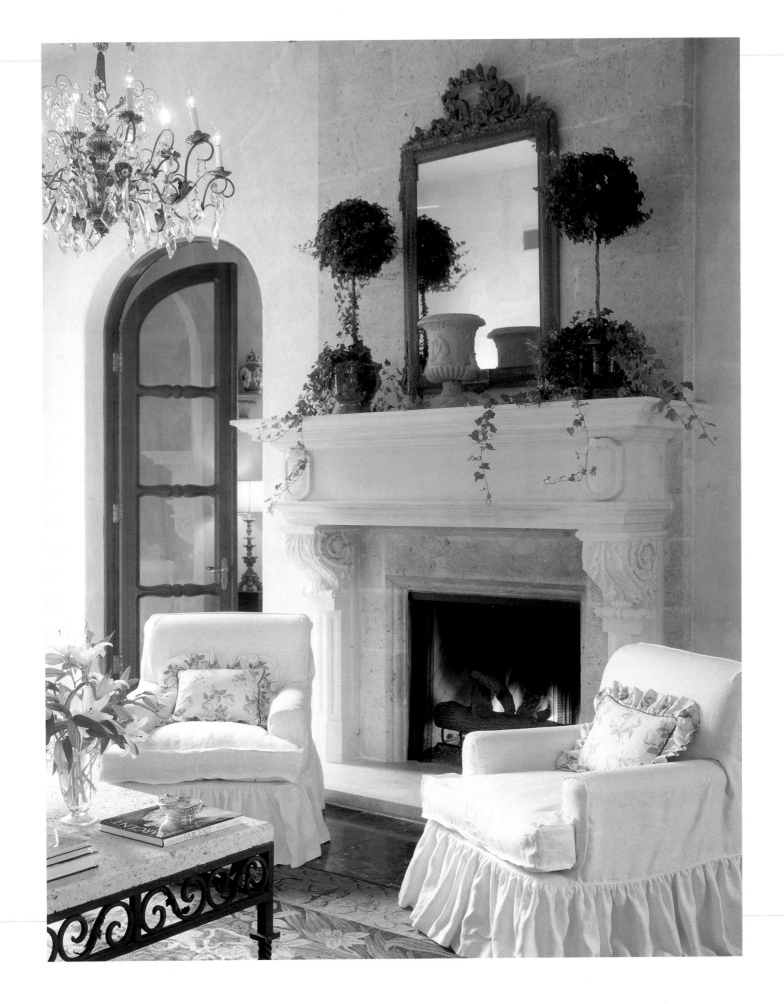

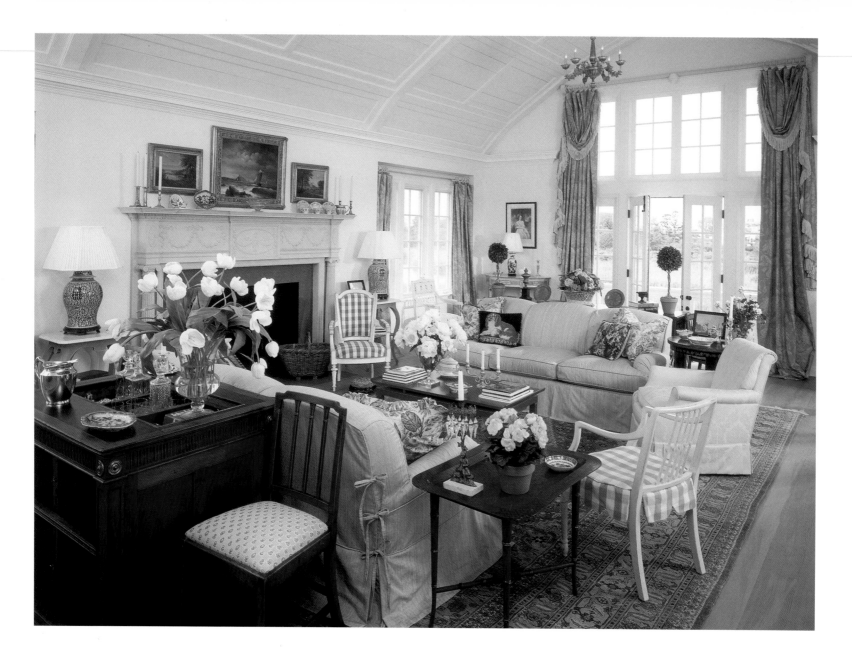

Gay has shared her interior design expertise with the state of Texas and the city of Austin. She has made invaluable contributions by supporting arts organizations that preserve and protect historical architecture and design. Gay is past president of the Heritage Society of Austin and is founding vice chair and current board member of the Friends of the Texas Historical Commission. She is a past president and board member of the Friends of the Governor's Mansion, a group that oversees the mansion property and its collections. She also serves on the advisory board of the School of Architecture at the University of Texas.

In the mid-1980s, Gay participated in the refurbishment of the governor's reception room at the state capitol, restoring its original late 19th century grandeur. She and other members of the project team received a national preservation award from The Victorian Society for their efforts. About the same time, Gay also redecorated the governor's personal apartment in the governor's mansion.

Upholding the Texas tradition of entertaining, Gay and her husband Shannon frequently open their home to family, friends and community organizations. They host simple lunches to elegant dinners and special occasion parties. Ever the designer, Gay believes decorating the table is as important as the food and its presentation. She transforms their home into a magical setting with flowers and candles and accents the table with her fabulous collection of porcelain, silver and accessories.

MORE ABOUT GAY. . .

What is Gay's favorite color and why?
Gay loves all colors but says a soft Italian chamois yellow makes a great background for a variety of colors.

What is the most unusual piece that she has placed in an installation?
Gay installed an unabashedly contemporary glass and brass circular suspended staircase in a downtown Austin office building. It connects a law firm's reception area with its library.

What is the best compliment Gay has received about her work?
Clients have told Gay that her projects don't look decorated. The houses and rooms she's designed appear to have evolved gracefully over the years.

How do Gay's friends describe her?
Involved, happy, energetic and hard working.

What is one of Gay's decorating niches?
True to her love of entertaining, Gay enjoys assisting clients with their collections of special china and silver pieces and then helps them create charmingly festive party tables. She believes all possessions, no matter how grand, should be used and enjoyed.

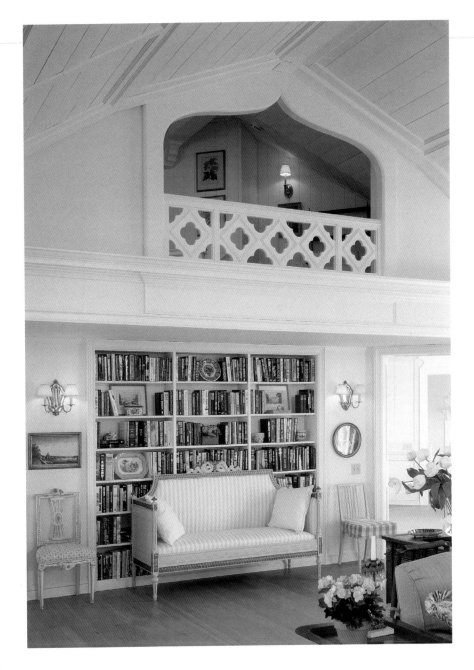

Left: In this enormous living room, Gay mixes an eclectic collection of English and Swedish antiques with comfortable upholstered and slipcovered pieces for an elegant retreat.

Above: The upstairs minstrel gallery overlooking this same living room offers a cozy niche for rainy day reading, just one of many enchanting structural elements designed by architect John Mayfield. An 18th century neoclassical Swedish canape sits regally in front of the bookcase and is flanked by 18th century Swedish chairs and 19th century English paintings.

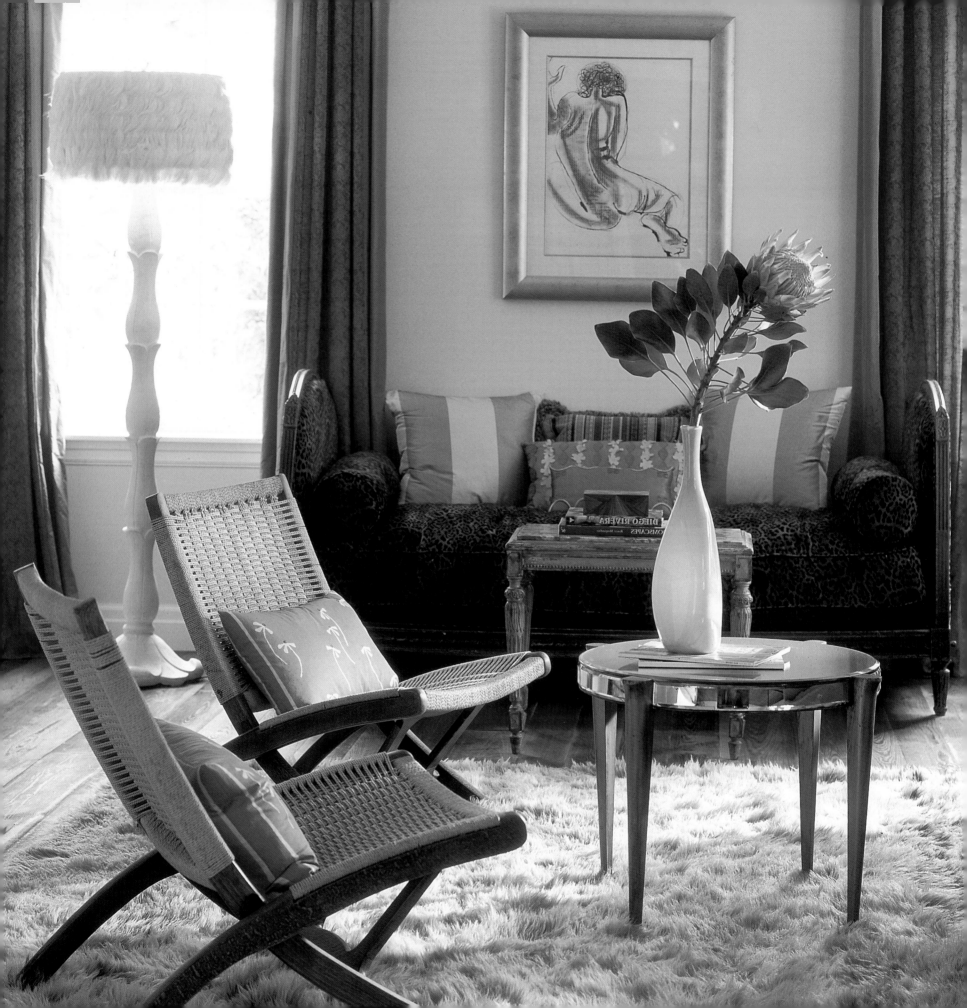

FERN SANTINI

Abode

4414 Burnet Road
Austin, Texas 78756
512-300-2303

You had to believe the odds were against Fern Santini becoming an interior designer when she graduated from college with a bachelor's degree in accounting and political science. But Fern took the time to listen to her heart, and it paid off.

In college, Fern opted for what she thought was the safest route. But she kept the flames of design burning, auditing art classes and assisting her roommates with design assignments. After graduation, she began work at a high-end women's clothing boutique, eventually becoming shop manager and buyer.

After hours Fern took an occasional design job. Her style caught on with realtors, who eventually sold some of the residences she designed, and with her boutique clientele, she had a ready-made little black book of future business contacts. When her design assignment calendar filled up, Fern took a deep breath, quit her boutique job and plunged into interior design full time. She's never regretted it.

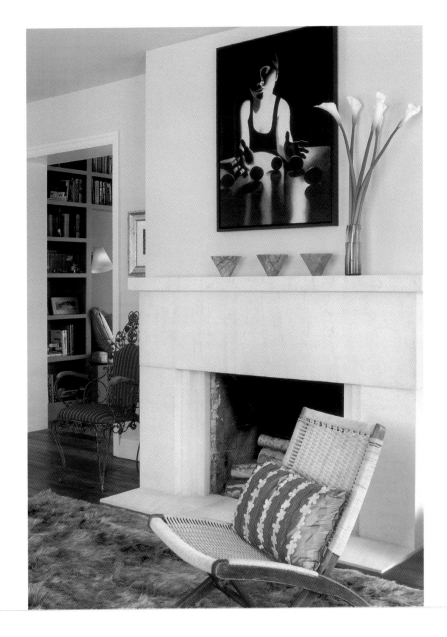

Left: Fern's talent for mixing textures, styles and colors is evident in this living room. A duo of Hans Wegner rope chairs, a 1940s French mirrored table, a Louis XVI daybed and Carlo Scarpa plaster floor lamp circa 1949 with custom feather shade creates a setting that speaks for itself.

Right: A custom limestone fireplace, jade bowls from Gardens, Austin, and a painting by Erin Cone, Santa Fe, complete the living room's one-of-a-kind look.

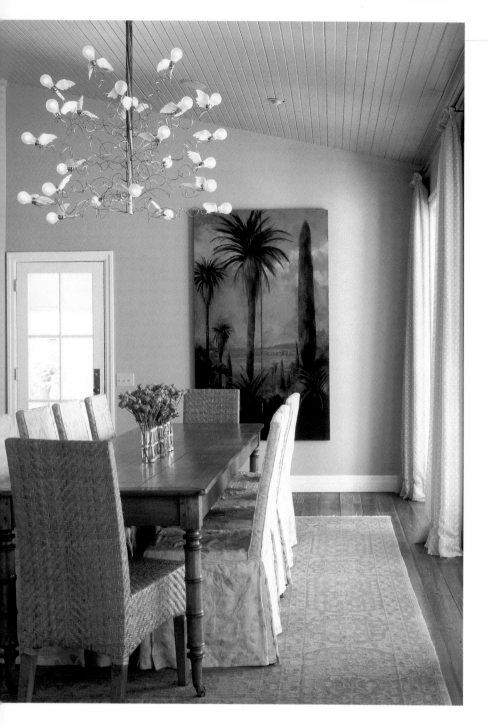

Looking back, Fern always had a yen for the arts. She began sewing when she was 10. For her 12th birthday, she asked for subscriptions to French *Vogue* and *Architectural Digest* magazines, then papered her bedroom walls with them.

Aunt Fern, her namesake and mentor, encouraged Fern as a child to be inquisitive and appreciate the arts, introducing her to Houston's museums, gallery openings and local artists. According to Fern, her aunt, whom she describes as the Auntie Mame of her time, believed it was vital to know that Elsa Schiaparelli invented the color hot pink, a lesson Fern's always remembered.

Fern is at home in Austin, which much to her delight has retained its bohemian quirkiness despite the invasion of the high-tech industry. She's had a successful interior design business there for 10 years and raves about the incredible talent pool in this city on the edge of the Hill Country.

In her work, Fern is drawn to rooms that have similar qualities: wonderful light, great proportions, and a mixture of textures, styles and colors. Every room should have a bit of history and glamour (especially the master bedroom, master bath and powder room), she says, and a certain unpredictability (like the flying light bulb chandelier in her dining room).

Above: This dining room's pièce de résistance is the "Birds Birds Birds" chandelier by Ingo Mauer. Antique longleaf pine floors and French table anchor the setting. The painting is by Mickey Mayfield, Austin.

Right: In this library, a Biedermeyer game table doubles as a desk and work area. It's surrounded by Jean Moreux French iron chairs circa 1940. A vintage "Sputnik" chandelier and French painted chest circa 1840 are notable accents.

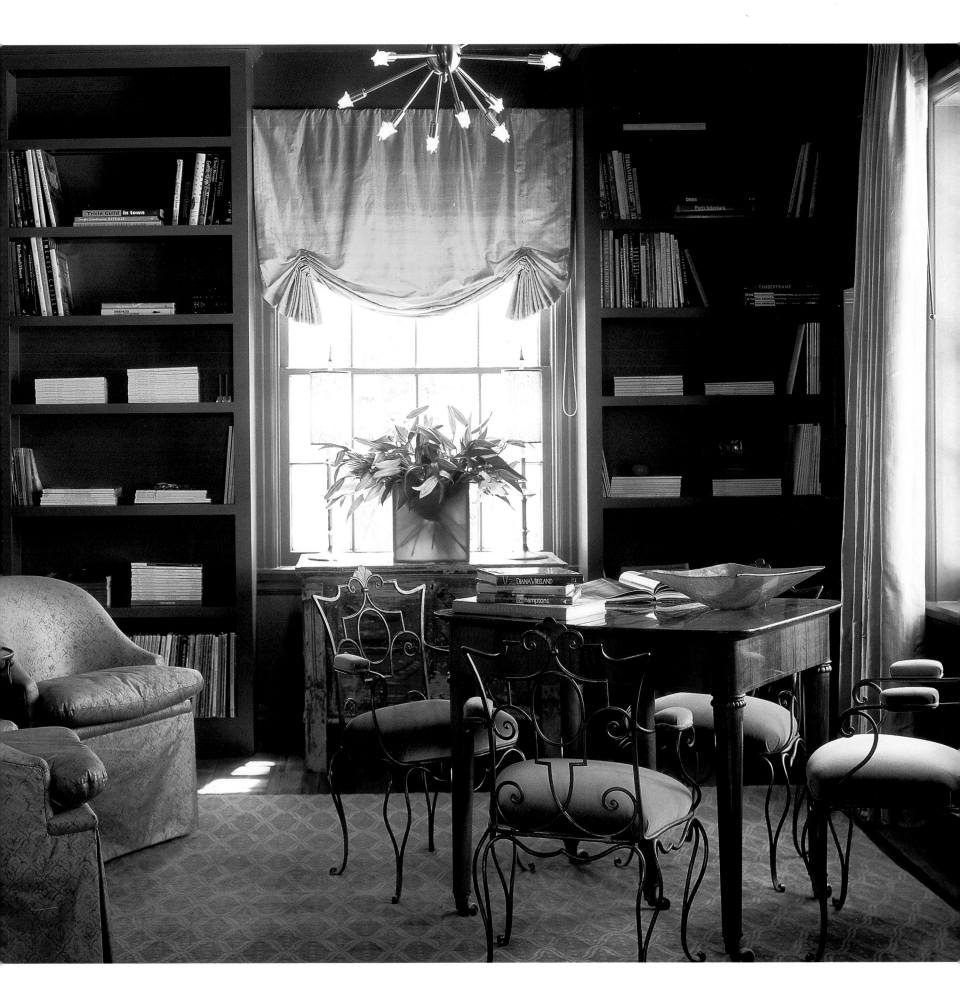

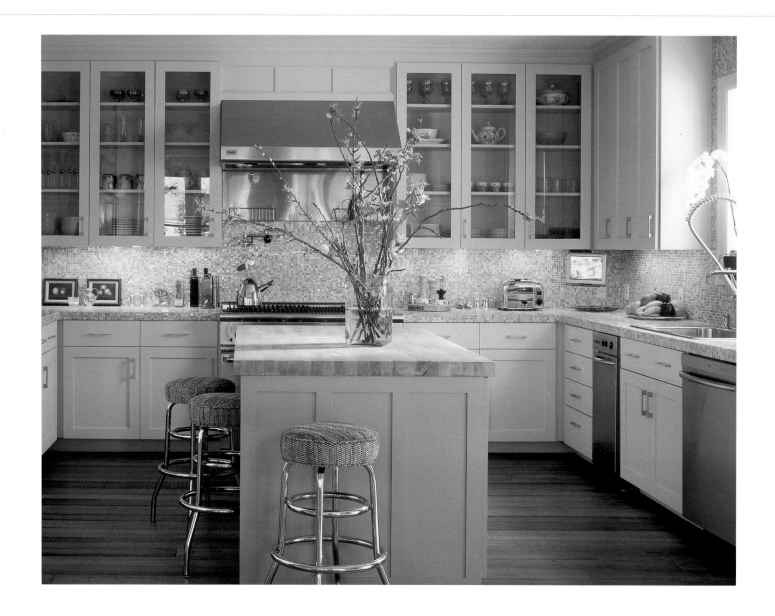

Fern's designs are not formulaic. She likes nothing better than to juxtapose pieces from different periods. A prime example of her derring-do is a project she's been working on in the Austin hills for seven years. It's a Mayan-inspired estate, where she's combined a 1650s Spanish colonial table, Biedermeyer chairs circa 1800s and a Holly Hunt sofa in the same room. Fern went one step further, adding a whimsical note with a rope and grass sculptural chair by Christian Astuguevielle, which she and her clients nicknamed the "hula chair."

It's easy to see there's nothing Fern won't try. Like the motorcycle trip she took with her husband to tour the lighthouses of the Great Lakes. Or traveling to the Mayan ruins in the Yucatan for project inspiration and research, where she hiked in Bottega Veneta sequined slides.

MORE ABOUT FERN. . .

How does Fern approach a new project?
Fern believes the most successful jobs are handled by a team comprising the architect, contractor and designer, as well as the artisans on the project, who always make valuable contributions during the design process. The team approach works best when egos are left at the door, says Fern. That's when the best ideas start to percolate. And strong client involvement is vital to the success of every project.

What is the single thing Fern would do to a room to bring it to life?
Hang a fabulous piece of original art. According to Fern, great art can carry a room even when it's empty.

What does she like best about being in the design business?
Helping people create their own personal spaces.

What is her favorite color?
Chartreuse because it's so unpredictable and has many underlying tones.

What personal indulgence does Fern spend the most money on?
Shoes! As a little girl, Fern used to play dress up. Her Aunt Fern's shoes, size 4, were the perfect fit, and Fern's fetish was born. Today a favorite pair is an Emma Hope olive-green velvet mule accented with luscious fuchsia, cobalt blue and gold embroidery.

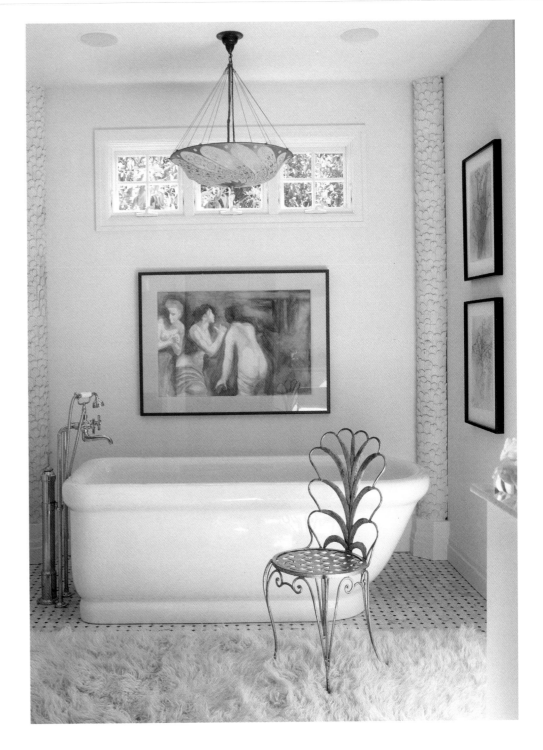

Left: With glass mosaic counters and backsplash and antique longleaf pine floors, this kitchen is a sophisticated juxtaposition of rustic and refined.

Above: This master bath, with Michael Smith for Kallista tub and faucet, is made for relaxing in luxury. A Fortuny chandelier and an ivory flokati rug on a marble mosaic tile floor set the mood. A chic vintage gilded iron chair and art by Roi James, Austin, are the ultimate in sophistication.

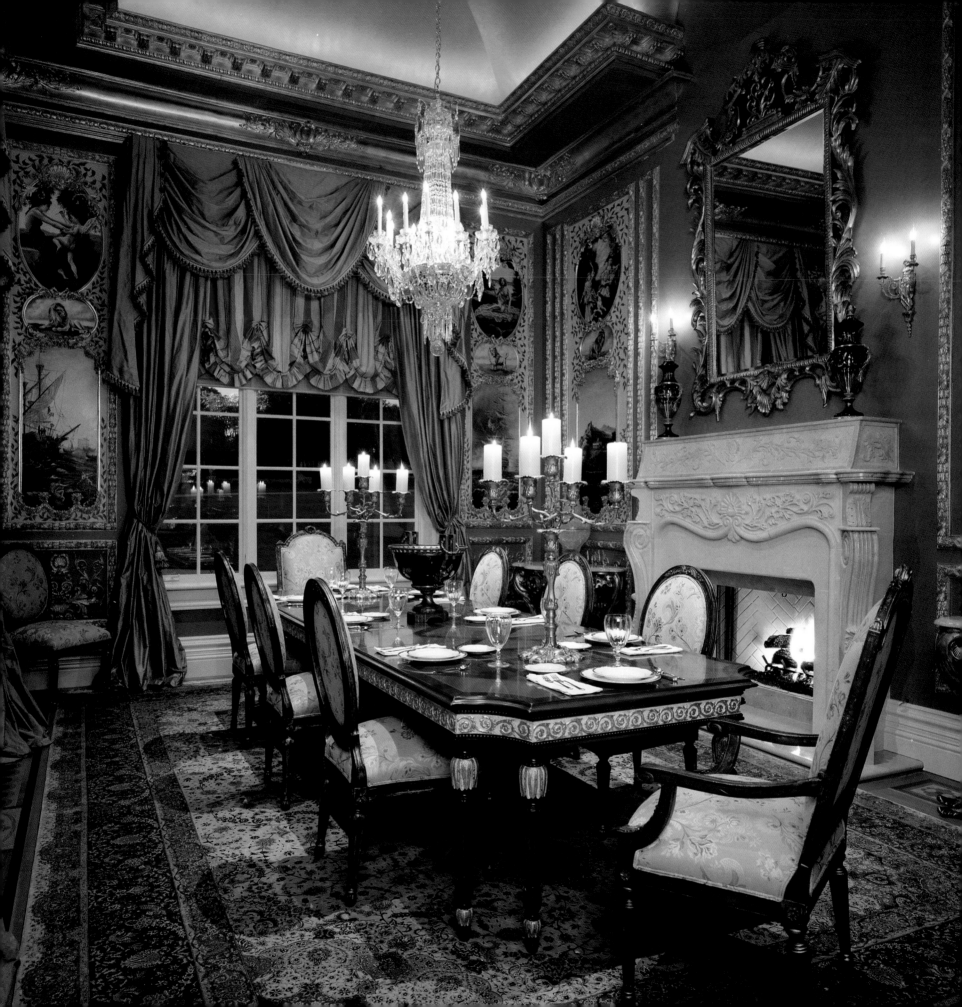

MARK SMITH & JOE BURKE

Mark W. Smith

Joe Burke, ASID

Design Center

4929 Ranch Road 2222

Austin, Texas 78731

512-343-2222

Joe Burke and Mark Smith bring unparalleled expertise to the design process, producing award-winning interiors for residential and commercial clients. This Austin duo creates a unified look from concept through installation, thanks to their dual architectural and interior design expertise. Joe is a University of Texas interior design graduate, and Mark has a degree in architecture from Texas Tech University.

Mark and Joe say strong client relationships are the key to success in the design business. Their primary goal is to understand clients' personal needs, and then to create attractive, functional and comfortable living or working environments compatible with clients' desires.

Left: Elaborate Dupioni silk draperies are layered over striped taffeta balloon shades in this dining room. The Italian hand-carved Botticino Classico marble fireplace, gold-leaf ceiling and silk rug unite the setting.

Above: Six mural panels with ornate custom moldings highlight this dining room.

Right: Breccia de Van Dam and Botticino Classico marble floor design follows the entry's architectural curves. The custom old-world grand wrought iron stairway includes 14-carat gold accents. The antique Baccarat chandelier was purchased in Paris.

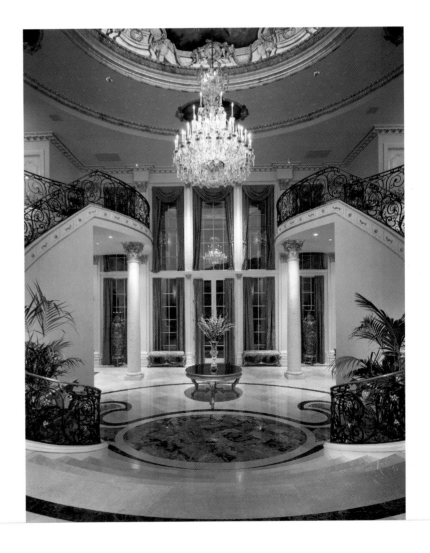

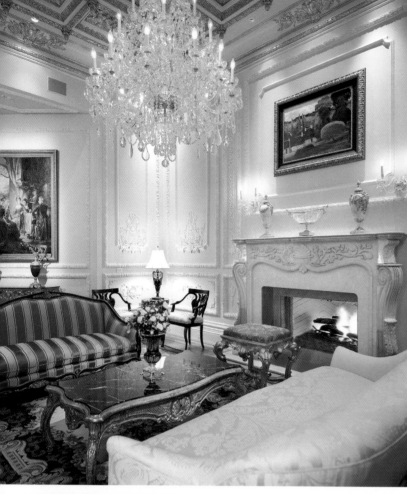

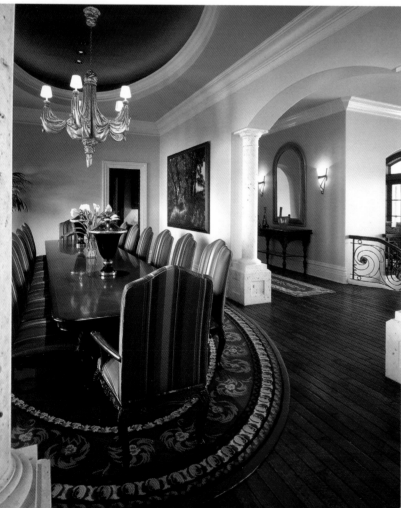

Top left: A hand-carved bench upholstered with silk brocade graces the hearth of the Italian hand-carved Botticino Classico marble fireplace in this chic French-style living room. A chocolate brown coffee table complements the conversation area. The coffered ceiling with a lion mask motif and an antique Aubusson rug complete the look.

Bottom left: Texas limestone columns from a local quarry are a central architectural element in this Lake Travis home. The large Spanish dining table with marquetry inlay seats 20, a sign the homeowner enjoys entertaining. Joe and Mark custom designed the rug to echo the ceiling detail. The flooring is five-inch quartersawn oak that was hand-planed on site. The art is by Jimmy Jalapeno.

Right: The great room of this Lake Travis residence is the heart of the home. The colors of the surrounding Hill Country drive the palette. An enormous custom sectional sofa accommodates guests. A substantial serpentine limestone-topped coffee table pulls in the outdoors, and French doors lead to the pool.

Joe and Mark, who have regular access to global market resources from Milan to Los Angeles, excel at all aspects of design. Above all, the foundation of their work is an innate sense of scale and proportion. They are well known for their versatile approach to style, creating clean, tailored contemporary rooms to those touched with the warmth of tradition, and every look in between.

Mark and Joe prefer rich, saturated color, which, they say, has a rhythm if applied properly. Reveling in the challenge of color experimentation – with a client's consent, of course – they boldly go where designers rarely choose to go. Their clients, many of whom love red, appreciate this fearless approach. Generally, their personal color preferences are determined by mood and season.

When it comes to customized design details, their reputation precedes them. Joe and Mark have a penchant for detail, which lends quality and sophistication to every room. Their personal touches often include customized moldings, cabinetry, countertops, woodwork, window treatments, flooring and rugs.

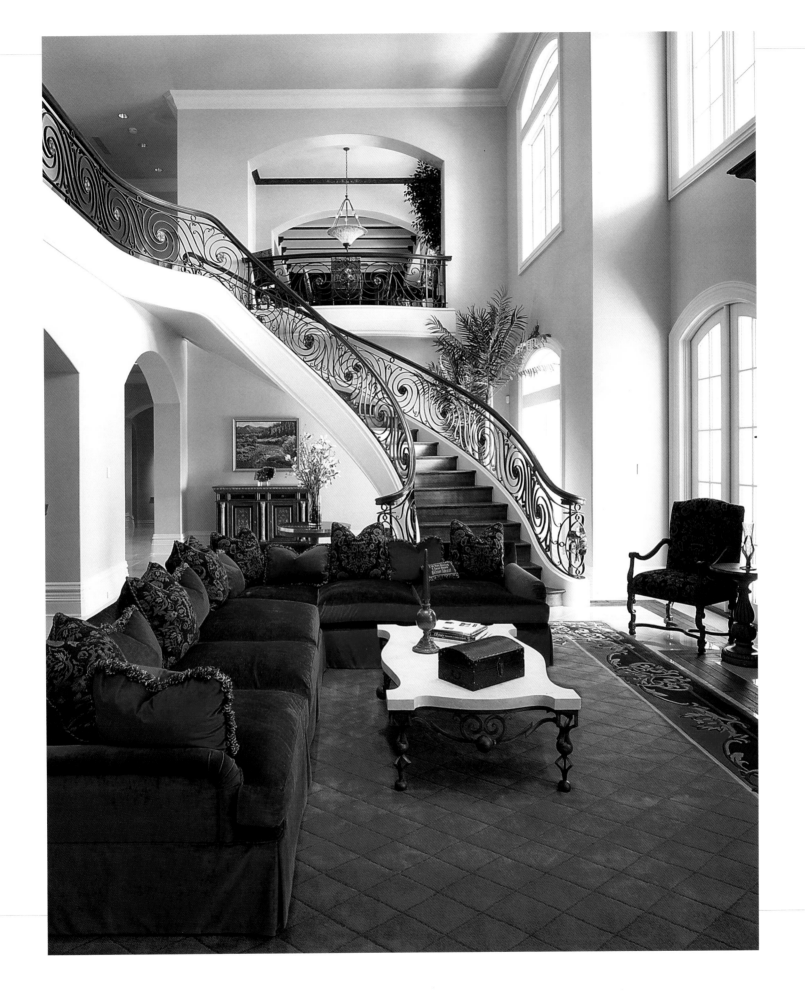

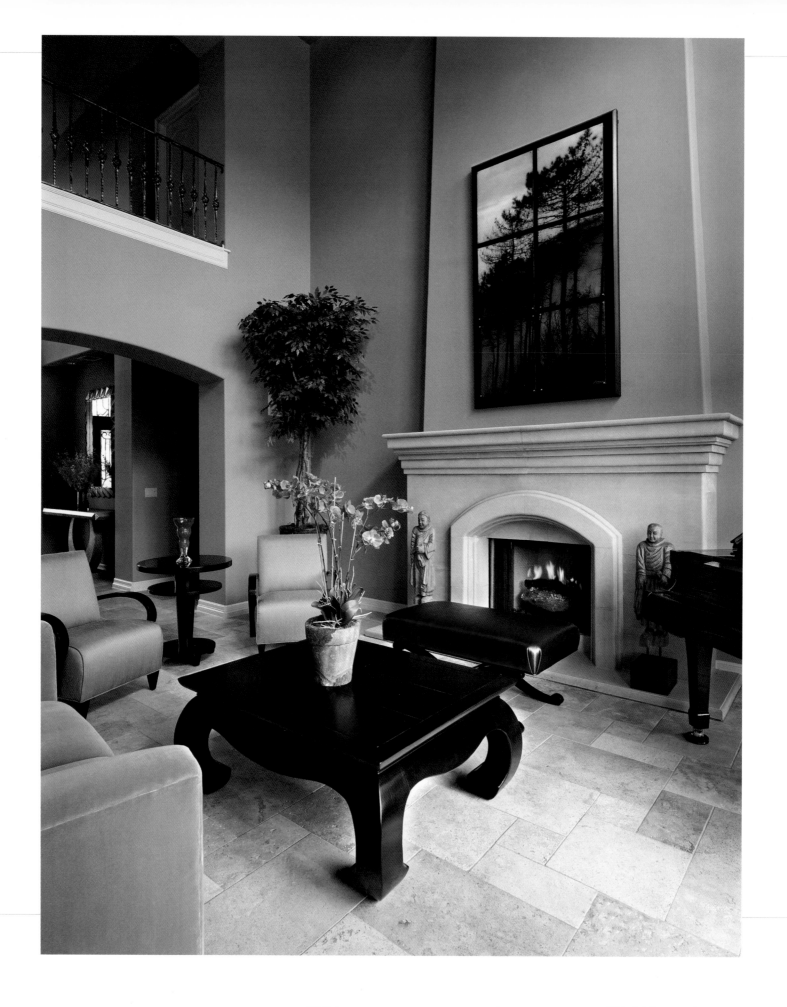

The twosome's heroes include notable legends of perfect scale and proportion: Andrea Palladio, respected Italian architect who revolutionized Renaissance architecture; Dorothy Draper, designer of the startlingly elegant Greenbrier resort in West Virginia; and Richard Meier, renowned contemporary architect.

Their common passion is antique American art glass dating from the late 1800s to the 1930s. Their collection primarily comprises rare Steuben and Tiffany colored-glass decorative pieces, many reminiscent of flower forms.

Travel rejuvenates Joe and Mark's creative spirit. They favor culturally diverse destinations like Europe where they can absorb great architecture and memorable interiors. They especially enjoy Italy and the Mexican coasts. They are blessed to live and work on Lake Austin, where on weekends you can find them relaxing on the water, musing about how to make their clients' dreams come true.

MORE ABOUT JOE AND MARK. . .

What is the most unusual piece Joe and Mark have used in an installation?
A rare three-foot-tall fertility god from New Guinea carved from wood and mud. It is festooned with hand-sewn seashells and earrings crafted from bird-of-paradise feathers.

If they could eliminate one design element from the world, what would it be?
Misinterpretation of design execution.

Why do Mark and Joe like doing business in Texas?
The people of Texas have an incredible independent spirit that is unencumbered by societal conventions. Even those who adopt Texas as their home state readily assume this approach to life — no questions asked.

Left: This living area exudes a classic Asian look with its clean lines and simplicity. The sofa is upholstered in dense mohair and the chairs in patterned silk.

Above: Large custom leaded-glass doors open onto the master suite's vestibule. Inlaid marble floors accentuate the room's jewel box feeling. Joe and Mark took special care to illuminate the niche.

Orville Carr Associates, page 134.

San Antonio

SAN ANTONIO

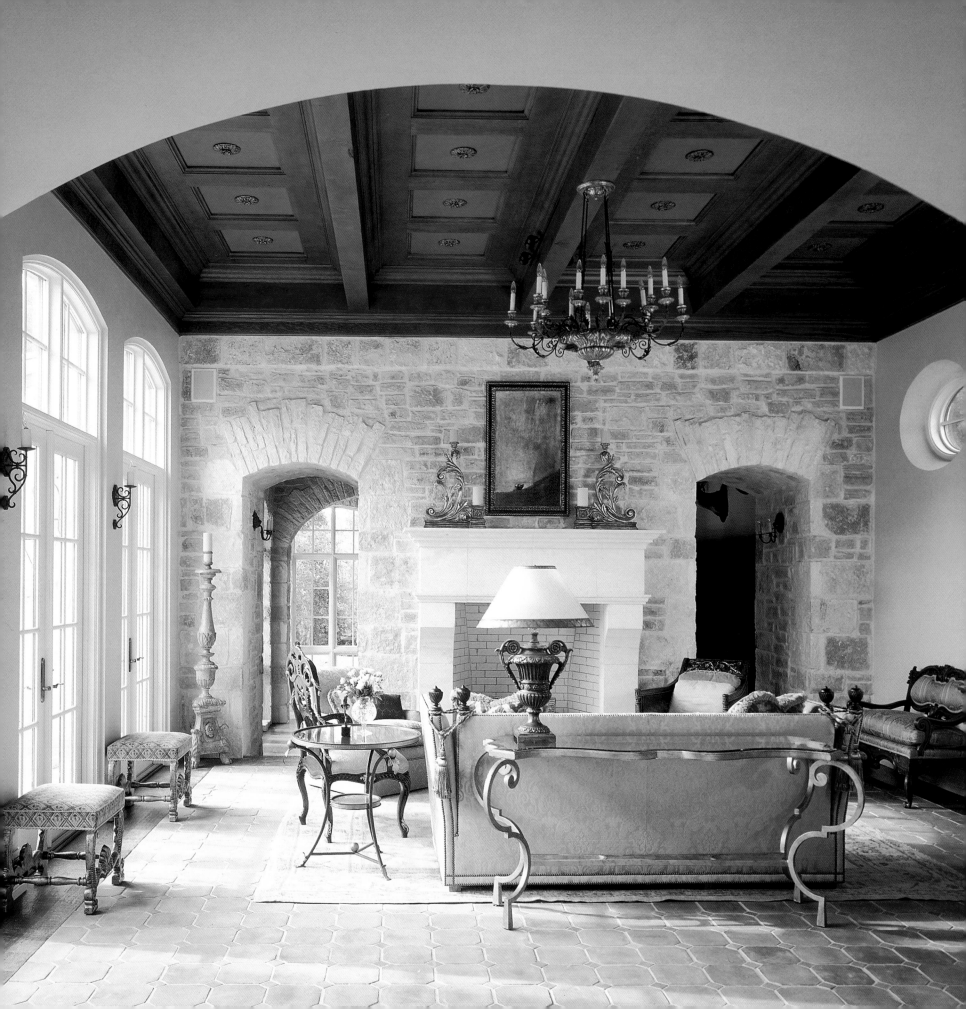

DEBBIE BAXTER

Debbie Baxter, ASID, IIDA

Baxter Design Group

242 West Sunset, Suite 101

San Antonio, Texas 78209

210-828-4696

Talking to Debbie Baxter is like taking a crash course in business management 101 peppered with an occasional guest speaker in art and design. Debbie founded her interior design company about 25 years ago as a consultant and now has eight employees. Her firm is headquartered in a 3,000-square-foot office building in San Antonio that she built and owns.

This no-nonsense creative most enjoys the project management aspect of interior design and is happiest when she's a member of a talented architect-contractor team. Debbie is the visionary of her straight-line organization. Her integrated approach allows every employee to be involved in every project, with each making a valuable contribution to a job's success.

She and her husband have traveled the globe for his career, living in several locations, including Caracas, Venezuela, and Madrid, Spain. She is especially inspired by Latin America. The passionate lifestyle, richness of the landscape, and environment's brilliant colors and textures have influenced her work and how she approaches a project.

Left: Debbie was inspired by the historic continental use of natural materials for her ceiling and floor designs. They integrate well with the room's Italian architecture, furnishings and textiles.

Right: Beautifully waxed and stained common yellow pine paneling provides the contrast for Venetian treasures.

Because of her easy access to the rest of Europe while in Spain, Debbie traveled extensively on the continent and became enamored of the architecture and design, taking in museums and galleries to further her education in her craft and learning Spanish as a second language.

When Debbie attended the University of Texas at Austin, interior design studies were centered in the home economics department so Debbie opted for a degree in humanities. Nevertheless, interior design won out. She enrolled in post graduate courses and began work as a consultant for an architectural firm in Miami. Eventually, she and her husband returned to his native San Antonio where she launched her business.

Her artistic roots reach back to childhood when, as a little girl, she designed her outfits daily and, as a teen, painted her television set to match her bedroom. She inherited her creative bent from her grandmother who was an incredible seamstress with great taste. She still remembers her grandmother bringing back a bolt of pink Dupioni silk from Italy and stitching window coverings, then a tailored suit for herself from the remnants.

Debbie is a strong believer in good design, not a trademark style. Balance is the basis for a great look, according to her, and knowing when to stop — having restraint — is the key to achieving her design goals. She looks at design from an architectural viewpoint and uses antiques sparingly, allowing the architecture to stand on its own. Debbie also prefers historically correct references in a modern setting. Her hero is John Saladino whose designs are woven around architecture and who Debbie says has the same color palette sensitivity she has.

Left: Debbie orchestrated a Tuscan entry of historically correct proportions and color thanks to local San Antonio artisans.

Right: The colors of a lake house "greatest" room were determined by the view and the client's voyages to Africa. Debbie's client requested a Tuscan-African ambiance, which she achieves by using appropriate colors and textures.

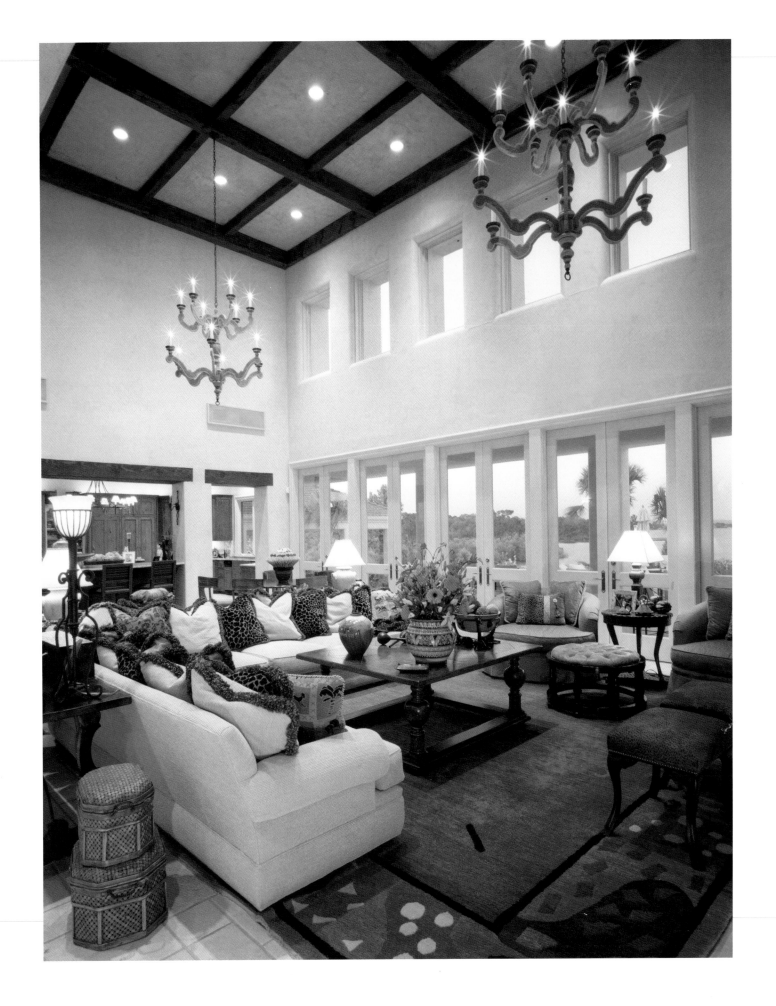

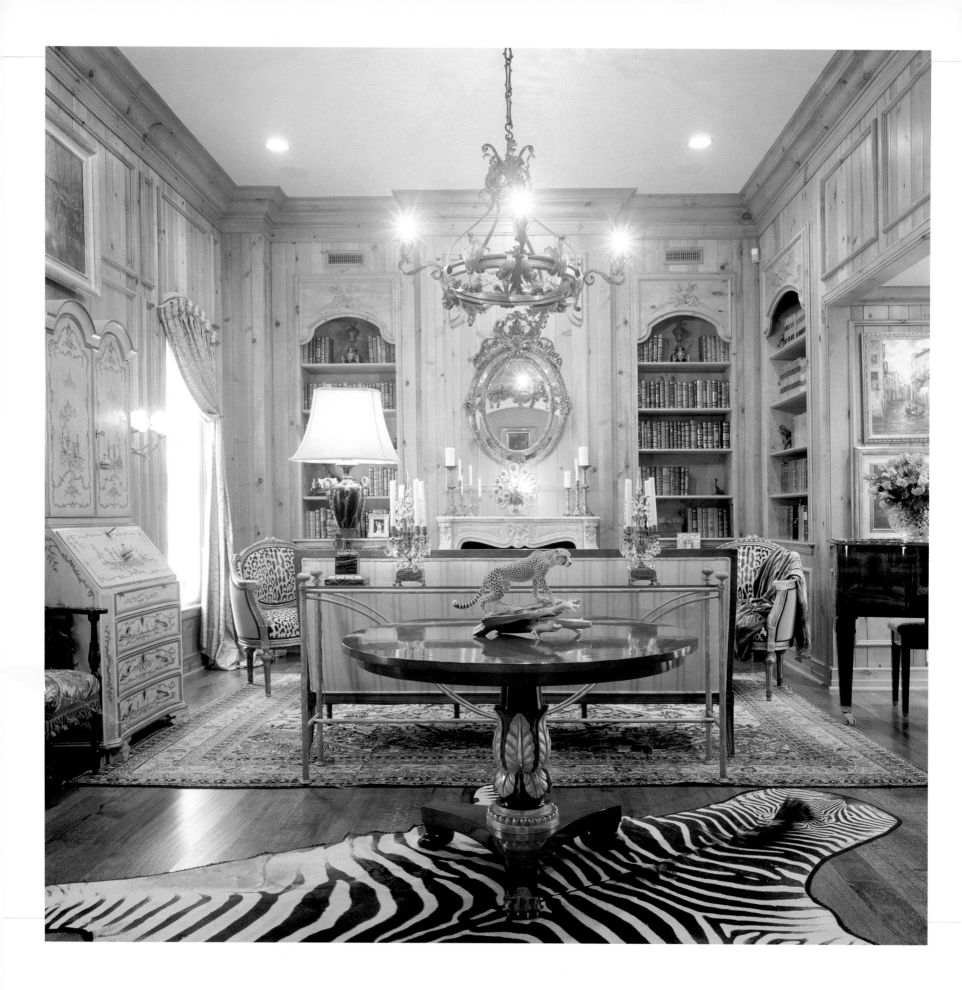

Left: Debbie creates a formal but cozy living room by integrating elements from South Texas, Europe and Africa. The vintage peacock lamp on the mantel represents the peacocks discovered on the property during construction. The mirror over the mantel hung in the Texas state capitol.

Right: An antique French sideboard and red skylight warm up a cook's kitchen.

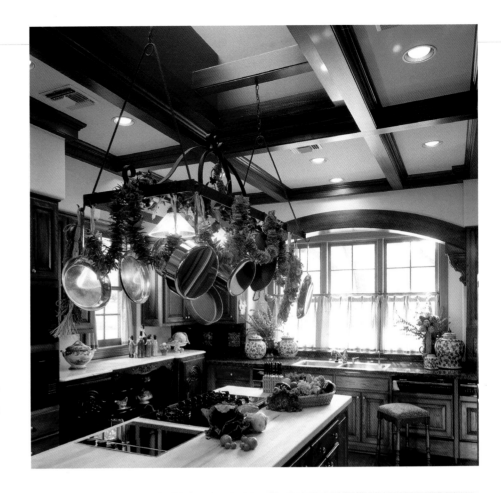

She's adamant about her clients understanding their lifestyles before they make a sizable investment in a residence and its interior design. According to Debbie, your surroundings should be about who you are, not what your family, friends, colleagues or the shelter magazines tell you they should be.

A 5'2" blonde, Debbie has a carefully coordinated wardrobe comprising solid-color suits (no prints for her) in a limited signature palette so she's taken seriously on job sites. After hours, Debbie is mad about evening couture. She admires Yves St. Laurent for his textural ingenuity and Ungaro for his great color combinations, even though he uses prints.

With a hectic schedule and little down time, Debbie is known to keep moving with little sleep. When not in her office or on a job site, she's helping her children make the big leap into the job market or socializing with her many friends all over the country.

MORE ABOUT DEBBIE. . .

What does Debbie think is the best part of being an interior designer?
Every day presents challenges and opportunities for improvement and learning.

What are the most unusual pieces she has placed in an installation?
Framed his-and-her nude photographs of her clients in their master bath.

Does Debbie think her name fits her?
No! Debbie says she's not "cutsie" or light hearted in temperament. "Debbie" is a 1950s name but she believes she's an 18th century or a late 20th century soul.

What color best describes Debbie?
Pink, because she is such a "girl" at heart. But she has had to conceal this frequently to make it in design's business world.

If she could eliminate one design element from the world, what would it be?
Faux-painted cast plaster that's supposed to resemble wood.

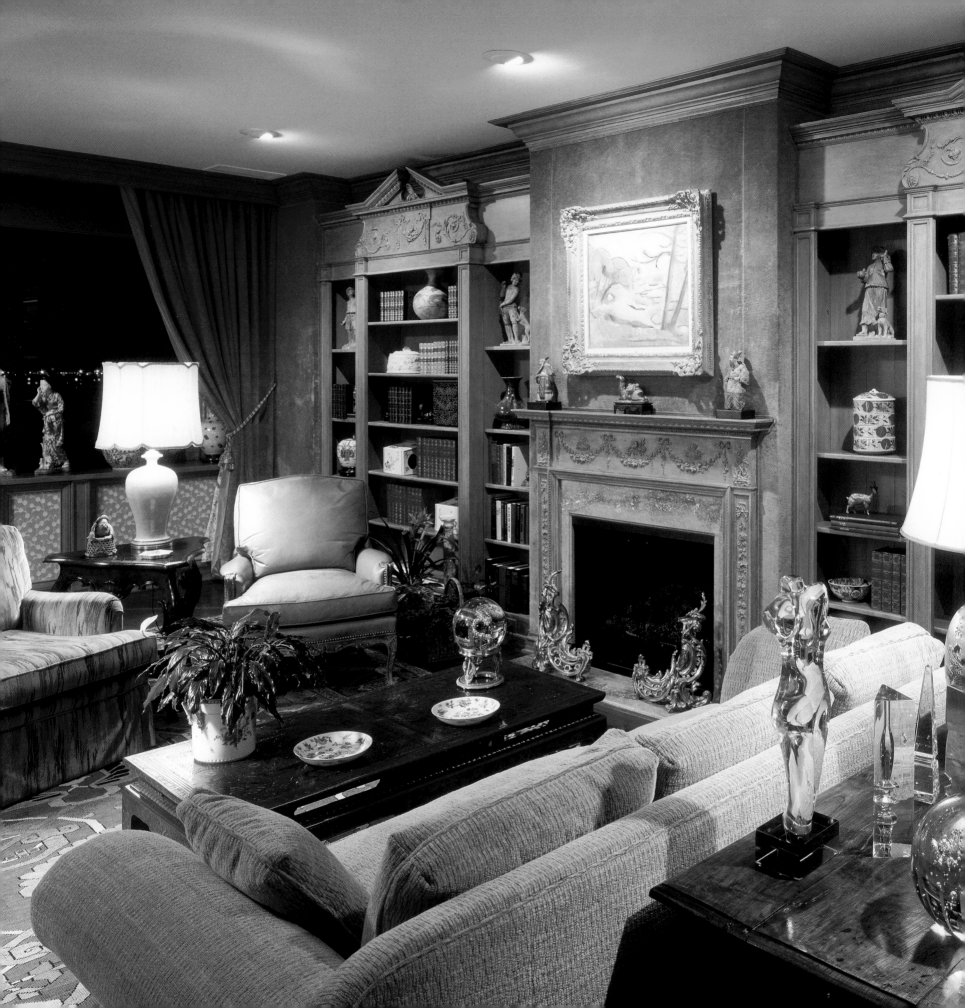

ORVILLE CARR

Orville Carr, FASID
Orville Carr Associates
8015 Broadway
San Antonio, Texas 78209
210-226-8251

Anyone who's anyone in San Antonio, or the interior design business for that matter, knows Orville Carr, a fellow of the American Society of Interior Designers. Idolized by his clients, Orville is an elegant fixture in the Alamo City where his business has thrived for more than 50 years. His classical designs appeal to the rich and famous from Texas to the Caribbean to southern France.

One of Orville's claims to notoriety is his two-story remodeled office building complete with marble floors and crystal chandeliers. The complex includes a 6,000-square-foot showroom, open to the public, which Orville graciously offers for local charity events. Exemplary of his design style, the showroom is brimming with incomparable, fine antiques; original impressionist paintings from Paris; objets d'art; and the O.C. Couture line of select fabrics and top-of-the-line furniture. With this inventory at hand, Orville rarely has to shop the market: He conveniently can furnish a house at a moment's notice or supply the perfect accessory before a client's soirée of the year.

Left: Upholstered antique linen walls and knotty pine woodwork are the perfect foil for a collection of vintage Oriental temple figures in this living room.

Right: The custom rug border mirrors the elegant Fortuny fabric on the dining room chairs.

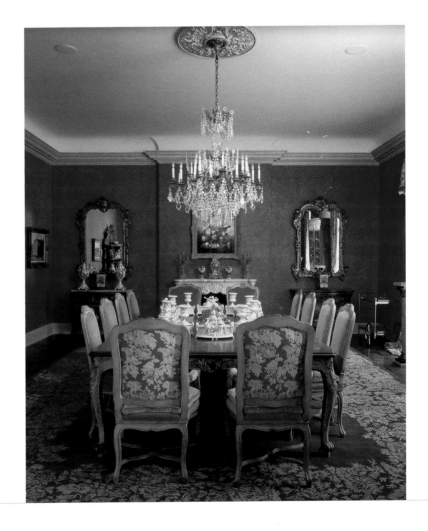

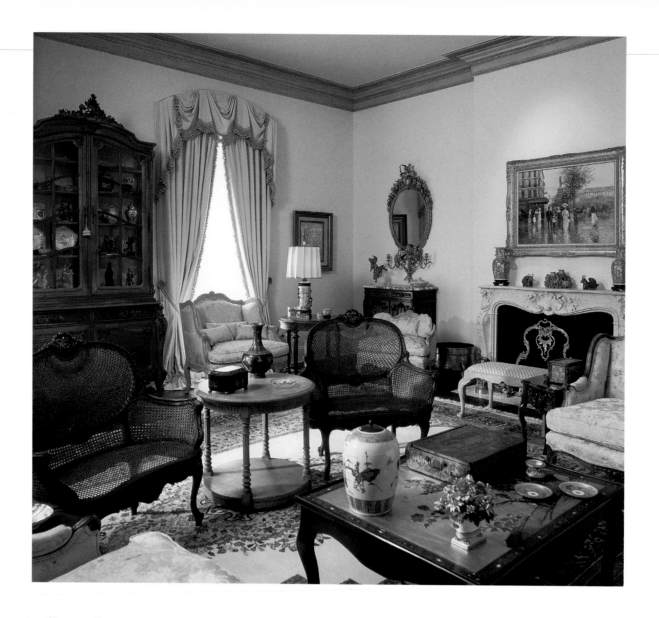

Born in San Antonio, Orville initially paid his dues at Bloomingdale's antique and design department in New York. Then confident friends hired him to create the perfect setting at their Westchester home. Shortly thereafter, Orville decided to head for the West Coast for a change in scenery, stopping off in San Antonio for a visit. That's where he's been ever since, initially lured by respected designer Mildred English to be his partner. The result: a long-term working relationship built on mutual talent and trust. Mildred English, who had a marvelous following, was his muse and great teacher, Orville says.

Twelve years later, Orville left the partnership with Mildred English's blessing and started his own business, forever inspired by her success and style. Today Orville's following is enforced by a second generation of clients, disciples of his original privileged clientele who were among the first to claim an Orville Carr residential design. He is a recognized figure among the city's social set and spends several evenings a week on the local party circuit.

Above: A hand-carved marble fireplace and delicate silk moiré draperies with custom trim accent a collection of antique French furnishings.

Top right: The hand-carved stone fireplace, hand-etched ceiling beams and stone floors inlaid with wood carry out a natural theme in this great room. An antique silk rug wall hanging and a pair of sculptural floor lamps with Fortuny shades add unmatched luxurious touches.

Bottom right: Jewel-encrusted mahogany doors at the end of the entry hall provide a royal entrée into this home's living area. Other touches of class include a marble floor, mirrored ceiling, and one-of-a-kind iron and brass grillwork that keeps an elevator entrance a secret.

Since Orville has been in business, he says the interior design scene has changed for the better with well-informed clients who recognize that design is just as much a business as it is an art. And he likes the fact that more spouses are involved in residential projects. With a growing global economy, there is a proliferation of retail gift shops now, but fewer design studios and even fewer showrooms, according to Orville, who corners the market on both counts.

At this point in his career, Orville Carr can claim the luxury of writing his own ticket. When not working, he's traveling the globe or applauding musical stage performances in London, New York or San Antonio.

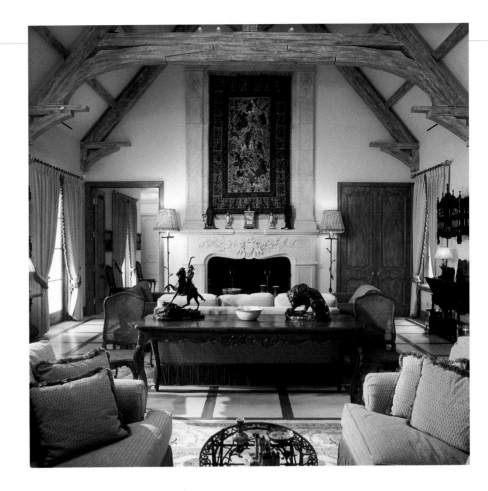

MORE ABOUT ORVILLE. . .

If Orville could eliminate one design element from the world, what would it be?
Victorian decor.

What object has Orville had for years that remains in style today?
A Ming dynasty porcelain roof tile. Orville collects Oriental art, especially Chinese porcelain.

What personal indulgences does Orville spend the most money on?
Automobiles (he owns several late-model cars) and travel. He also indulges in clothes, which has paid off for Orville with a lifetime achievement award in 1998 from The Fashion Group International.

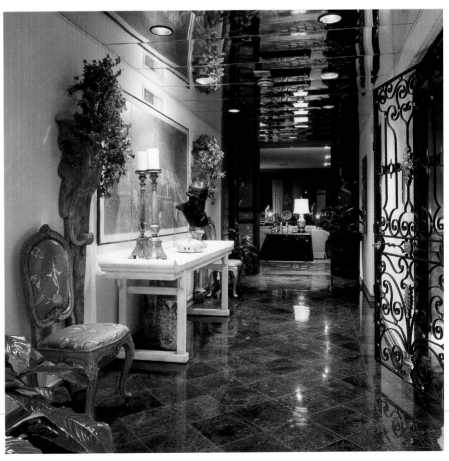

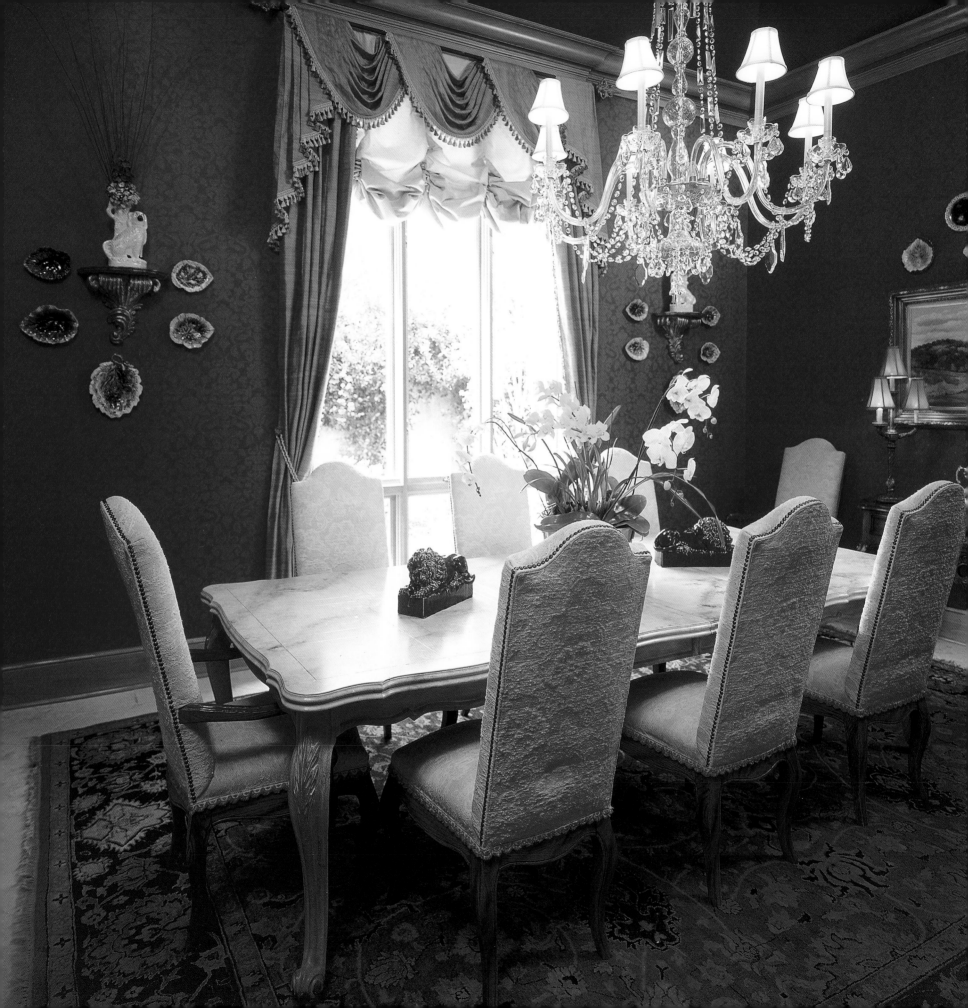

DERRICK DODGE

Derrick Dodge, ASID
Derrick Dodge Interior Design
111 West Sunset Road
San Antonio, Texas 78209
210-824-1959

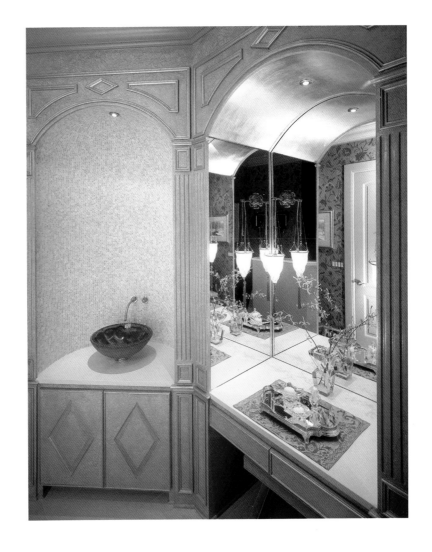

Derrick Dodge has color acuity of 99%, so it's easy to see why clients choose to work with him. Renown for his daring, exuberant color schemes, Derrick prides himself on the dramatic green and purple bedroom he designed, or the red, white and blue French residence that has been a photographer's dream ever since.

His love of color stretches to the ceiling where white is his nemesis. He's a firm believer that every ceiling should be accented with color to tie a room together and make it come alive. Derrick's definition of a "colored" ceiling ranges all the way from a tint to saturated color like his own dark charcoal office ceiling.

Left: A grand antique Queen Anne chandelier illuminates lacquered Chinese red and copper walls and faux copper ceiling, creating a warm atmosphere for dining.

Right: This master bath's barrel-vaulted ceiling and columns allude to the gothic church origins of the property.

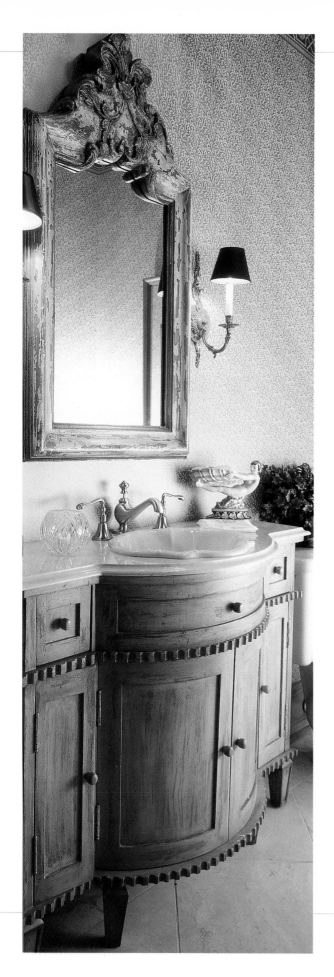

Left: Custom vanity cabinets, red and gold wallpaper and an oversized mirror bring elegance and sophistication to this powder room.

Right: Fiber-optic lit niches highlight prized antique Japanese screens, establishing a soft color palette for an Edward Fields rug, custom-printed bergère fabric and lightly glazed walls.

Floors are not to be neglected either, according to Derrick. He is a big proponent of designing floors with borders constructed out of the floor product, usually wood, stone or tile. Borders, which connect the product to the wall, create a cohesive flow throughout the interior. A bordered floor also adds important definition, like a big area rug.

Born and raised in the Midwest, Derrick was introduced to design as a young boy when he visited his paternal grandmother in her Dallas Highland Park home. Mother Kay, as his grandmother was known, introduced him to beautiful and sometimes nontraditional furnishings like her pink flocked Christmas tree with pink ornaments.

Derrick always remembers how special he felt sitting in a luxurious chair in Mother Kay's living room. And that's the same kind of feeling he creates for his clients. He aims to leave their surroundings comfortable, friendly and intimate, but also exciting, warm and inviting. He prefers traditional, richly colored interiors but also creates contemporary and transitional designs with ease.

Derrick's second exposure to Texas came with a stint in the U.S. Army at Fort Sam Houston near San Antonio. The location was fortuitous. Derrick fell in love with the city where he eventually settled and launched his interior design business more than 30 years ago armed with degrees in art, art history and interior design.

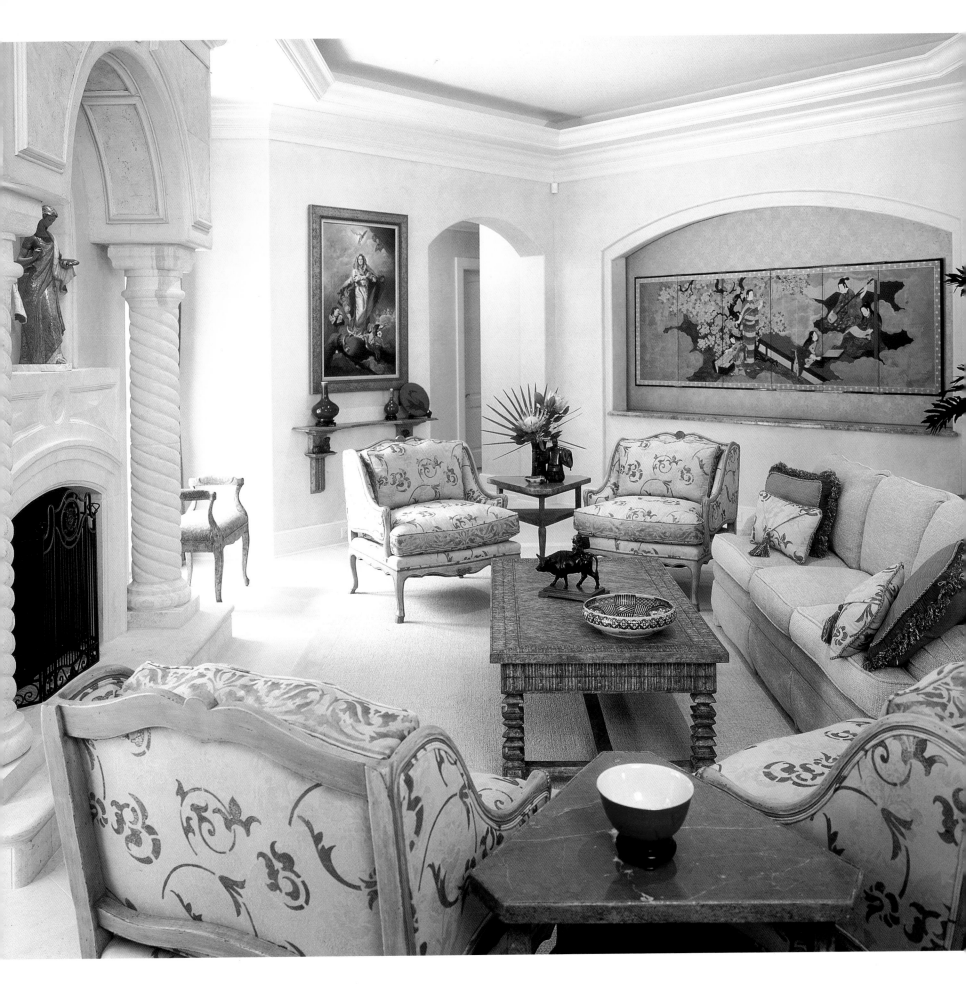

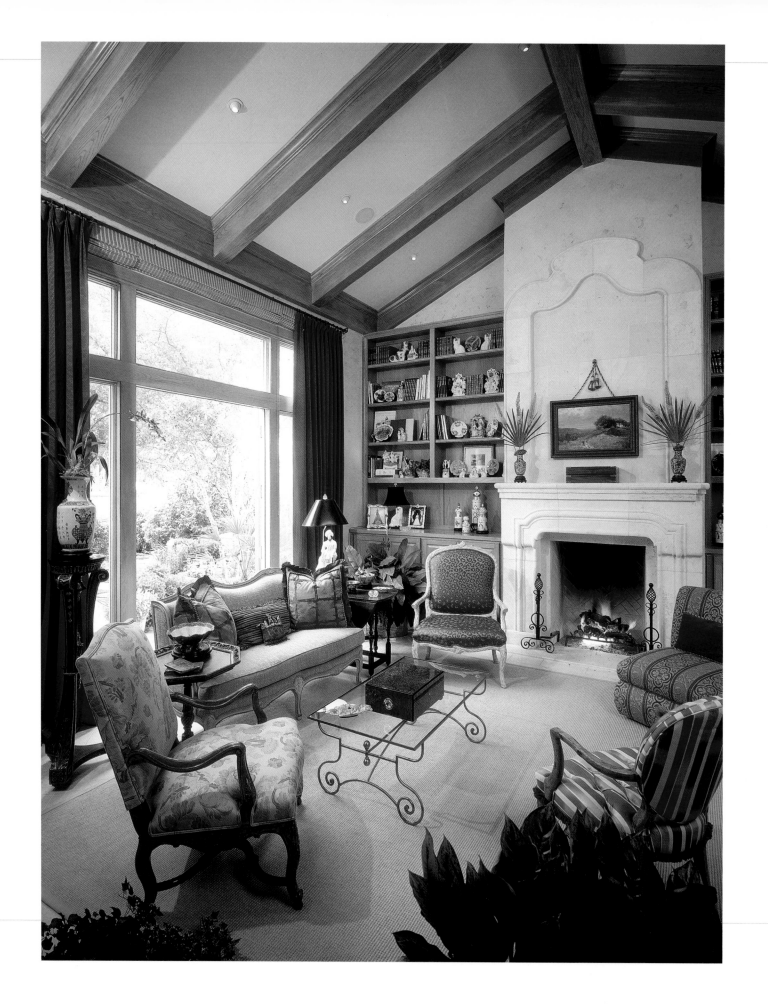

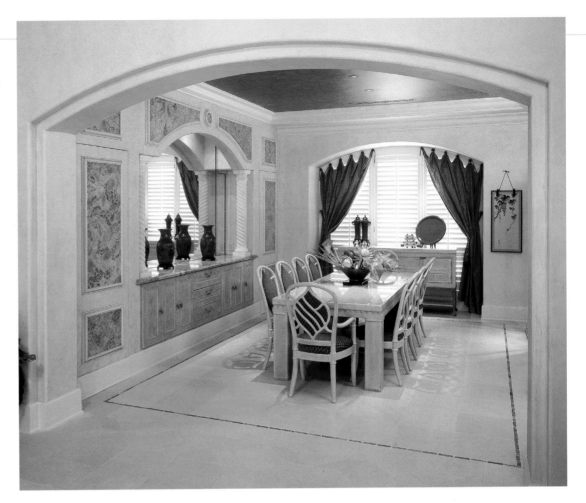

Left: A client's extensive majolica collection determines this home's color direction of muted greens, golds and terra-cottas. A soaring ceiling, impressive carved stone fireplace and light-filled windows create a spacious feeling.

Right: Asian-inspired furnishings add harmony and serenity to this dining room. Terra-cotta accents punctuate the space with rich color.

Confident in his instinctive and creative abilities, Derrick is not intimidated by what appears to be a difficult job. With an exceptional concept of space, he relishes the opportunity to demolish a house to its two-by-fours and start over.

Oprah, the adopted office cat, keeps Derrick company during long business hours, gaining his attention by stretching out on top of the latest floor plan. An Anglophile at heart, Derrick would love to buy a second home in England but couldn't bear to leave his house cats and dogs behind. Nonetheless, he frequently travels there to attend cathedral music festivals to refresh his spirit and gain inspiration. Derrick also is an accomplished watercolorist and has painted all the San Antonio missions.

MORE ABOUT DERRICK. . .

What is Derrick's favorite color?
Chinese lacquered red because it's rich in color saturation, and is warm and inviting.

What is the best compliment he has received professionally?
Several clients have told Derrick that his work has changed their lives.

What pieces have been staples of Derrick's designs that remain in style today?
Exquisitely detailed pillows, French and English bergères and fauteuils, table drapes and decorative floor screens.

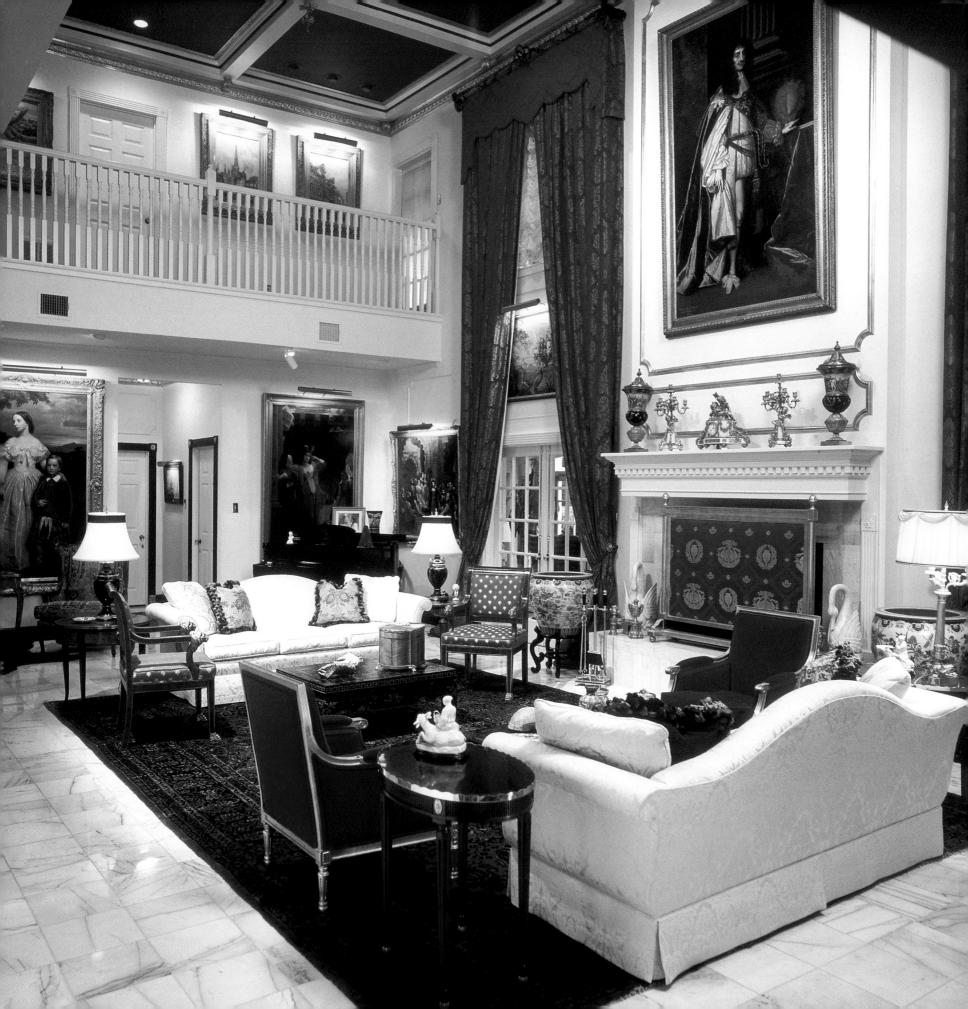

CHARLES A. FORSTER

Charles A. Forster, ASID
Orville Carr Associates
8015 Broadway
San Antonio, Texas 78209
210-226-8251

Charles Forster's forté is fabrics. He uses fabrics like other designers use paint — to create mood and attitude. Charles prefers classic fabrics, such as brocades or a lampas, but often adds quilting or hand painting for a treatment with a twist. A traditionalist at heart, he prefers classic furniture as well. The lines of an 18th century French secretary or an elegant camelback sofa inspire him.

Charles has been a designer since he was five years old when he began moving accessories from his parents' living room to his bedroom for a new look. His budding career as a designer ended abruptly when, during his black-and-white period, his mother discovered he was carrying priceless crystal vases to his room.

A diplomacy and international studies major, Charles worked during college as a display designer for a wine distributor. After receiving rave reviews for his originality, creatively reenergized Charles transferred to San Antonio's University of the Incarnate Word where he earned a bachelor's degree in interior design.

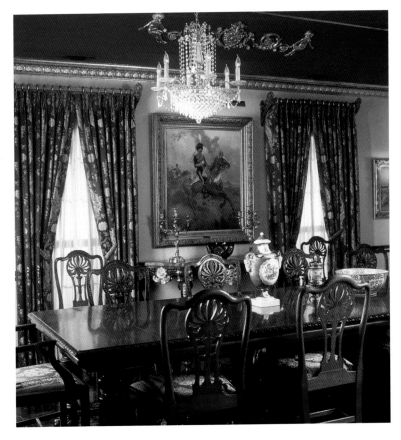

Left: Gold accents turn this already breathtaking red and white living room into a showstopper. The coffered ceiling boasts gold-leaf crown moldings and finials, and the silk damask draperies are woven with a gold motif.

Above: Elegance is the main course in this European dining room. Lampas floral silk draperies complement the coffered ceiling with its gold-leaf family crest and crown moldings.

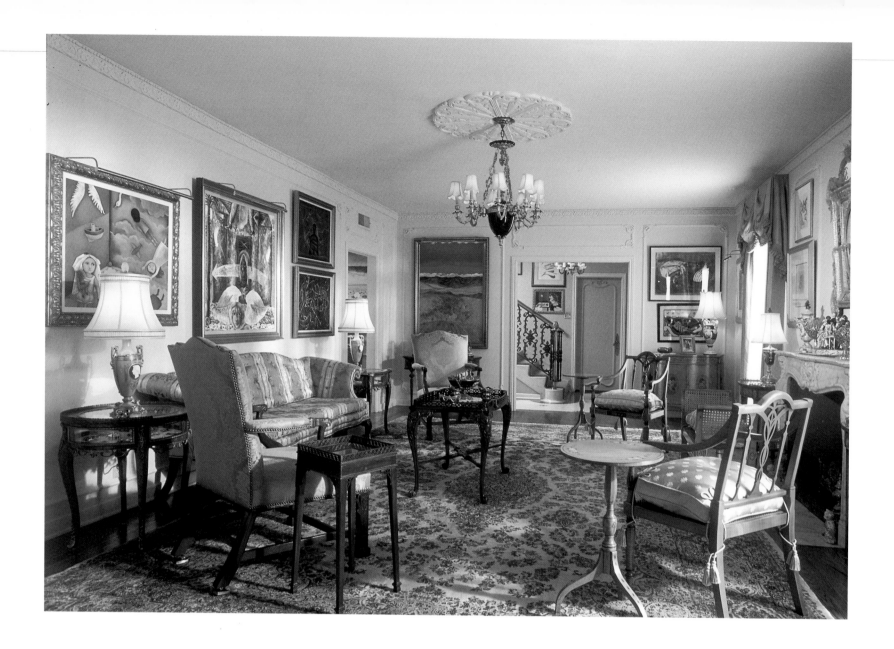

His inspiration and mentor is Orville Carr, revered San Antonio interior designer, who has provided invaluable encouragement and, as Charles says, "taught me everything." Charles was instrumental in the development of Orville Carr's exclusive fabric and furniture line, O.C. Couture.

Charles' projects are primarily residential, although he occasionally does some high-end commercial work. For both remodeling and new construction projects he enjoys creating multipurpose rooms equipped with easy-to-reach conveniences. His clients admire his straightforward manner, as well as his appreciation for quality and detail.

Charles' extensive travel in Europe, Egypt and Mexico has fostered his love of classical lines. An art lover and painter, he has organized a splinter group associated with the San Antonio Museum of Art, Artepreneurs, that visits museums, galleries and artists in their studios.

Left: An antique Imperial Kerman rug grounds an eclectic mix of English and French furnishings in this living room turned art gallery, home to treasured paintings by some of the great masters.

Top right: A French-inspired living area is the perfect environment for works by some of the great masters of art. An antique Imperial Kerman rug complements the scene.

Bottom right: In a standard two-car garage Charles miraculously adds a steam room, weight area and health food bar. And there's still room for the family car!

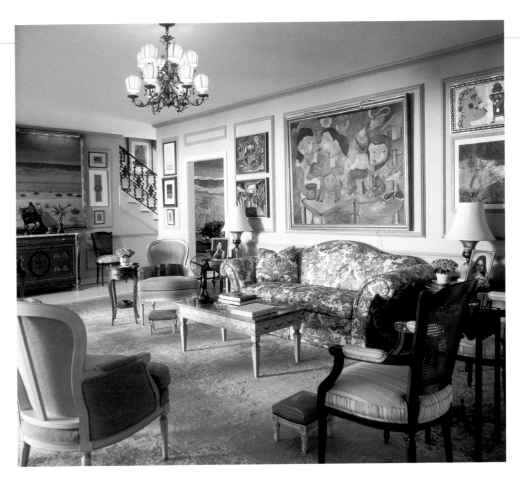

MORE ABOUT CHARLES. . .

If Charles could eliminate one design element from the world, what would it be?
Rococo.

In addition to travel, what personal indulgence does he spend the most money on?
Charles loves wonderful food. He says he's not a great chef but the presentation of what he prepares is fabulous!

If Charles could eliminate a color from the world, what would it be?
Mauve.

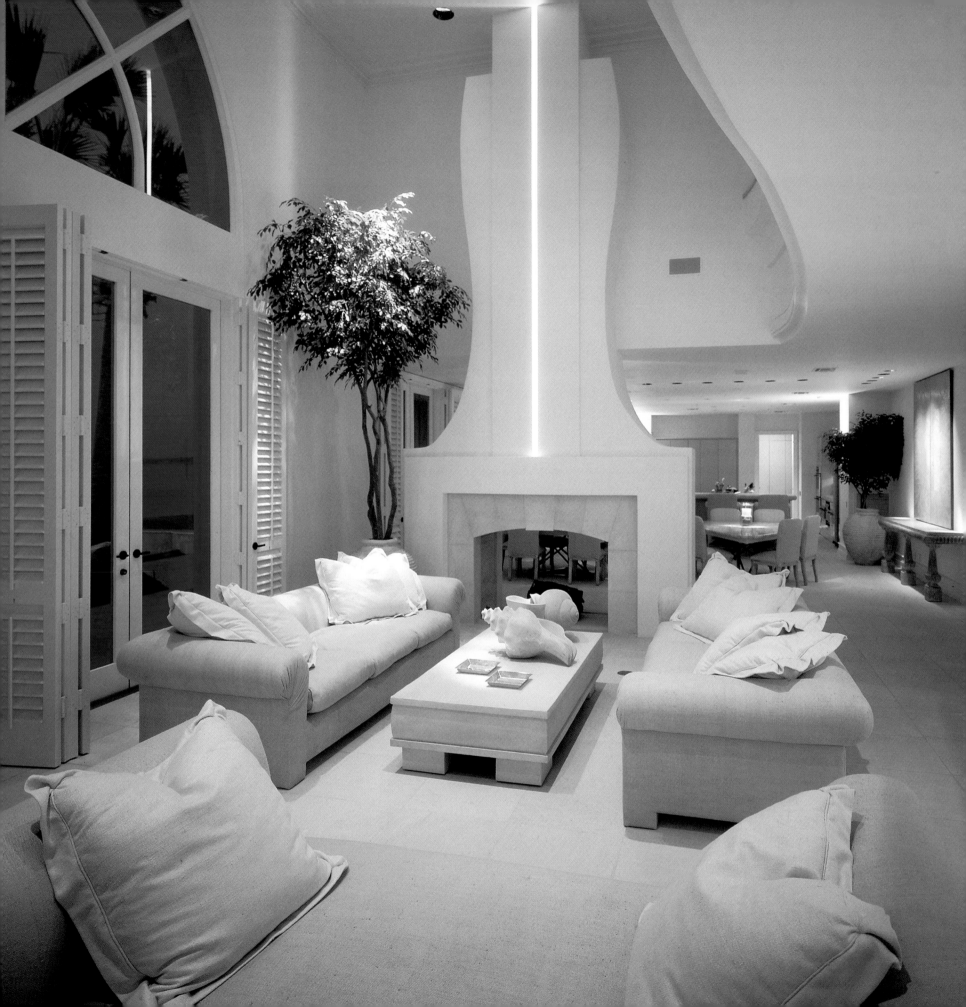

TONI MCALLISTER

McAllister Designs
3435 Twisted Oaks
San Antonio, Texas 78217
210-602-1307

Toni McAllister infuses her Texas designs with a bit of California glamour. Furnishings in her grand, light-filled rooms are soft, overscaled and spare for a clean, sophisticated look. Occasionally, she uses an outstanding antique for a refreshing, dramatic focus. Toni prefers tone-on-tone luxurious fabrics such as silks, damasks and chenilles for a resplendent touch. Drawn to textures rather than bold colors, she finds soothing creams and taupes elegant and timeless.

In the 1970s, Toni believes breakthrough design work was done on the West Coast when the pale, sumptuous, easy California Look took hold. The design revolution was led by tastemaker Michael Taylor, as well as Leo Dennis, Jerry Leen and Kalef Alaton, heroes all to Toni.

After studying graphic design and fine arts in college, Toni began her career in commercial art, which honed her eye for placement and balance. After owning retail antique shops in San Antonio, she gravitated toward interior design, prompted by eager customers who became inaugural clients.

Good, solid architectural elements give Toni the stage she needs for her sumptuous, sleek settings. A risk taker, Toni says her dream clients are "gutsy Texans" willing to chance her sometimes over-the-top designs, like the owners of a lakeside estate near Austin. Toni filled their 10,000-square-foot limestone floored home with irresistible, creamy splendor so there is little distinction between the interior and exterior. Nature adds the perfect accent colors – blues and greens from the surrounding Hill Country landscape.

Toni has brought a bit of California glamour into her own home with pieces like a French chest of drawers with a washed honey finish purportedly owned by fabled 1940s Hollywood movie star Joan Caulfield.

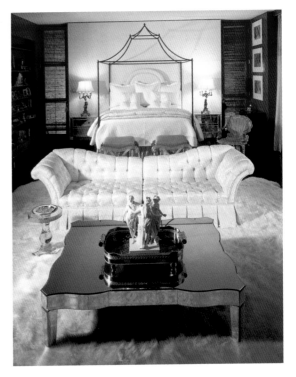

Left: J. Robert Scott sofas are dressed up in creamy tussah silk. Recessed lighting over the fireplace adds drama for romantic evening entertaining.

Above: A Clarence House silk damask covers a sumptuous 1940s sofa Toni found on an excursion to New York. A silk pearl-encrusted upholstered wall and custom New Zealand wool rug are glamorous touches.

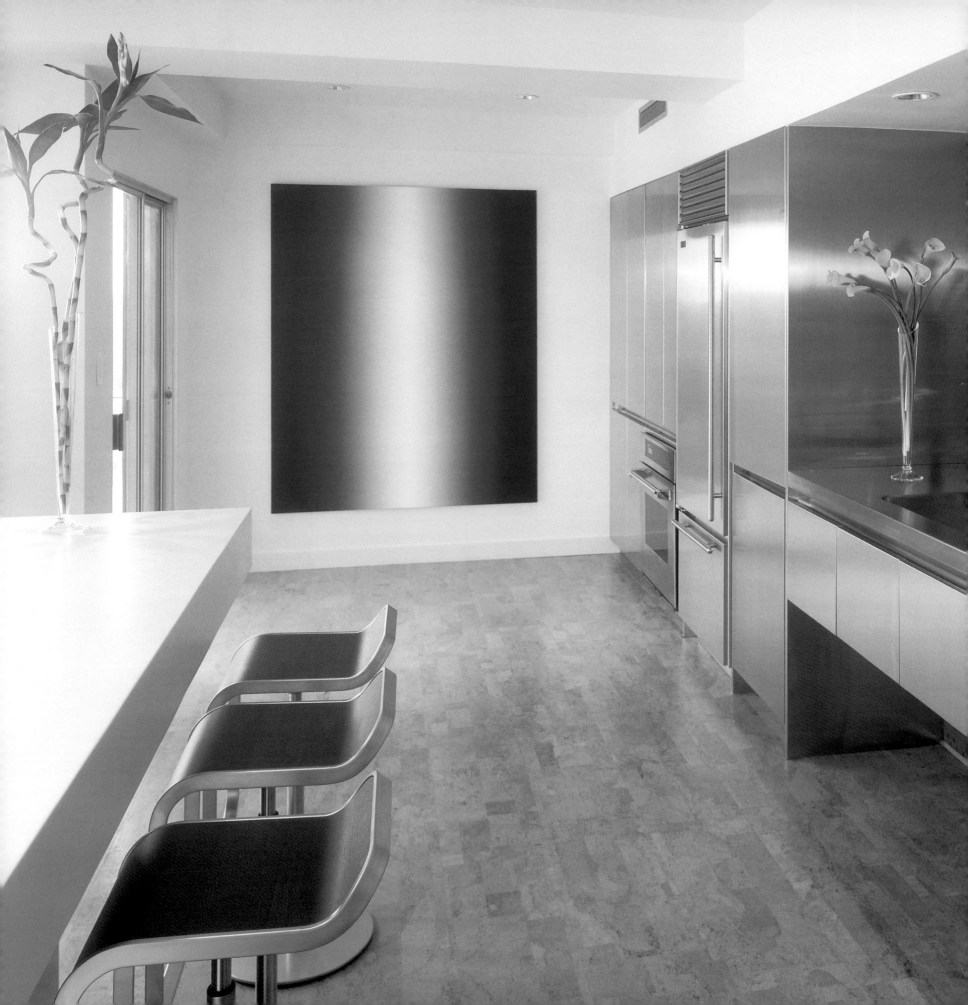

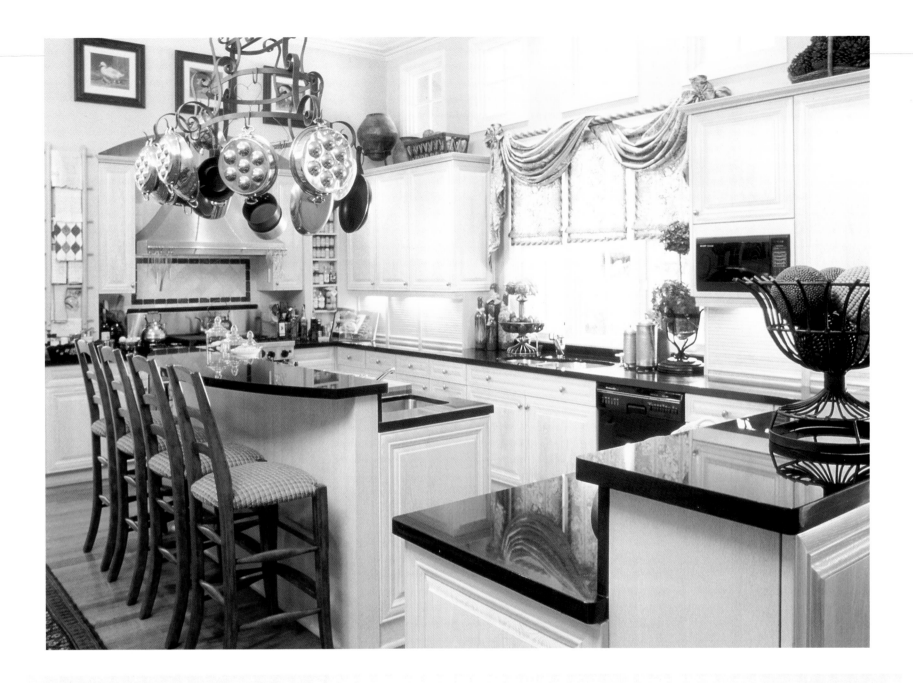

MORE ABOUT CHRISTI. . .

Who has had the biggest influence on Christi's career?
Her mentor, business partner and close friend William J. Todd, who has encouraged Christi while she's built her business. She met Bill designing a kitchen for him and his wife, who now accessorizes Christi's showroom.

How does she relax from her hectic schedule?
Christi has to leave town to get away from it all. She loves to travel, so you might find her fishing on the Texas Gulf Coast, scuba diving in Belize, or taking in Europe's museums and art galleries with friends.

If Christi could eliminate any design-related elements from the world, what would they be?
Fluorescent light boxes over kitchen islands. She also dislikes computer programs that produce generic designs. She's a strong believer in originality and says it's important not to lose the skill of hand drawing. Even though all her floor plans are ultimately produced in an AutoCAD format to ensure absolute accuracy, Christi draws preliminary designs on butter paper.

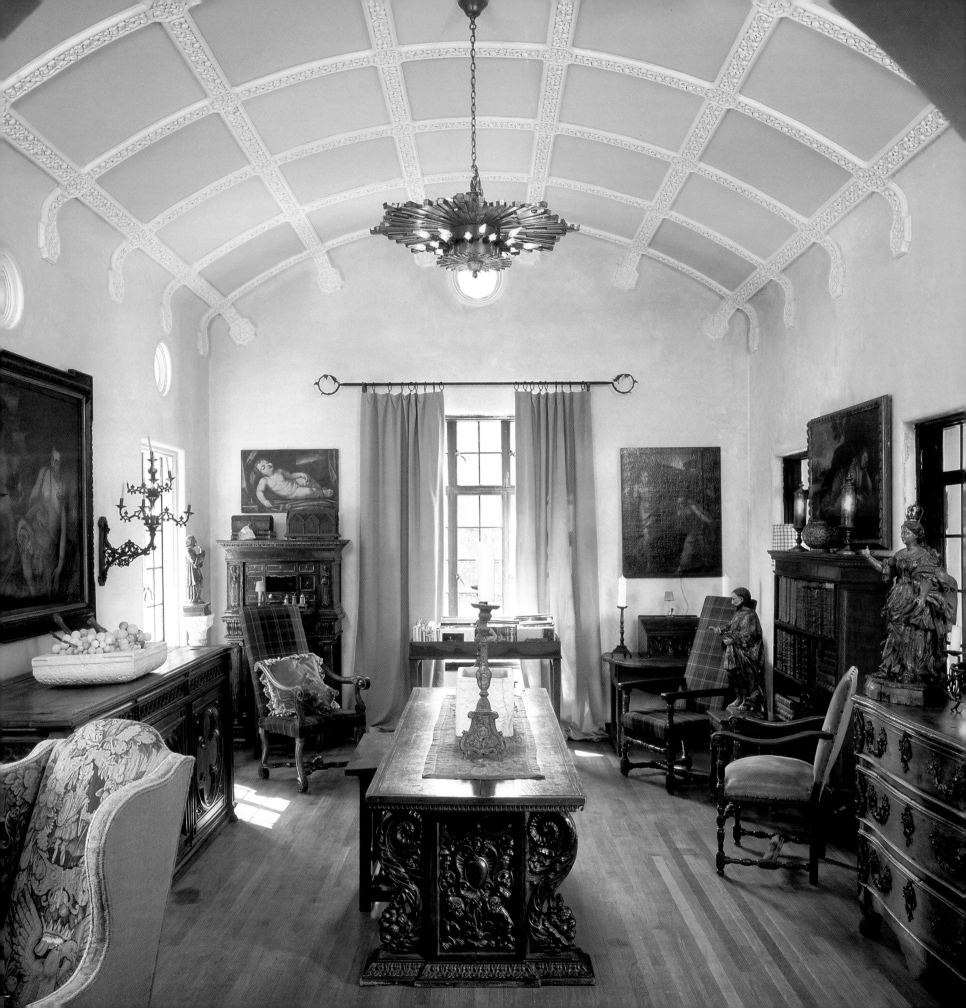

DON YARTON

Don Yarton Antiques
2322 San Pedro
San Antonio, Texas 78212
210-734-9900

Don Yarton offers his clients a privileged trip aboard a magic time machine. An antiquarian, Don transports them to eras past – different times, different cultures, different lives.

Don, one of the most respected antiques dealers in Texas, specializes in 17th and 18th century continental antiques and tapestries. Collecting and marketing antiques is far more than a vocation for him. It's a lifelong passion. He is fascinated with their mere existence and by the ages and other worlds of which they were a part. He is taken by their design, their patina and, ultimately, their spirit.

Don's obsession with antiquities began when he fell in love with romantic settings as a child. Growing up in Toledo, Ohio, he went to the local museum, frequently visiting a vignette of a small Dutch room with a polychrome Delft tile stove. You could walk up stairs and sit by the little table and stove, Don recalls with fondness. The room setting – its ambiance and accessibility – made a lasting impression on him and was a pivotal influence on his career choice.

Left: Most of the furnishings in this sumptuous library are Italian Renaissance. The commode, one of a near pair, is early 18th century Lyonnaise. The 16th, 17th and 18th century paintings are French and Italian.

Right: Dramatic arches frame a classical marble basin and 13th century marble figure.

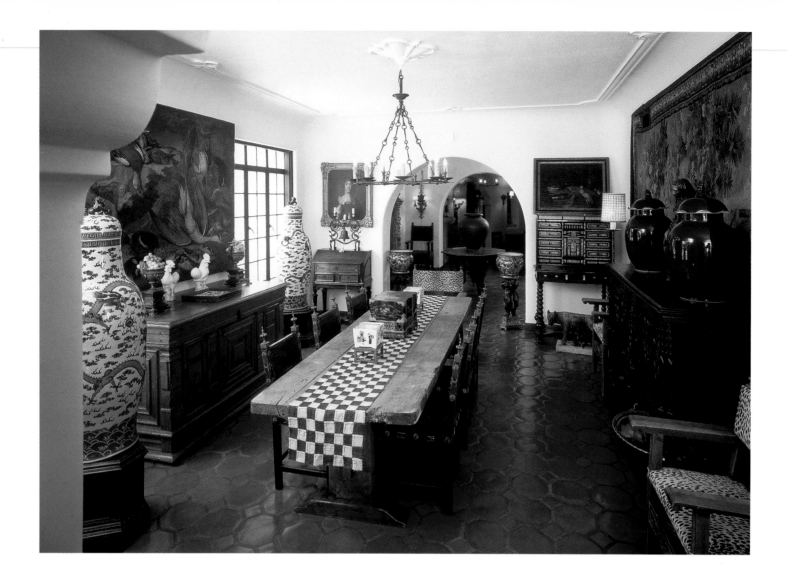

As a young boy, Don was surrounded by a love of the past. His mother, also an antiquarian and antiques dealer, collects and markets 18th century original-surface New England furniture. His father is an experienced artisan and cabinet maker.

Don made his way to the San Antonio area where he was stationed courtesy of the U.S. Army. Wanting to make his mark as an independent antiquarian, he chose to remain and develop a market niche. Today, Don has a solid business and a legion of loyal followers. Some are devoted clients for whom he has created enchanting interiors filled with choice antiques. Others lift their spirits by merely dropping by his San Antonio shop to wander amidst ancient beauty and share their appreciation of antiques. From his San Antonio headquarters Don markets antiques all over the world, frequently advising customers about their design placement.

Don is inspired by the future as well as the past. He always is in awe of his surroundings and enamored of all things lovely and beautiful, whether they're natural or manmade. He looks to esteemed and influential antiques dealer and interior designer Alex Vervoordt of Belgium for inspiration, as well as the work of Sir Edward Lutyens, an architect of the English crafts movement who had an unerring eye for absolute simplicity.

Above: A pair of important Chinese temple jars and African textile table runner in this dining room reflect Don's easy ability to mix treasures from different cultures with western European antiques.

Right: A great hall boasts abundant furnishings, including a 16th century Flemish tapestry, faience garnitures and a rare example of maritime votive art suspended from a hand-hewn beam.

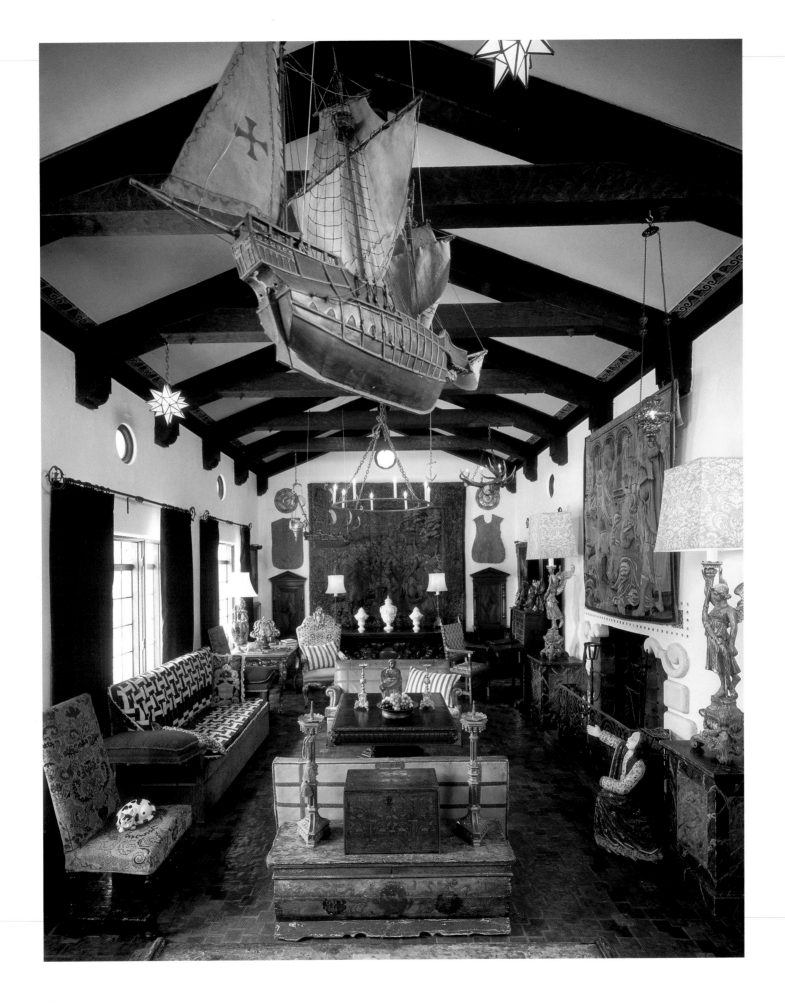

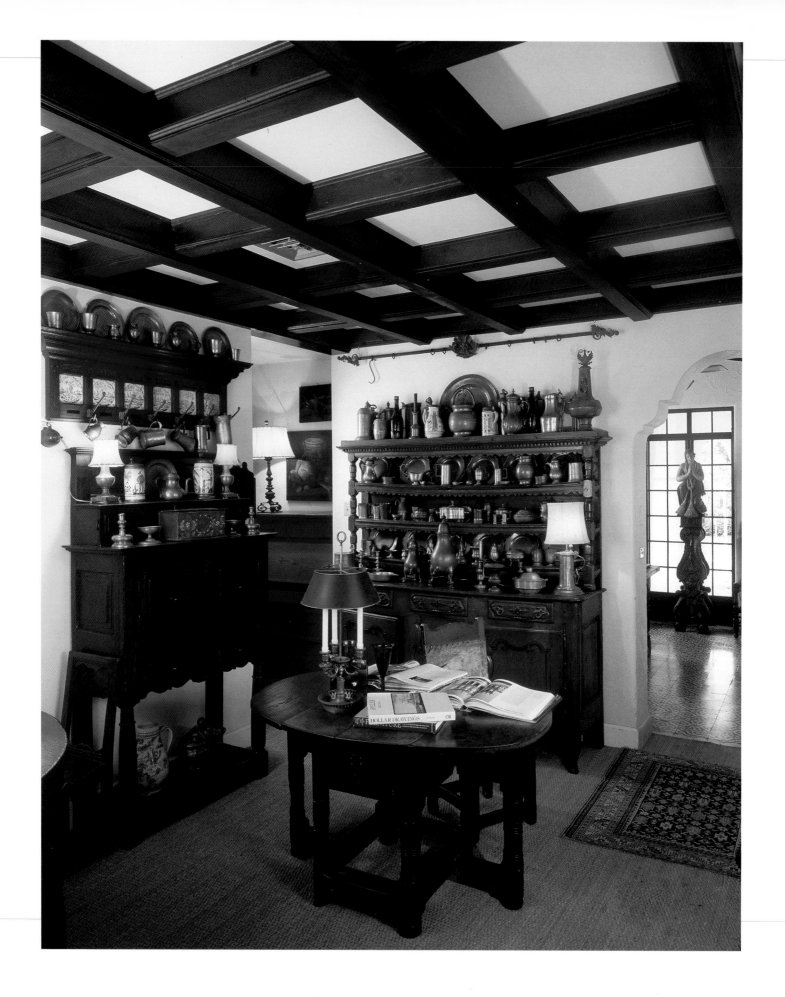

Left: This breakfast room is the perfect setting for a vast collection of 17th-19th century pewter.

Right: A foyer features scagliola columns, a 17th century Italian gondola chair and a marquetry table with ivory inlay. A hand-painted Batchelder-tiled spiral staircase draws the eye skyward.

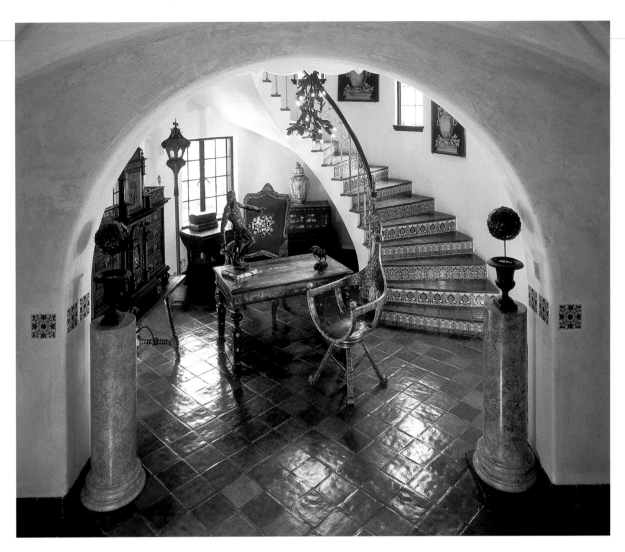

Don is fascinated with the role antiques play in design. His design preference has evolved from a more period, purist look into one that is informal. He enjoys juxtaposing beloved artifacts with upholstered furnishings, draperies and accessories in unexpected shades of white and cream. The more casual, lighter setting creates an environment of contrast, dramatizing the dynamic lines – and the mere existence – of the antiquities.

Thanks to 40 years of cultivating resources, Don purchases most of his antiques – either for clients or his personal collection – in the United States. When he travels, he heads to Europe, but strictly as a tourist. Don's favorite destination is Paris, the quintessential romantic city, where he enjoys immersing himself in the local culture, strolling down side streets and popping into cafés and shops.

MORE ABOUT DON. . .

If Don could eliminate one design element from the world, what would it be?
Plastic.

Why does he like doing business in Texas?
His clients are generous and daring.

What is Don's favorite pastime?
He loves and respects books. He satisfies his creative soul browsing through photographic books on art and furniture, and volumes on architecture and landscape design. When he has time to read, he opts for biographies.

Kelly Gale Amen, page 166.

Houston

HOUSTON

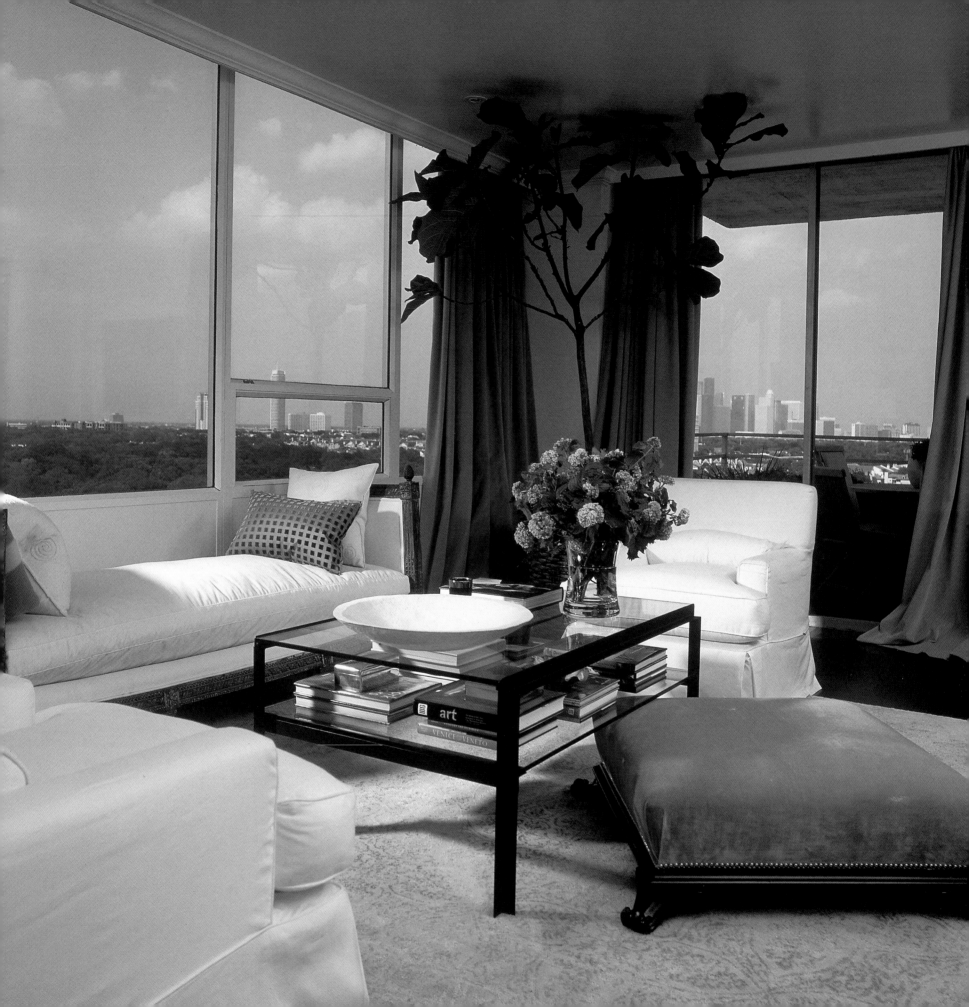

RENEA ABBOTT-MANTERIS

Shabby Slips
2304 Bissonnet
Houston, Texas 77005
713-630-0066

Ask Renea Abbott-Manteris how she would enliven a room, and she would answer with a resounding "Slipcover the furniture in white linen!" Renea's monochromatic designs focus on neutrals and natural fibers for a clean eclectic transitional look. For contrast, she adds a simple, classically distinctive antique or two like a Louis XVI arm chair. Primarily inspired by great architecture that provides a solid backdrop for her work, Renea also gleans some of her best ideas from original art.

After earning a bachelor's degree in fine arts from the New York School of Interior Design, Renea remained in the Big Apple. She had the once-in-a-lifetime opportunity to work for decorating master Keith Irvine of Irvine Fleming Bell for several years, a career-making experience.

In the early 1990s, Renea moved to Houston where she and her mother, Barbara Carlton, founded a design and retail establishment, Shabby Slips. The retail shop specializes in custom-designed furniture and slipcovers in all-natural cottons and linens in variations of white. The shop also carries fine 18th and 19th century European antiques and accessories.

Left: There's no better way to view the Houston skyline than from this spacious window-walled living room. Renea creates a simply luxurious environment with an antique French gilded daybed from Paris, slipcovered club chairs and coffee table from her shop Shabby Slips, a Barbara Barry silk velvet ottoman, velvet draperies and an Odegard silk and wool carpet.

Right: Renea Abbott-Manteris.

Shabby Slips' elegantly casual slipcover style caught on quickly among retail customers. Renea and Barbara have opened Shabby Slips franchises in Austin, New Orleans and Rosemary Beach, Florida, with others on the horizon.

Slipcovers make furniture appear less formal, Renea says, and enable you to easily maintain or change a room's mood. White furniture silhouettes are more dramatic and prominent against a variety of backdrops.

Left: In Renea's dining room, all eyes are on the Ford Beckman triptych. Rounding out the scene are the Thomas O'Brien java-finished dining table, Barbara Barry chairs covered in white linen, Fortuny chandeliers and Kuhl-Linscomb silver accessories.

Top right: This media room is cool, calm and collected with a Holly Hunt velvet sofa, Barbara Barry end table and arm chair, Shabby Slips mirrored coffee table, Donghia slipcovered chairs, and Odegard silk and wool rug. A crystal lamp from Venice and silver-leaf candlesticks from Paris add an old-world touch.

Bottom right: A Baker four-poster bed with sumptuous Frette linen in white and chocolate brown is this bedroom's centerpiece. A Christian Aubrey beaded pillow tops it off. Barbara Barry java-finished side tables and leopard-print carpet from Creative Flooring complete the setting.

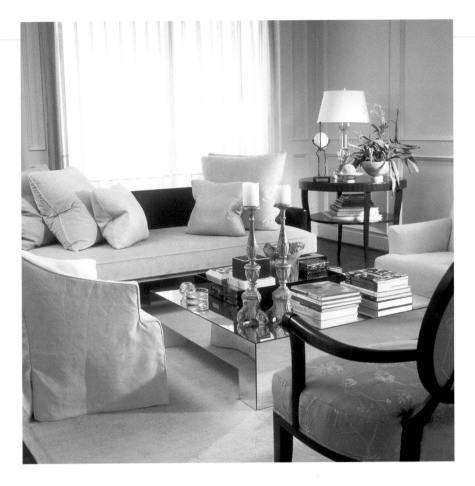

Renea devotes most of her time to interior design, as well as showroom merchandising. She buys for the retail side as well as her design clients, regularly traversing the United States and Europe to purchase French, Italian and Spanish antiques and artifacts. Her treks help her keep abreast of upcoming trends.

As a successful decorator, Renea has a favorite motto: "Don't complicate it!" She makes decisions quickly and takes everything in stride.

MORE ABOUT RENEA. . .

What does Renea like best about being in the design business?
She has earned a PhD in moving furniture.

What is the most expensive item she has purchased for a client?
A $65,000 armoire is at the top of the list, but she thinks a $45,000 pair of antique French arm chairs — with no upholstery — takes the cake!

If Renea could eliminate one design element from the world, what would it be?
Fluorescent lights.

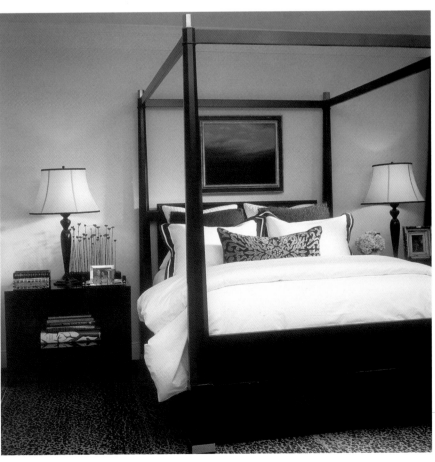

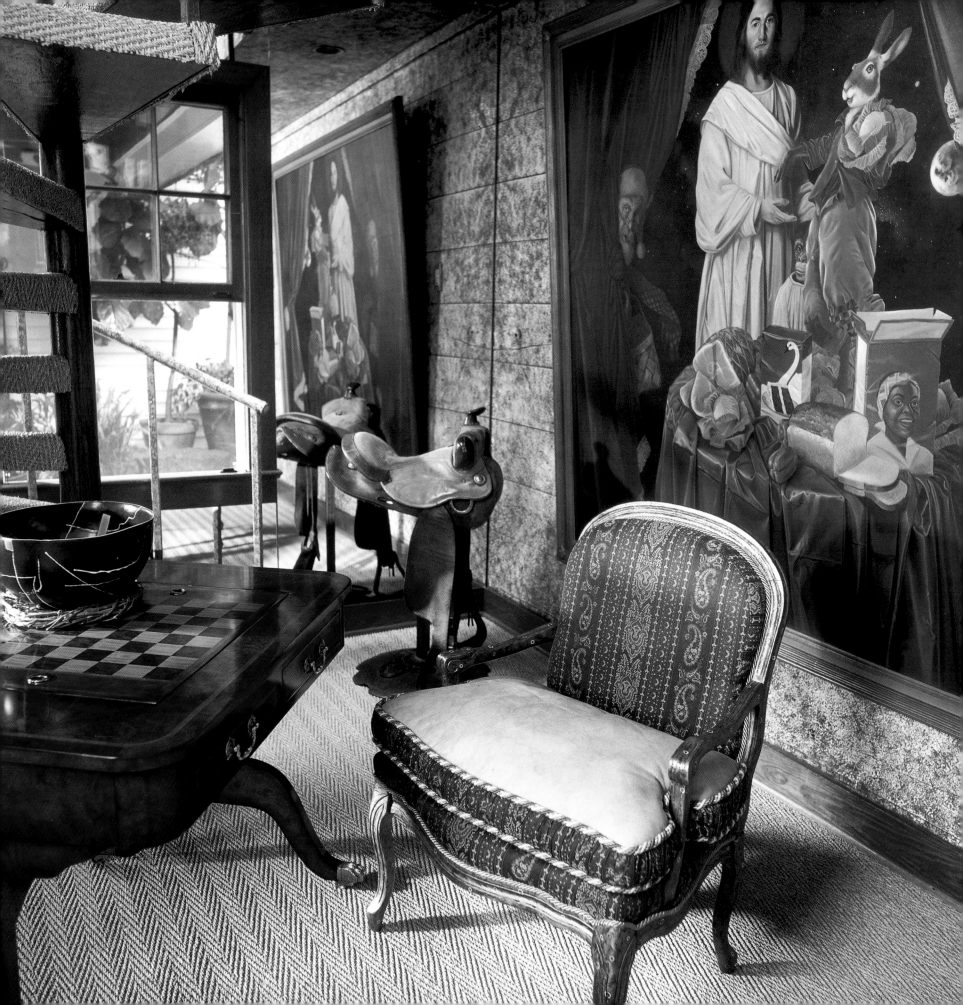

KELLY GALE AMEN

KGA

P.O. Box 66447

Houston, Texas 77266

713-522-1410

Kelly Gale Amen is an enigma. He is a self-proclaimed liberal in thought and conservative in action. He's simultaneously bold and modest, an extrovert and an introvert. If there's one constant about Kelly Gale it's that he's an icon in the interior design business, not only in Texas but around the globe. Kelly Gale has earned his exceptional reputation the hard way; he's worked for it. And for years he's been reaping well-deserved rewards of recognition and applause.

Immediately after graduation from the University of Oklahoma with a degree in interior design, Kelly Gale evaluated several U.S. cities and moved to Houston because he believed it was the freest, most undefined and youngest city on his list, a place where he could be what he wanted to be and could set his own agenda.

Indeed, he has done just that. After more than 30 years in the business, Kelly Gale is a premier interior designer and entrepreneur with clients stretching across America to France, India and beyond. He's also made a tremendous contribution to the city of Houston by supporting worthwhile community causes like literacy and medical research, making it a more loving, giving place to call home.

Left: At Kelly Gale Amen's home, better known as the KGA Compound, the game room features a layered mix of objects and textures, exemplary of his talent for melding the old with the new, the exquisite with the extraordinary.

Right: Kelly Gale's prized linen collection adorns one of his soft-sculpture upholstery beds. Photographs of a work of performance art entitled "Fire" draw attention to the wall.

The key to Kelly Gale's success is his ability as an artist to create the unexpected, which he hopes stimulates his clients' emotions. Each client, according to Kelly Gale, is looking for something he or she has never experienced. Through experimentation, he hopes to provide his clients with that twist on life they've been searching for. Often Kelly Gale initiates residential clients with what he good humouredly calls "the flip." With their permission, he moves everything around in new clients' homes to different locations, renewing their ability to view possessions and treasured objects with fresh eyes.

Kelly Gale finds inspiration and relaxes from his hectic schedule at the KGA Compound, an eclectic consortium of structures in "The Cave" addition of the bohemian inner-Montrose area of Houston. He lives in two 1940s cottages on the property, and a third house, built in 1907, serves as guest quarters and a gallery where he promotes local artisans' work. Every window of each structure overlooks the interior garden. Kelly Gale's creativity is stimulated and renewed in this environment where he "lives in art."

During his career, Kelly Gale has focused primarily on two aspects of design. One is creating exceptional living environments for his clients. The second is his custom furniture line of old-world cast metal he's created in bronze, aluminum and iron. He supervises its construction at an Alabama foundry. He also designs furniture constructed of wood and fabric, which he calls "soft-sculpture upholstery."

Kelly Gale describes his interior design style as "layered visual," a multi-dimensional approach that encompasses lighting, color, texture, fabrics and collections. On the surface, his look is spontaneous, but he has exquisitely planned every detail, with each piece possessing its own power and making a valuable contribution to the synergy of the whole.

A morning person with an exceptionally high energy level, Kelly Gale has been known to keep four business appointments by 8 a.m. The rest of the day is likely jam packed with everything from more client visitations to participating in a Houston art car parade to hosting a benefit dinner party for 36 while entertaining three out-of-town house guests. To most, this would be an exceptional day. To Kelly Gale, it's an ordinary one.

Left: A rich velvet chair is accented by a KGA signature pillow and Moroccan rug.

Right: A guest room at the KGA Compound is enhanced by Kelly Gale's soft-sculpture upholstery. An African sculpture and Afghani rug add exotic flavor.

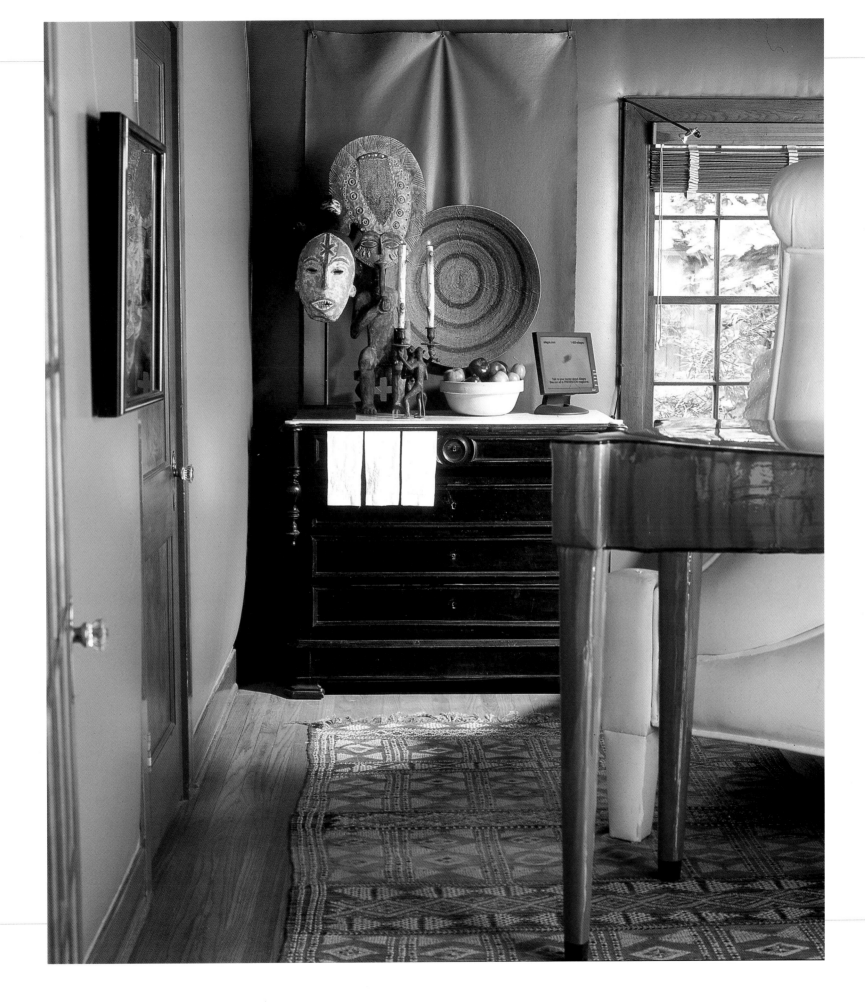

MORE ABOUT KELLY GALE. . .

What is Kelly Gale passionate about?
Going, doing, seeing and learning – not wasting time.
And being with interesting people.

What is Kelly Gale's favorite color?
He has no favorite color; he loves them all.

What motivates him?
Kelly Gale is fascinated with how people live and why
most people believe there's a right and wrong way to
place and use objects.

**What personal pieces does Kelly Gale use in his
home that he values most?**
First, his amazing collection of white cotton and linen
sheets, especially coveted by his house guests. And second,
his exquisitely designed, luxurious dog beds that also dou-
ble as ottomans. Akin to thrones and affectionately dubbed
"poofs" by Kelly Gale, they also are prized by his clients'
furry friends.

**What has been a life-changing experience for
Kelly Gale?**
Kelly Gale, a cancer survivor, confronted his illness head
on and invited his friends to embrace the experience
with him. Consequently, he serves as an example of
courage and enlightenment for everyone he meets. The
experience reinforced his belief in breaking the rules,
now an inherent part of his design philosophy. Not
surprisingly, one of Kelly Gale's mottos is "life is too
short." In other words, use your best silver and crystal
now. What are you waiting for?

Left: A four-legged friend lounges on a KGA dog bed sans "poof." A KGA aluminum lamp table and an
upholstered chair embellished with one of Kelly Gale's "brassieres" add panache.

Above: The KGA Compound garden is especially enchanting at night. On a KGA triple bench a basket of towels
awaits guests after a midnight dip in the pool.

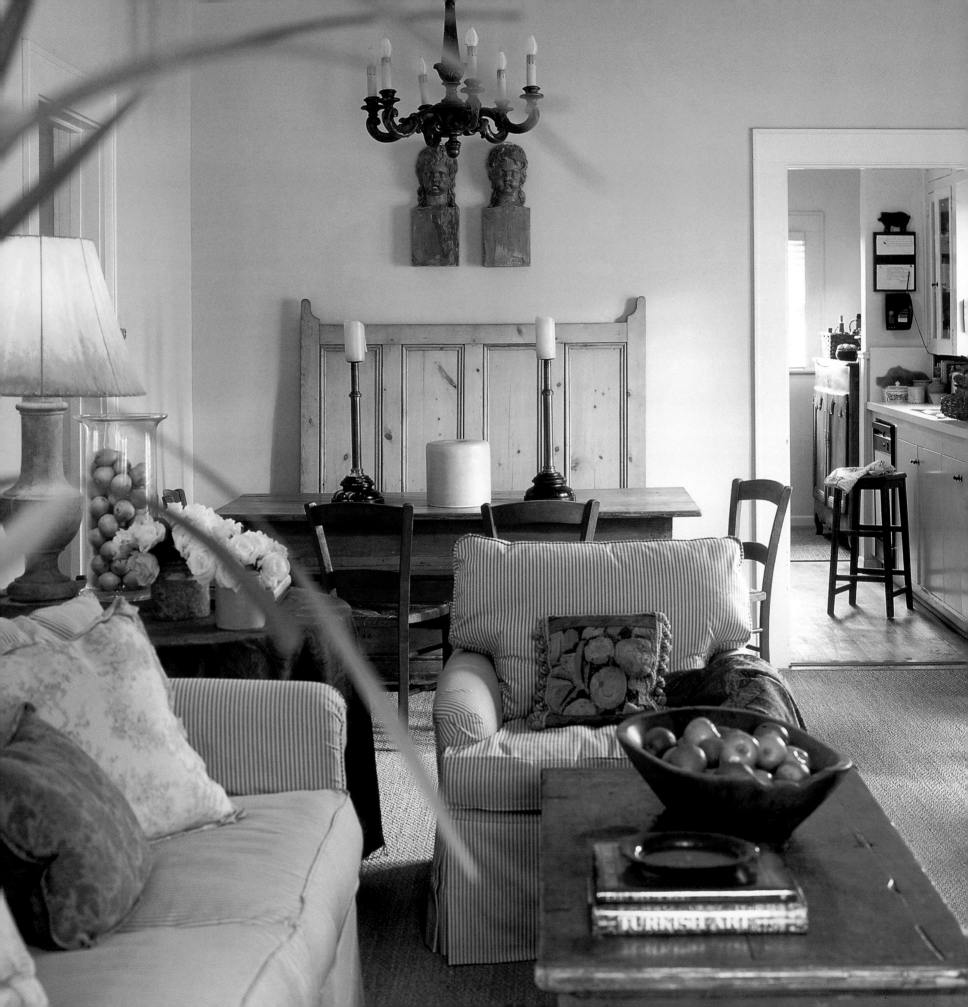

GINGER BARBER

Ginger Barber, ASID
Ginger Barber Interior Design
The Sitting Room
2121 Woodhead
Houston, Texas 77019
713-523-1925

Ginger Barber and Mother Nature are best friends. While growing up in Florida, Ginger was surrounded by water and sunshine year 'round. She learned to admire nature and make it part of her life. She grew up in a river cottage within a stone's throw of orange groves and remembers a casual lifestyle amid slip-covered furniture, ceiling fans and sisal floor mats before they were discovered by the rest of the world. Ginger moved to Houston in the late '70s but her childhood environment still inspires her.

If nature is Ginger's biggest inspiration, then her mother is her biggest influence. Ginger's mother, an interior designer, indoctrinated her daughter into the ways of the design business and surrounded her with creativity and energy.

According to Ginger, her mother always had a project under way. It could have been anything from designing a client's living room to taking an art class to planning and hosting annual community events. Whatever it was, Ginger was her mother's number-one assistant and was swept along with the tide. She even remembers making topiaries for a wedding party when she was seven or eight years old.

Left: A pine settee with a vertical paneled back gives an eating nook interest without art. The carved wooden angels on the wall are from England, circa 1700s.

Right: Ginger creates a charming tabletop vignette. An antique stone balustrade lamp from France and retablo from San Miguel de Allende, Mexico, are its centerpieces.

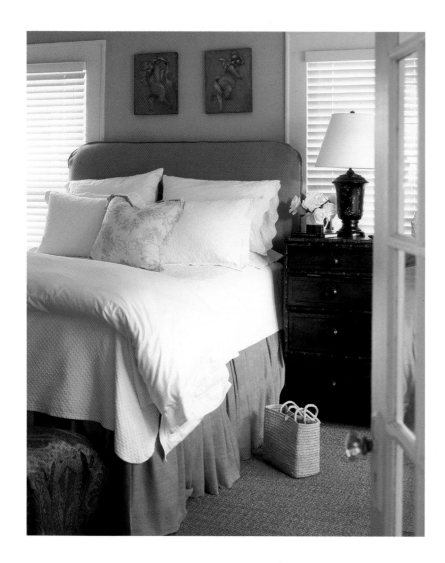

With her intuitive understanding of proportion, texture and color, Ginger likes the relaxed look, incorporating some antiques that you might see in a European country villa. Her favorite objects comprise anything woven, and she is a big proponent of texture and contrast, sometimes using clay or stone with wicker, for example. She favors relaxed rooms with textural variety.

Ginger approaches interiors with a neutral palette. She prefers solid white, beige or a subtle repetitive pattern such as ticking, and then lets nature take its course. Baskets, sea grass, tortoise shell and bamboo stand out dramatically against the monochromatic scheme. Then she easily adds the pièce de résistance – a vase filled with sunflowers or deep red roses, or a paisley shawl draped on an ottoman or table. An antique Mahal rug from Turkey adds drama and intrigue to the setting.

With that solid foundation, Ginger studied further, receiving a bachelor's degree in fine arts with a major in interior design from Sarasota's Ringling School of Art and Design. Then friends who were architects beckoned her to Texas where her first job was as a space planner for an architectural firm, followed by a brief stint as a designer for a gallery. Within four years, she opened her own design business. She quickly learned that the casual living and natural surroundings she took for granted in Florida appealed to her clients, who resided in a similar climate and wanted a laid back lifestyle at home to escape the stresses of city life.

Amid her busy schedule, somehow Ginger finds time to own and operate The Sitting Room, a Houston shop she founded about 10 years ago. Decorated with real-room settings, the shop is filled with new and vintage garden-style furniture and accessories, including dried topiaries, wicker baskets and unusual lamps mixed with natural-fiber upholstered pieces and European antiques.

Left: Ginger believes black finishes add drama to any setting. In this bedroom, an antique faux-grained bamboo chest of drawers punctuates the monochromatic scheme.

Right: This living room's neutral palette – shades of celadon and taupe with a touch of silver leaf – highlights art and accessories.

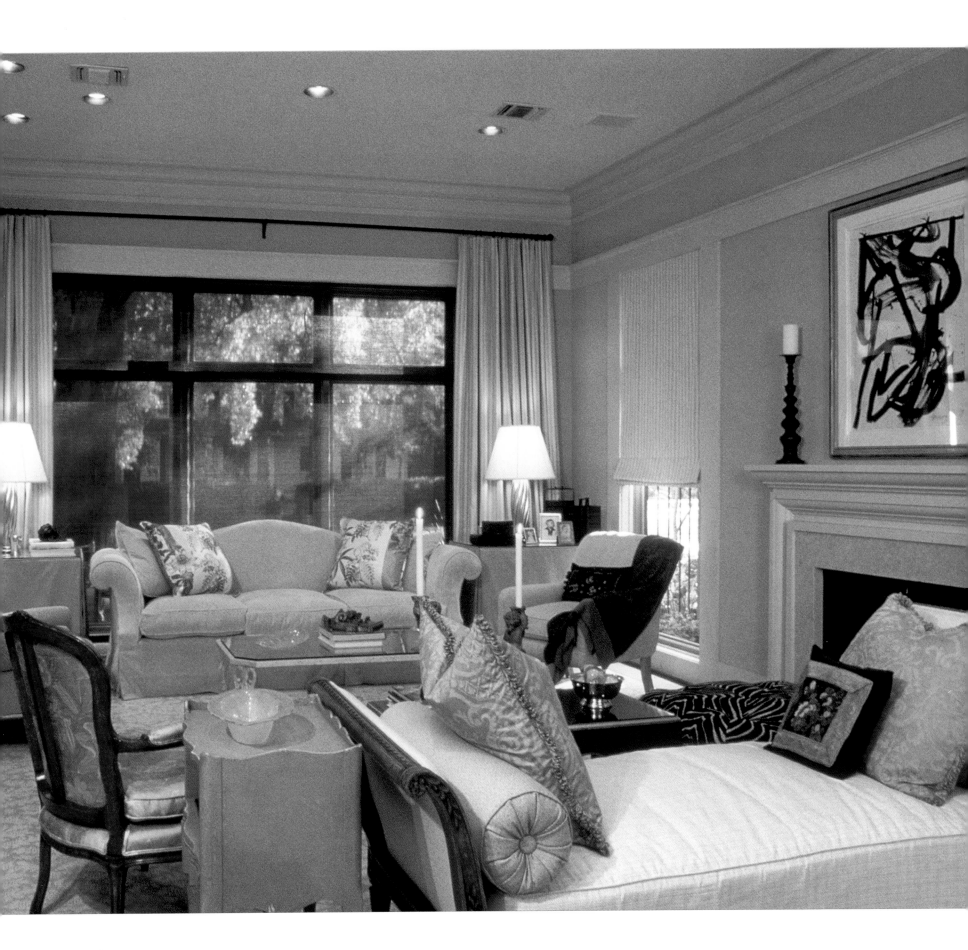

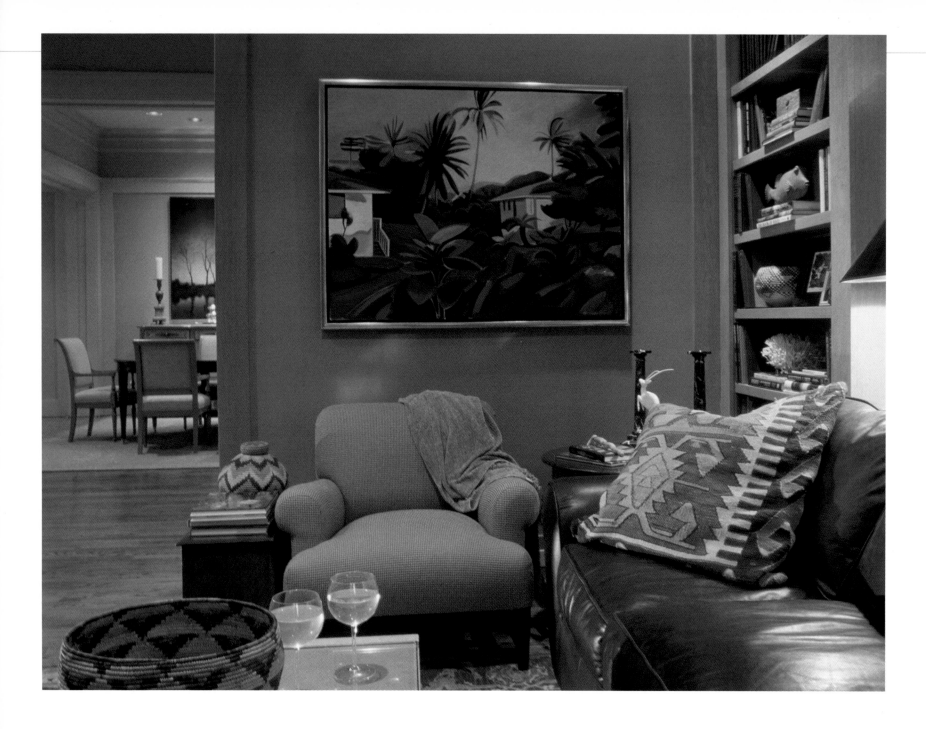

Ginger's great organizational skills help her keep both businesses running smoothly. She is a list maker who efficiently maneuvers through Houston traffic, keeping her meetings and errands corralled by region. She not only has a list for herself, but for each client as well, so she stays ahead of the game. According to Ginger, time management is one of the most important traits a designer can have.

The art of creating is part of Ginger's life. One of her favorite pastimes is making soup (something from nothing, she says) or finding blissful peace working in her garden, once again surrounded by nature. She treasures time at the beach with her son, Chris, or relaxing in a chaise with a trade publication that's caught her eye.

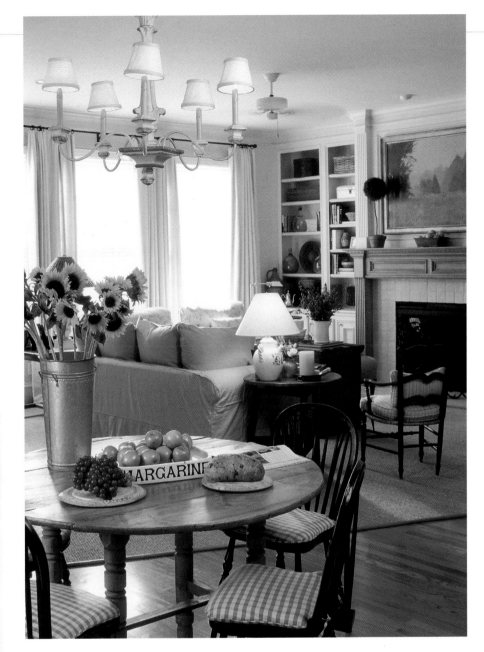

Left: Ethnic accents and colorful contemporary art make this study, which sometimes serves as a home office, a comfortable place to relax as well as work.

Right: The open design of the kitchen and family area accommodates the needs of Ginger's clients who have children. The antique pine mantel, a special find, is a cozy focal point.

MORE ABOUT GINGER. . .

What does Ginger like best about being an interior designer?
Her clients have become such close friends. And also the great satisfaction of looking back on a project after it's completed and knowing that everything fits – and works together well. According to Ginger, you have to be confident when you're spending other people's money!

What is the best compliment Ginger has received about her work?
Clients say her work is easy to live with, not decorated or trendy.

What is the most unusual piece that she has placed in an installation?
A hand-chiseled, overscaled stone table and benches she used in a loggia.

What is the single thing Ginger would do to a room to bring it to life?
Simplify! Make the walls light and neutral.

What objects does Ginger have in her home that she couldn't part with?
A pair of rare woven high-back chairs from Thailand and carved wooden angels from England, circa 1700s.

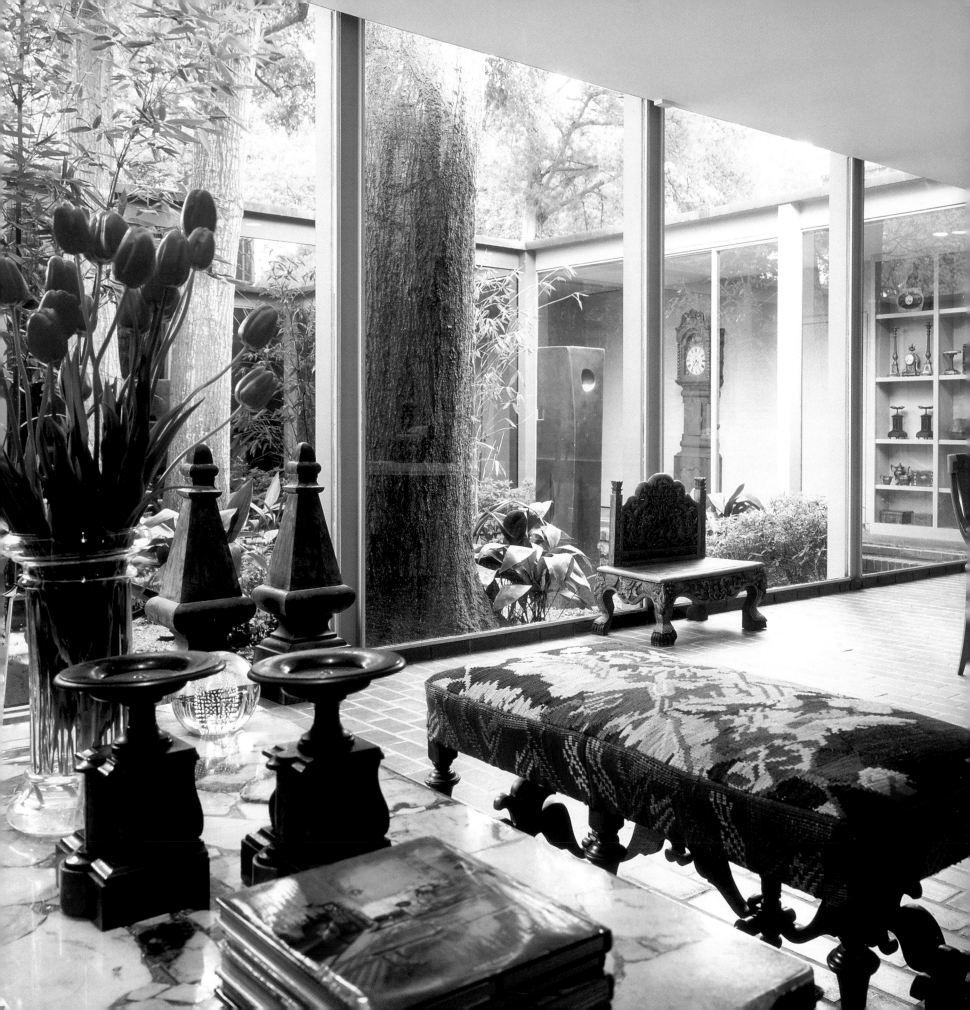

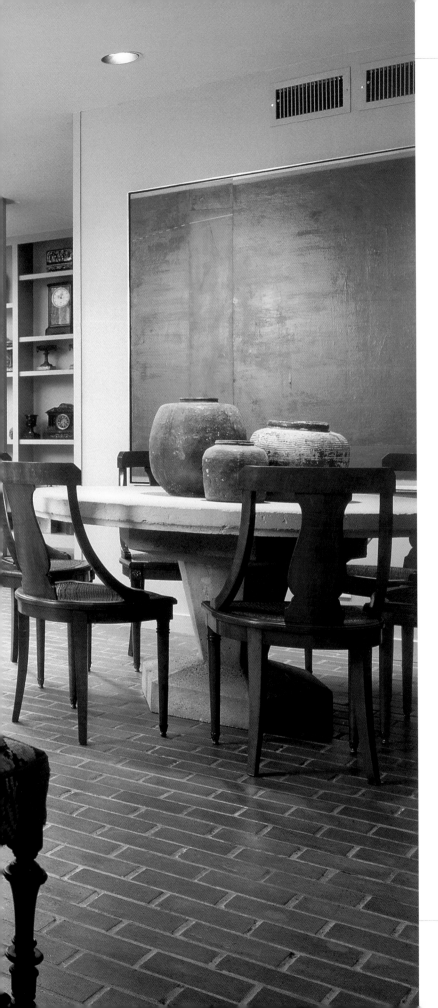

RICHARD BRANCH

Richard Branch, ASID

Richard Branch & Associates

4899 Montrose

Houston, Texas 77006

713-528-7375

Richard Branch's design practice and his homes in Houston and Denver are testament to his diverse tastes, discerning eye and high energy.

His practice, a marriage of entrepreneurial savvy and creative exuberance, primarily comprises high-end new construction and renovation projects for residential clientele in both cities. His portfolio also includes exclusive commercial work.

Richard champions a transitional, modern style, even in settings steeped in tradition, because he believes any approach to good design has a restrained contemporary edge. He adds flourish to his favored monochromatic palette with dashes of strategically placed color, producing chic environments alive with personality.

Richard works closely with his clients, gently encouraging them to express their design needs and desires. He excels at matching their lifestyles with his life settings but delights in shaking things up, too. He thinks nothing of painting walls pale pink in a traditional environment or hanging a bold, colorful contemporary painting above a Chippendale sofa.

Left: Richard once owned this international-style Houston home designed by the late Ralph Anderson, well-known architect of the Astrodome. Its clean lines and original brick floor are the perfect backdrop for a wonderful collection of contemporary and traditional art and furnishings.

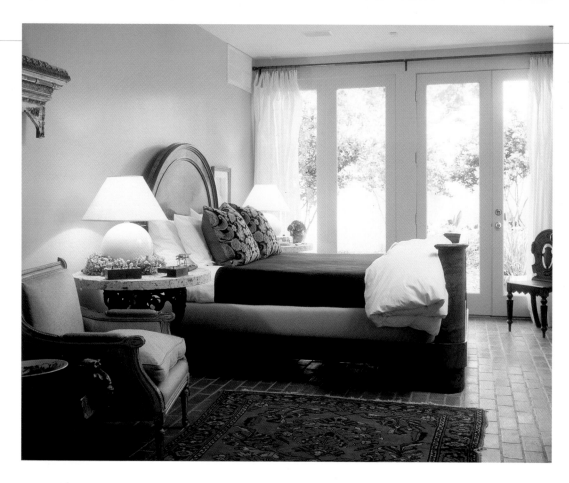

Top Left: This bedroom has an old-world feel with a burled walnut bed, English pub table with updated fossil-stone top and Persian rug, all antiques.

Bottom Left: Exposed shiplap walls in this 1920s home create a comfortable atmosphere. Texas shell-stone cylinder tables and contemporary mirror complete the eclectic setting.

Right: This bungalow's den in Houston's Rice University area opens to a pool and gardens. The oversized couch and stamped crocodile leather ottoman make an inviting conversation area.

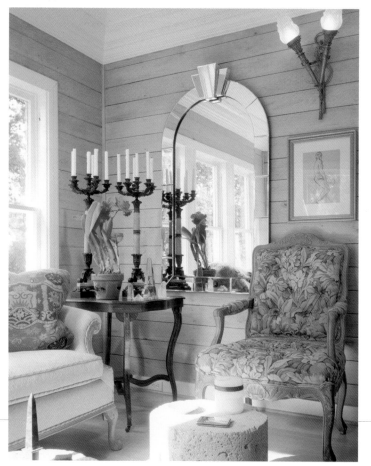

Richard practices what he preaches. In Houston, he calls a modern high-rise home. With 12-foot ceilings, exposed duct work, hardwoods and granite, his apartment is a sophisticated juxtaposition of raw and finished. In the Mile High City, he lives in a two-story brick Denver Square circa 1908 where he has enlivened a more traditional look with unabashed splashes of contemporary originality.

Richard was meant to enter the design world, but took a circuitous route. After graduating from Stephen F. Austin University with a bachelor's degree in business administration, he held a marketing position in Houston. In his spare time he purchased homes and renovated them for resale. Deciding he needed to broaden his decorating background, he studied design at the University of Houston.

Soon friends encouraged Richard to hang out his design shingle. So he took the plunge, first helping a friend-turned-client update her home. His business became a reality.

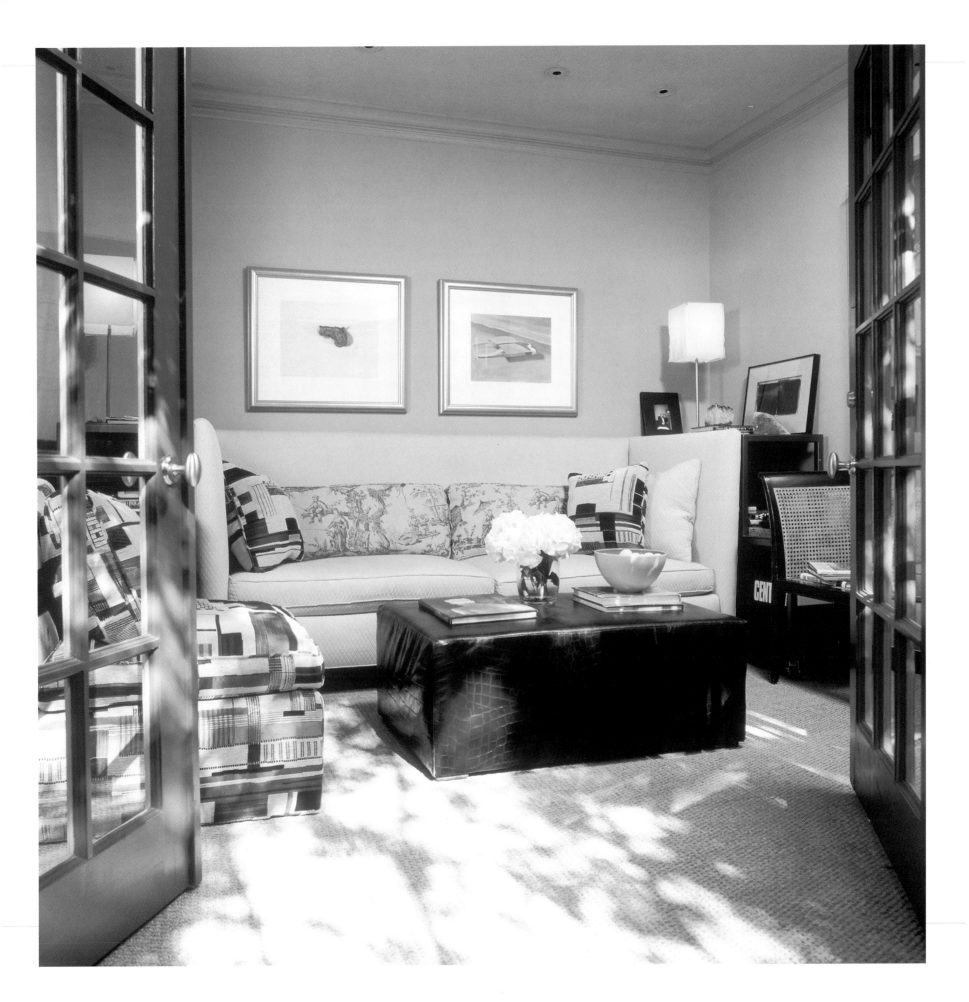

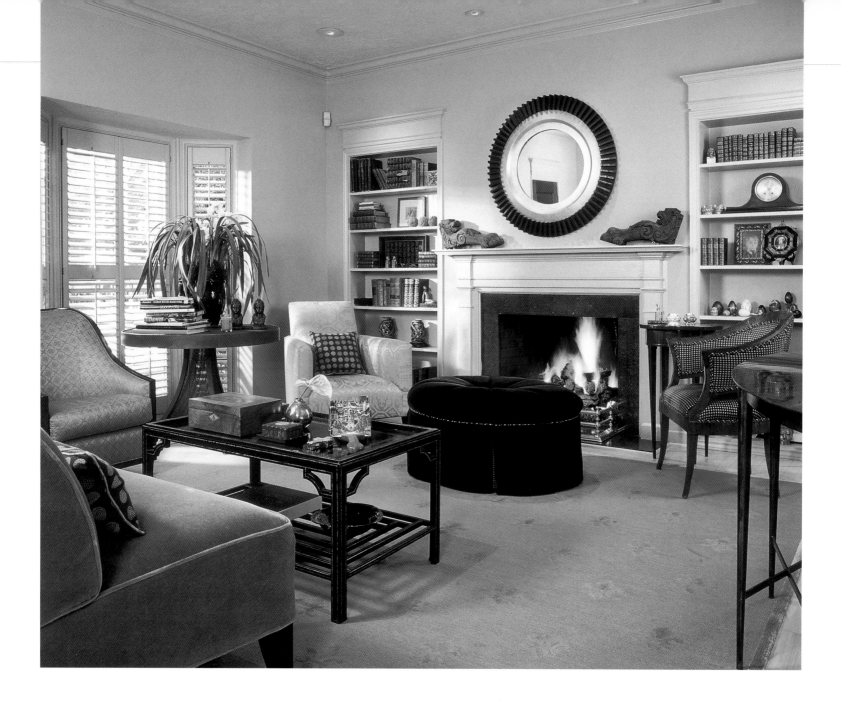

Finally Richard was pursuing his childhood passion borne of buying ventures at auctions and estate sales with his mother, an antiques dealer. Her motto, "If you love it, buy it, and you'll always find a place for it," still resounds with Richard, who collects beautiful objects.

Richard is inspired by what he calls "connecting," a two-way, almost spiritual closeness he develops with people and nature. Or sometimes his next idea comes from wonderful visuals or warm memories. His travels to Europe and the Far East also have indelibly marked his design psyche.

Richard is most passionate about his work, admittedly not understanding those who can separate their professional and personal lives. Even when lounging on weekends, he is never without a magazine or coffee table book on interior design.

Left: A collection of antique books flanks the fireplace in this living room. A stylized fleur-de-lis motif enlivens the custom-designed silk and wool tone-on-tone rug.

Right: A peek around the portiere reveals a breathtakingly elegant period painting and a custom contemporary dining table and chairs for an ideal juxtaposition of styles, dramatized by Richard's neutral palette.

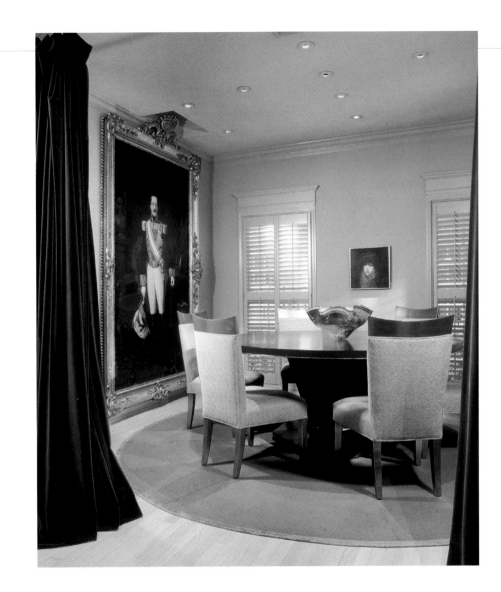

His creativity spills over into cooks' kitchens in both residences where his southern roots take hold and he produces chicken fried steak dinners. An advocate of helping others, Richard supports charitable organizations in Houston, Denver and abroad that benefit medical research.

Maintaining a business and homes in dual cities would debilitate most, but Richard thrives on the distance and the distinct differences of the two locales. Besides, he has a great traveling companion, his Cavalier King Charles Spaniel, Andy, who knows the Houston-Denver route as well as he does.

MORE ABOUT RICHARD. . .

What color best describes Richard?
Beige, because it is fresh but not stark, sophisticated but not intimidating, and contains enough color for a dash of flavor and spice.

Why does Richard like doing business in Texas?
Because people possess the pioneering entrepreneurial spirit epitomized by the daring response, "Let's go for it!"

What is the most unusual piece that he has placed in an installation?
Richard artistically arranged large chunks of glass slag atop a console of fossilized stone. Low voltage lighting dramatically plays off the pieces, magically transforming them into rare sculpture with tinges of color.

What is the best compliment Richard has received about his work?
A respected design industry executive, a guest in Richard's Houston home, praised his decorating restraint. Richard believes the ultimate challenge for every designer is to be a great editor, creating ideal spaces from the vast inventory of ideas and sources available.

What is the single thing he would do to a room to bring it to life?
Edit its contents.

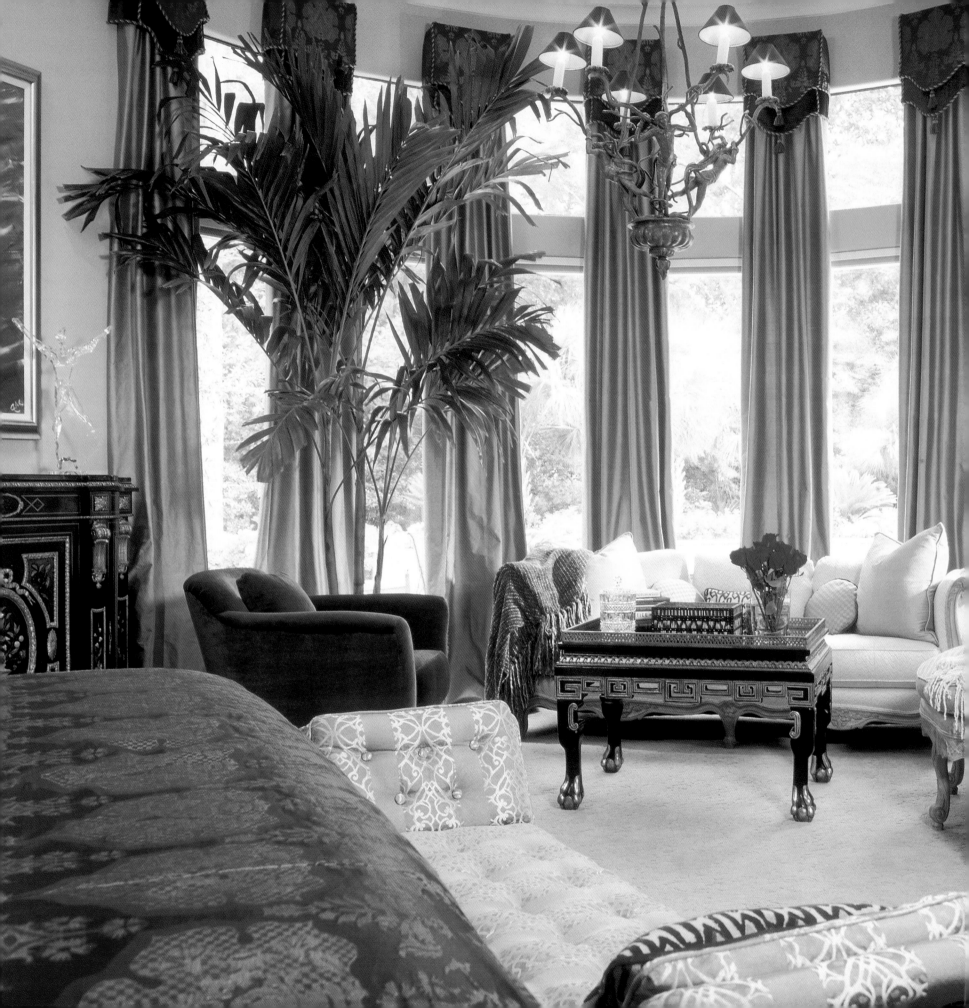

JANE-PAGE CRUMP

Jane-Page Crump, ASID

JanePage Design Group

500 Durham

Houston, Texas 77007

713-803-4999

Jane-Page Crump's business background has proven to be an invaluable asset during her career in interior design. Armed with a bachelor's degree in business and an MBA in finance from the University of Texas, Jane-Page was a tax accountant for a major accounting firm after graduation. But her passion was fashion, so in the evenings she designed clothes, selling her creations at nearby boutiques. Ultimately, she found the fashion world too illusive and decided to pursue an artistic career with more lasting value and reward.

Determined Jane-Page launched her own company shortly thereafter, successfully combining her discerning interior design eye and business acumen. She made the right choice. Today her firm is one of the largest, independently owned residential design companies in Houston. Her firm also handles commercial work.

Left: Luxurious fabrics and furnishings create an elegant sitting area in this master bedroom. The draperies frame a view of the lush landscape.

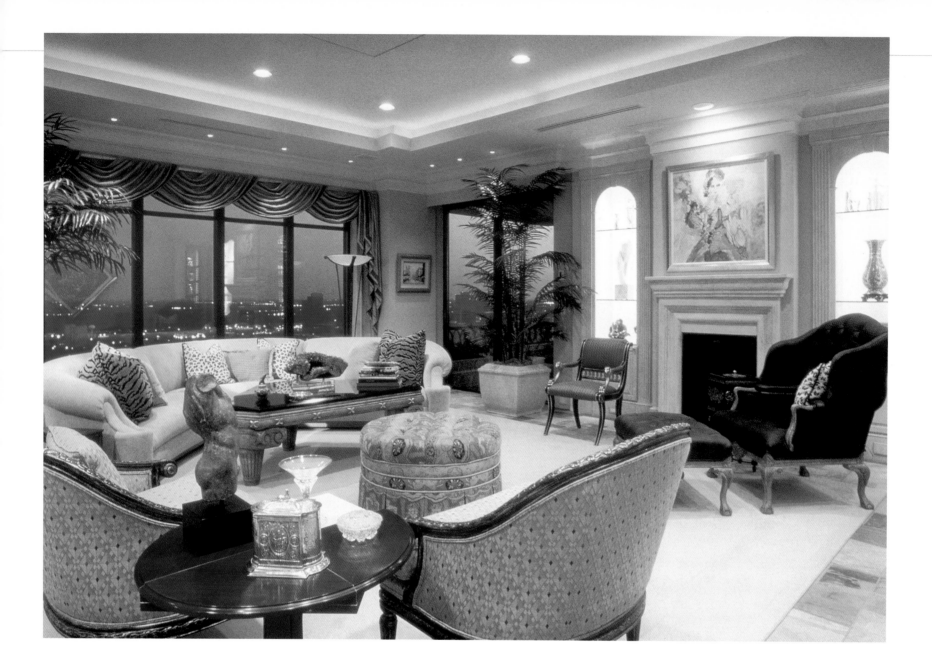

Jane-Page's business has earned a reputation for its professionalism, technical expertise and creativity. She and her staff team regularly with clients, architects, engineers and contractors on both new construction ventures and renovations. Occasionally, they take on turnkey projects as well. Jane-Page believes the top-notch designers on her staff have made a valuable contribution to the firm's success. Their abounding talent and positive attitude energize her.

Above: Jane-Page designed this living room to take advantage of the Houston skyline view. It is also a sophisticated environment for entertaining and movie viewing. A projector and 100-foot-wide screen drop from the ceiling at the push of a button.

Right: A warm palette creates old-world elegance in this study.

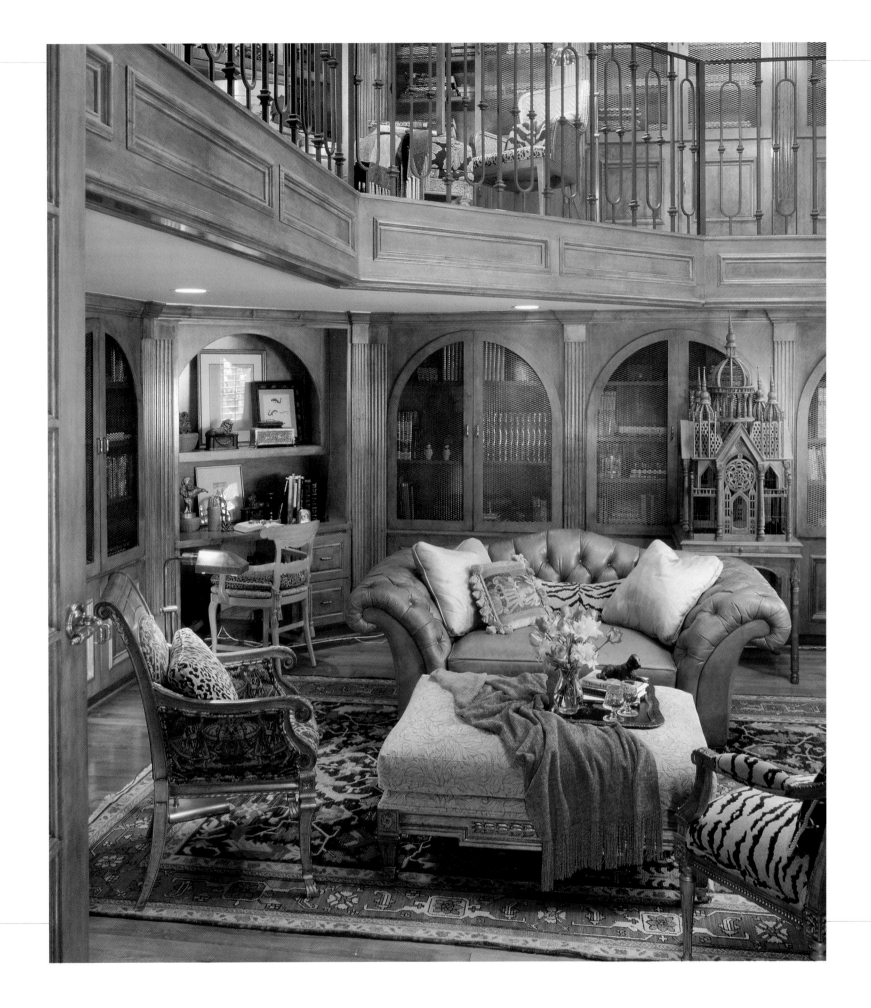

Jane-Page customizes each project's design style to meet a client's lifestyle and personal penchants. Nevertheless, she encourages a look of timeless elegance that is warm and comfortable. Aware that clients may sell their properties, she favors using a softer, more universal approach to design in a home's primary areas in order to maximize livability. But she believes flamboyancy and fun are fitting, especially in media and powder rooms. Even though client preferences also largely determine color scheme themes for each project, Jane-Page personally gravitates toward red (it's one of her favorite wardrobe hues) and purple (the first bedroom she ever decorated was lavender).

Jane-Page feels she is fortunate to have such wonderful clients who appreciate the value she brings to each project. She also enjoys the challenges they present her.

After office hours you can find Jane-Page relaxing with a mystery novel or nonfiction book, her dogs and cats nearby to keep her company. Adventurous Jane-Page also rides motorcycles with her husband James, sometimes returning to her native East Texas. They've also made the pilgrimage to the annual summer Harley-Davidson biker rally in Sturgis, South Dakota.

Top Left: The floor of this curved-wall grand entry combines quartzite, granite, marble and slate.

Bottom Left: Jane-Page custom designed this sumptuous powder room from the granite sink cabinet with Waterford crystal legs to the red granite baseboards and stenciled coffered ceiling.

Right: Comfortable furnishings, textured fabrics, a stone fireplace and quarter-hewn oak floors create an inviting family room.

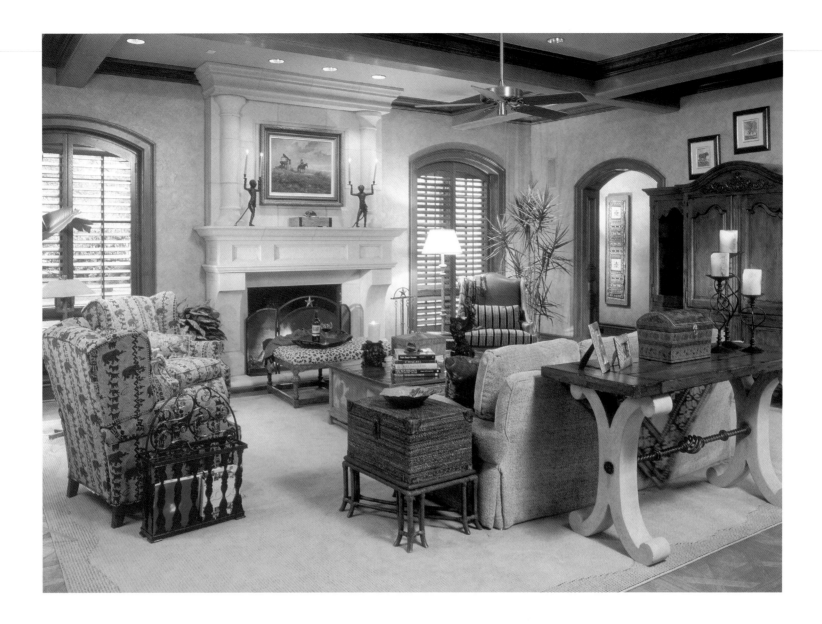

MORE ABOUT JANE-PAGE...

What is the most unusual piece that Jane-Page has placed in an installation?
A mirrored globe in a living room that doubled as a disco. She designed a custom chandelier that conceals the globe during the day. For dance parties, the chandelier – with globe – can be lowered and the globe rotated under spotlights for a little night magic.

What object has she had for years that remains in style today?
Her crystal box collection from the 18th and 19th centuries. Jane-Page's mother gave her a crystal box 25 years ago, which sparked her interest and search for more. Today she has many Czechoslovakian, Bohemian and French clear-glass boxes, recently adding red-glass boxes to enliven her collection.

Does Jane-Page think her name fits her?
Yes, because it stands alone! She doesn't know anyone with a hyphenated first name like hers.

What personal indulgence does she spend the most money on?
Clothes.

What does Jane-Page think is the best part about being an interior designer?
The wonderful clients she works with who frequently become good friends.

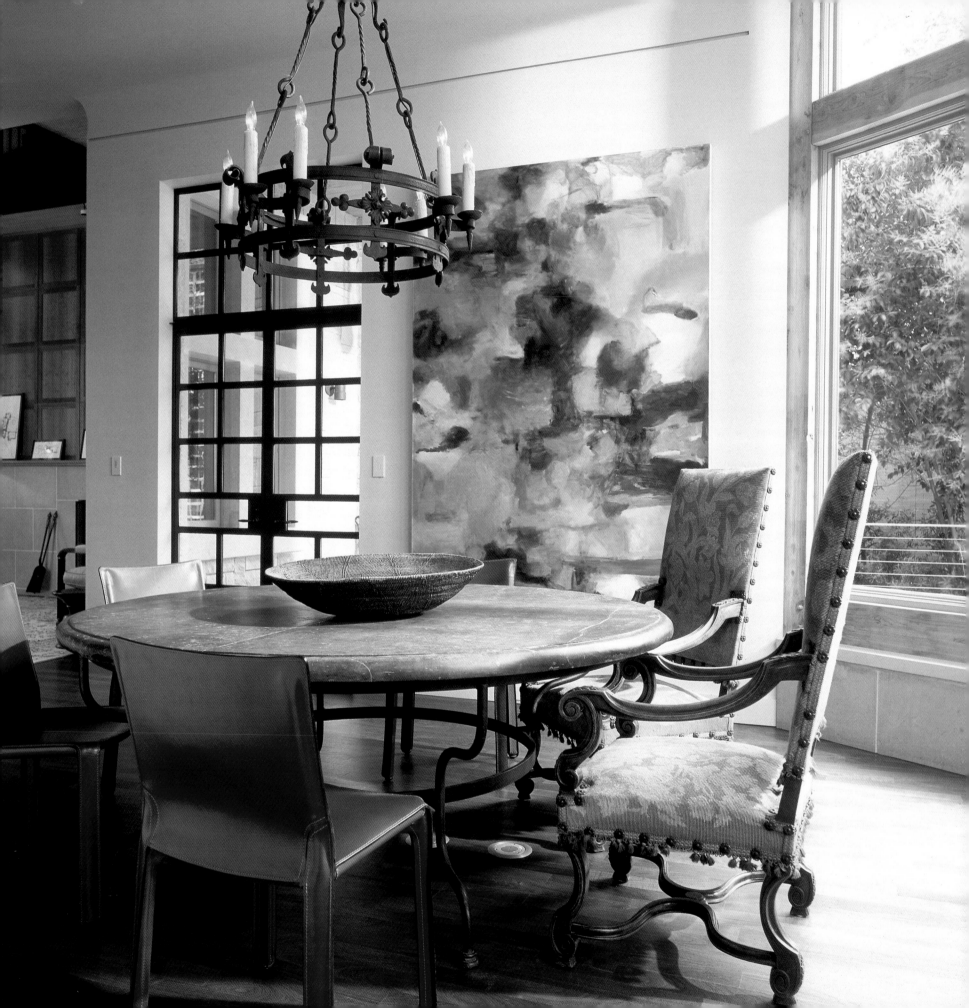

GLORIA FRAME & HILARY CRADY

Plus Two Interiors

7941 Katy Freeway, PMB 406

Houston, Texas 77024

713-688-6226

The mother-daughter team of Gloria Frame and Hilary Crady sees eye to eye on many aspects of design, but each maintains her independence when it comes to individual style and most clients.

After receiving a bachelor's degree in interior design from the University of Texas, Hilary was offered a career-making position with renowned designer John Saladino in New York, where she worked for five years. Soon after, she returned to Houston to rediscover a sense of community and do what she always knew she would – join her mother's design firm. Since then, they've opened an Austin office, too.

The twosome thrives on their differences as well as their similarities. Both prefer a neutral palette inspired by nature and have a clean, tailored look. But Gloria's designs lean toward the more traditional and comfortable, while Hilary prefers the sophisticated side of eclectic contemporary. Both use solid fabrics with occasional patterned pieces as accents and enjoy incorporating antiques for warmth and texture. While Hilary excels at space planning, Gloria's the expert at tracking down sources.

This designing duo has worked on some of their favorite design projects together. For a partnership based on mutual respect and brimming with talent, that's not surprising.

Left: Working with architect Hobson Crow on this gothic contemporary home, Hilary dramatized the dining room with an eclectic mix of Cassina leather chairs, a French antique table and arm chairs, and art by Terrell James.

Top right: A comfortable living area offers a panoramic view of Lake Travis. The upholstered sofas are by Plus Two Interiors. The fireplace is constructed of Texas field stone, and the ceiling beams are 150 years old. Austin architect Charles Travis designed this home located on an Arabian horse farm.

Bottom right: With the help of architect Charles Travis, Gloria joined three 150-year-old log cabins to create a cozy home. She uses textural accents against a neutral palette.

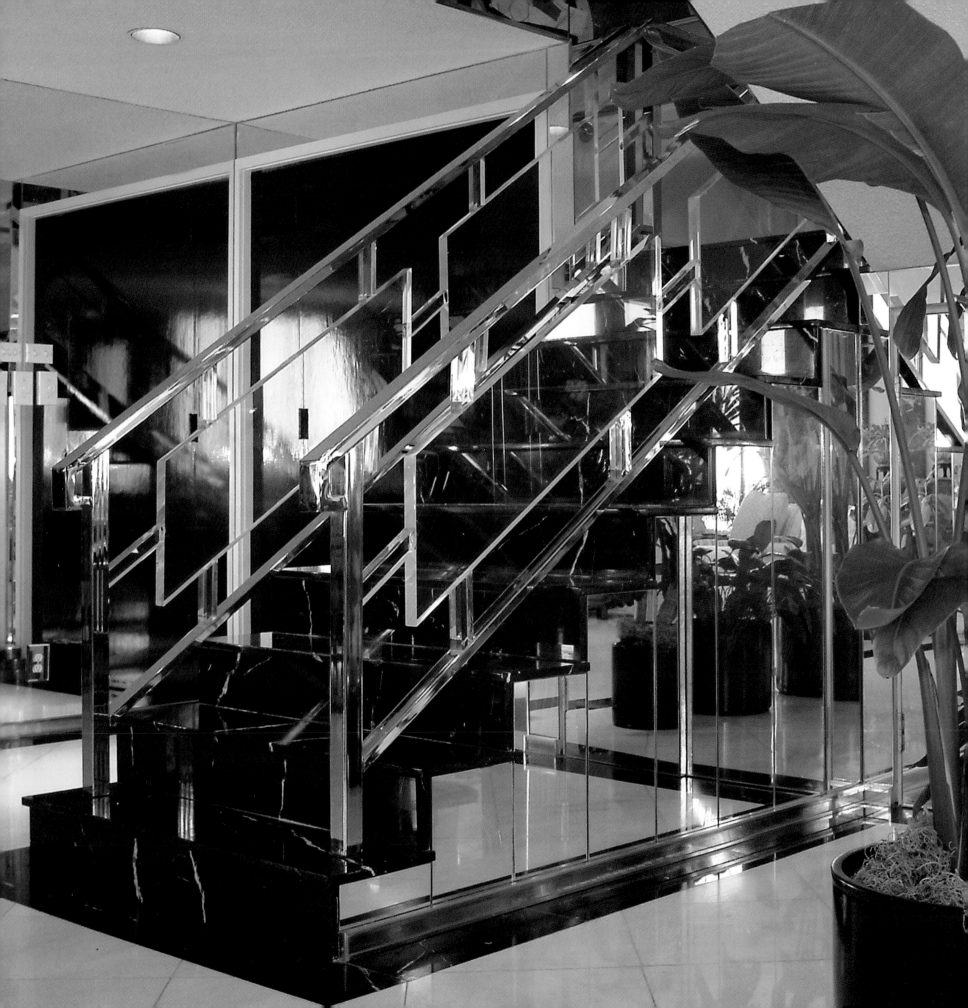

HELEN B. JOYNER

Helen B. Joyner, ASID
Helen B. Joyner Interiors
10 South Briar Hollow, Suite 80
Houston, Texas 77027
713-961-4361

Helen Joyner's artistic talent is in her genes – several times over. Her great-grandmothers painted oils. A special aunt is an artist. And her mother, who loved to decorate, perused *House Beautiful* and *House & Garden* while awaiting Helen's birth. To this day, her mother swears this is the real reason Helen became a designer.

When Helen was a teenager, she realized she didn't want to be a starving artist. So she opted for a more practical but still creative path: She would become an interior designer.

Pursuing her dream, Helen worked summers for two avant-garde Beaumont designers who were tuned into the local social set. She owes much of her early design experience to them, learning first hand about fabric sources, antique furniture and accessories. One of the designers even taught her how to refinish furniture.

Left: An acrylic and stainless steel staircase dramatizes this Houston penthouse entrance.

Right: One of a rare pair of antique hand-carved ebony blackamoors welcomes guests in an entry hall.

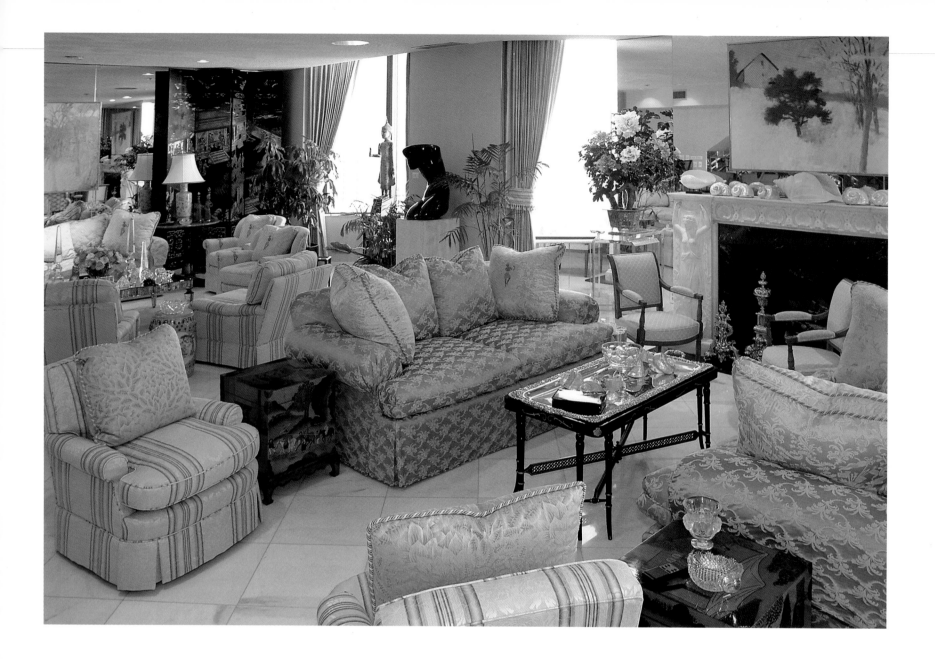

With some solid experience on her résumé, Helen attended Maryville College in St. Louis where she earned a bachelor's degree in interior design with a minor in art history. School-year trips to Europe broadened Helen's view of life, and design. She became acquainted, she says, with "deep architectural culture" – a sensibility she would draw on during her career.

After graduation, Helen joined the ranks of professional designers. She worked for and studied under Houston designer extraordinaire Evelyn Wilson, who proffered a traditional look and had a little black book of high-end clients. Evelyn trusted Helen's design judgment and respected her sales abilities, heady stuff for a young college graduate.

Left: A 200-year-old German fireplace surround sets the mood in this living room. It is flanked by jade trees on acrylic stands. One of Helen's custom-designed silver gallery tray tables with an intricately carved black-lacquered base complements the conversation area. Wolf-Kahn paintings and an UmLauf sculpture are important additions to the decor.

Top right: Contemporary art by Robert Goodnough and others is the focal point of this entertainment area. The sofa is upholstered in a white-on-white animal print, which contrasts with the lamps created from Japanese urns. Black-lacquered Chippendale chairs covered in zebra-print ultra suede and hand-painted zebra custom lamp shades add a sophisticated but whimsical touch. The homeowner's crystal collection is displayed.

Bottom right: In this vignette Helen successfully mixes Asian elements with a Louis XIV walnut chest and a hand-carved cherub mirror. The chest is flanked by Oriental panels that are part of a 14-panel screen. The majestic seashells are from Hawaii.

After Helen married, it was time to hang out her shingle. It was the ideal way to stay in the design game and give daughter Heidi some undivided attention. She started a practice and opened a shop that carried antique accessories and fabrics. Helen later returned to Beaumont so Heidi could have a better sense of family. There she opened another design business, retaining many Houston clients.

Today, Helen has resettled in Houston where she has a loyal following. She is known for her deft use of color in a variety of schemes, from contemporary to eclectic to traditional, and sums up her style as one of understated elegance, whether formal or informal. She especially enjoys designing clients' second homes whether they're nestled on the beach, hidden in the mountains or sprawled across the Texas plains.

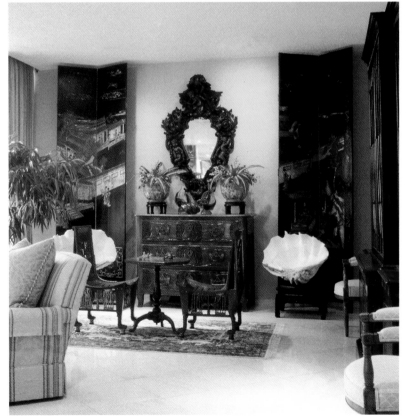

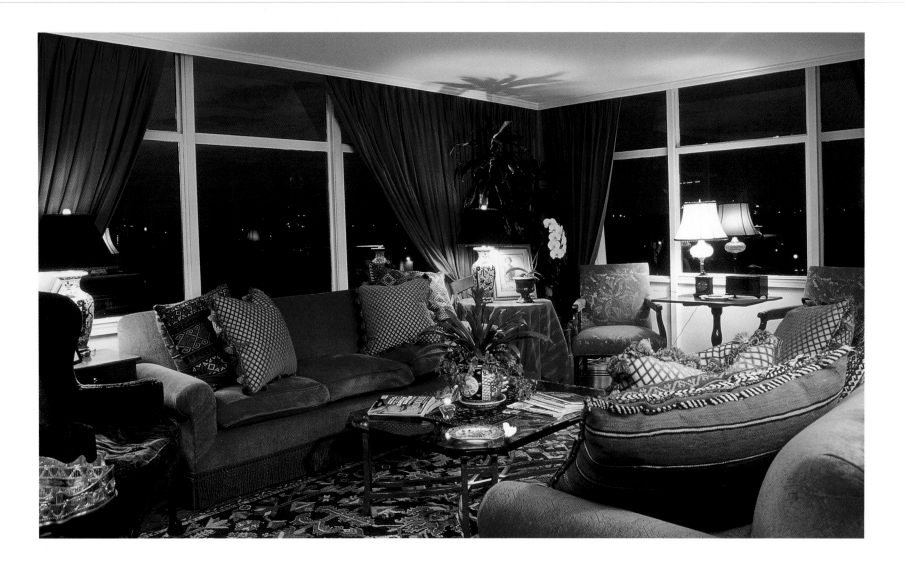

Helen has a gift for creating sophisticated environments for clients' furnishings. She excels at incorporating their decorative-arts collections, including paintings, sculpture and antiques, in sumptuous settings.

Helen embraces new clients because they offer the greatest gift — incomparable inspiration. And once they get to know each other, she says, they often become lifelong friends. Clients adore Helen's warm, outgoing personality and her ability to make them feel special. They're comfortable expressing personal preferences and ideas to her, confident she'll take them to heart and create the interiors of their dreams.

What is one of Helen's favorite pastimes? Why decorating her own abode, of course! She collects traditional French and English antiques, accenting them with Oriental elements. Three vintage panels depicting Marco Polo's journeys transform her stairway into a real eye-catcher and, coupled with the fact they once adorned Jackie Kennedy Onassis' apartment, an irresistible conversation piece. Helen also designs wooden and silver gallery tray tables on custom stands for lucky clients.

On weekends Helen and her husband Carter, who gives her the emotional freedom she needs to pursue her craft, visit their children and grandchildren in Austin and Dallas.

Left: In this penthouse Helen's warm palette of rich navy, gold and coral is inspired by the antique rug. A pair of priceless Amari lamps flanks the sofa. A silver gallery tray with tailored mahogany stand, designed by Helen, offers an ideal space for a book and a cup of coffee.

Right: A priceless grand chandelier that once hung in New York's Radio City Music Hall and art deco dining table and chairs create an ambiance from another era. The silver-leaf ceiling enhances the chandelier's glow.

MORE ABOUT HELEN. . .

What is the most unusual piece that Helen has placed in an installation?
An early 19th century 5'6"-tall elephant tusk hand carved with Japanese motifs. It graces a client's entryway.

What would Helen do to a room to bring it to life?
She would design a room around vibrant color, then ensure intimate, inviting conversation with overstuffed furniture, comfortable pillows and elegant rugs. Personalized accessories and ambient lighting would add important, final touches.

What is the most expensive item she has purchased for a client?
A 19th century marble fireplace mantel.

What is her favorite color?
Aqua, because it relaxes and soothes like the beach. She loves aqua as a background color, mixing it with apricot, peach, coral, yellow or green.

How do Helen's friends describe her?
They say she is giving and thinks of others' feelings first. She's active, she's friendly and she's never met a stranger.

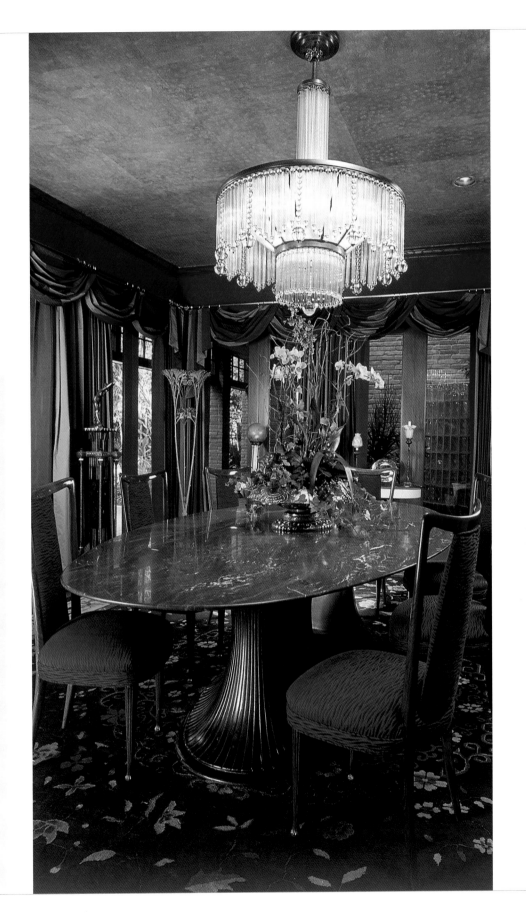

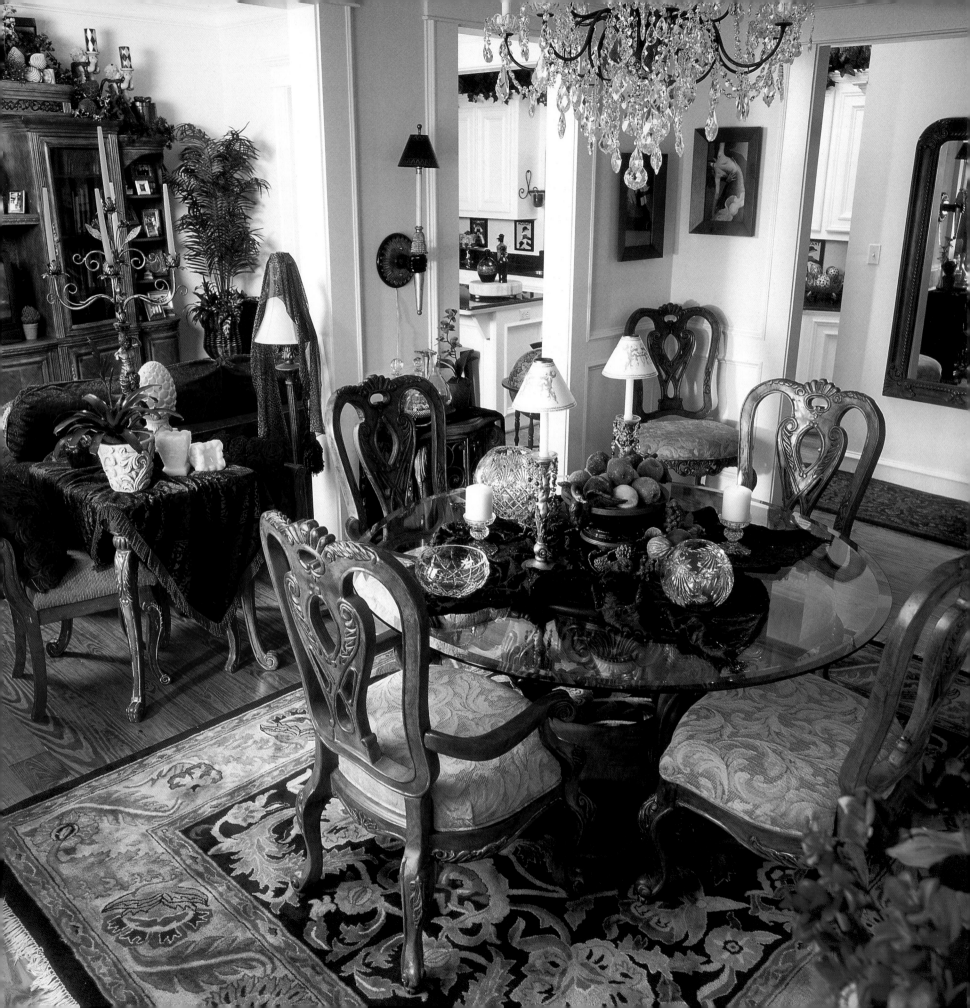

MARCIA KAISER

Marcia Kaiser, Allied ASID
Marcia Kaiser Interiors
2206 Caroline
Houston, Texas 77002
713-650-6818

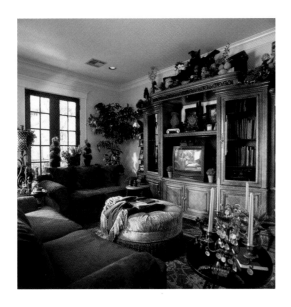

Marcia Kaiser is a dynamo. The designer for seven Houston home builders, Marcia haunts job sites every day. She is the creative liaison between the builder and the client, specifying everything from where to move a wall to paint color to flooring material and brick style. She once worked simultaneously on 36 residences under construction.

Marcia also has her own high-profile clientele. She assists them with exclusive new residential construction, selecting an architect and a builder, planning a budget and creating a personal, stylish environment. She manages each project's design from inception through completion.

Marcia has had a lifelong aptitude for creative pursuits. After receiving an associate degree in art and with her children grown, she opted to earn a bachelor's degree in fine arts with a minor in architecture from the University of Houston.

Pictured: It's a romantic trip to New Orleans' French quarter in Marcia's Houston townhouse. Ornately printed fabrics, lush color-saturated velvets, rich woods, crystal and candles add warmth and texture to the space, creating a relaxing retreat from the hubbub of city life.

With decorative preferences that run the gamut from classic ("it's elegant and moves") to funky ("it's alive and kicking"), Marcia pushes herself, and her clients, to innovative design levels, adding verve to every setting. She and business partner Glenda Bizzell, the Faux Blondes, often add a bold punch by painting murals or applying faux finishes. A mixed media artist, Marcia also crafts remarkable collages and stained-glass windows and door sidelights. She recently added airbrush painting to her repertoire.

Marcia is passionate about art and architecture, a love she shares with her assistant, Thomas Ehlers, and has made several trips to Europe to witness masters' work. A hero is Spanish architect Antonio Gaudi, known for his undulating art nouveau designs that border on the surreal. Another is Michelangelo whom she idolizes not only for his superb talent but also for his perseverance and stamina as a muralist.

With a hard hat as her wardrobe staple, Marcia is a driven, hands-on designer who lives to create — seven days a week. And she wouldn't have it any other way.

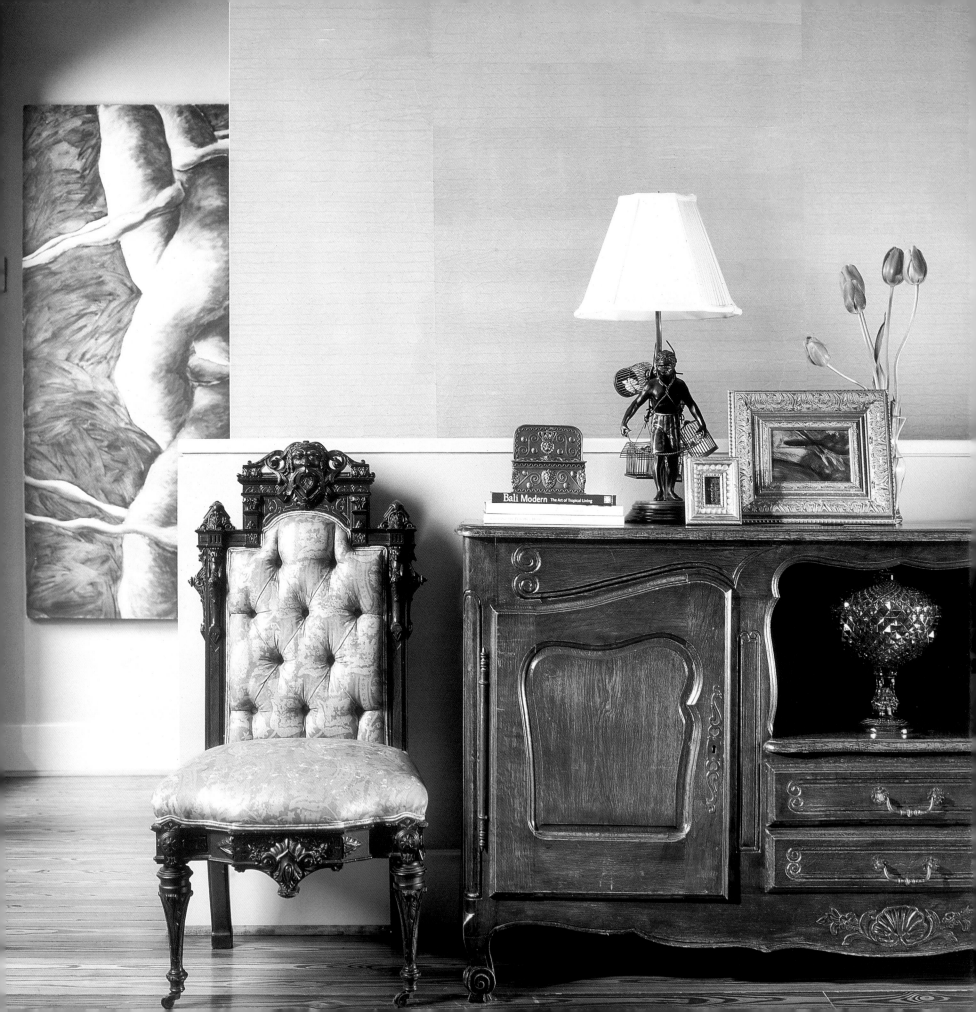

KEN KEHOE

KMK Interiors
2223 Hopkins
Houston, Texas 77006
713-523-0580

With Ken Kehoe, you expect the unexpected. His style is eclectic, and he uses antiques in unusual ways. Like placing a Louis XVI armchair on a concrete floor, using a vintage window surround as a cornice board, or installing iron scroll work from old Paris Metro stations as stairway balusters and handrails.

Ken, who was named a top emerging designer by the Decorative Center of Houston, studied interior design at Southwest Texas State University. After college, he worked for a San Marcos interior design firm owned by Rod Baughn, who became Ken's mentor. Even today, Rod's astute business advice and design counsel resonate with Ken.

Left: Antiques are juxtaposed with a modern hand-pleated wallcovering and contemporary art.

Right: In his home, Ken mixes old and new, creating a classic comfortable feeling.

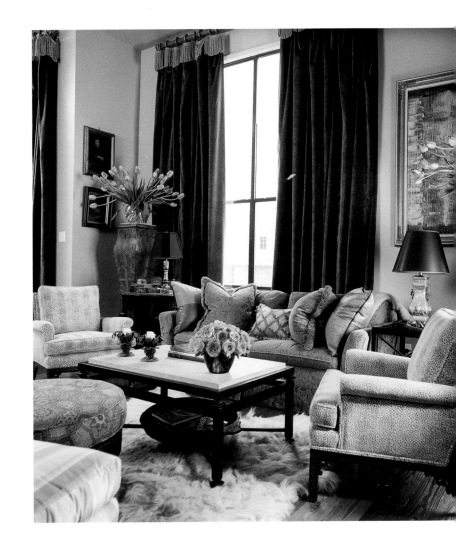

After establishing his design firm in Houston, Ken put his business on the back burner. He decided to get hands-on experience in a showroom. He also worked as a project manager for a construction company while still accepting a few select design jobs. When the time was right, Ken focused on building his business. His sister, Kathy Karotkin, joined the firm as project manager and aids him with color and fabric selection.

Most of Ken's work is residential, even though occasionally he takes on commercial projects. Ken likes to know a design job inside and out, so he prefers joining a project on the ground floor. He sometimes even hires the project architect.

Ken's designs have clean, architectural lines complemented by unusual decorative arts for eye-catching appeal. The result is a comfortable, cozy environment. His favorite color is golden brown because it's warm and enveloping.

Ken is inspired by his clients' enthusiasm and says the best part about a project is developing long-term relationships with them. He finds creating close personal space that influences how a client feels every day especially gratifying. Ken promotes what he calls "progressive design": He would prefer clients invest in a few quality pieces they can pass on to their children, rather than purchase numerous less-expensive items that will not stand the test of time.

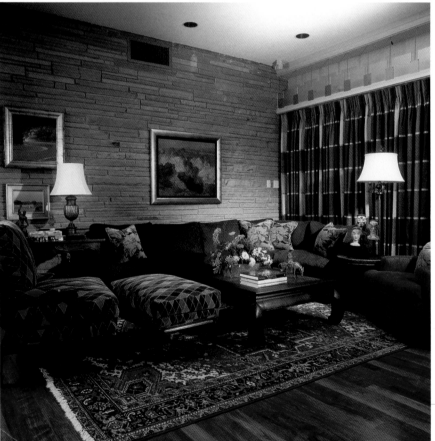

Top left: Contemporary art accents cozy tradition in Ken's master bedroom sitting area.

Bottom left: Ken imparts a hint of today in the living room of a classic 1950s Hill Country residence.

Right: Loft-like architecture makes an ideal backdrop for antique furnishings and art in this master retreat.

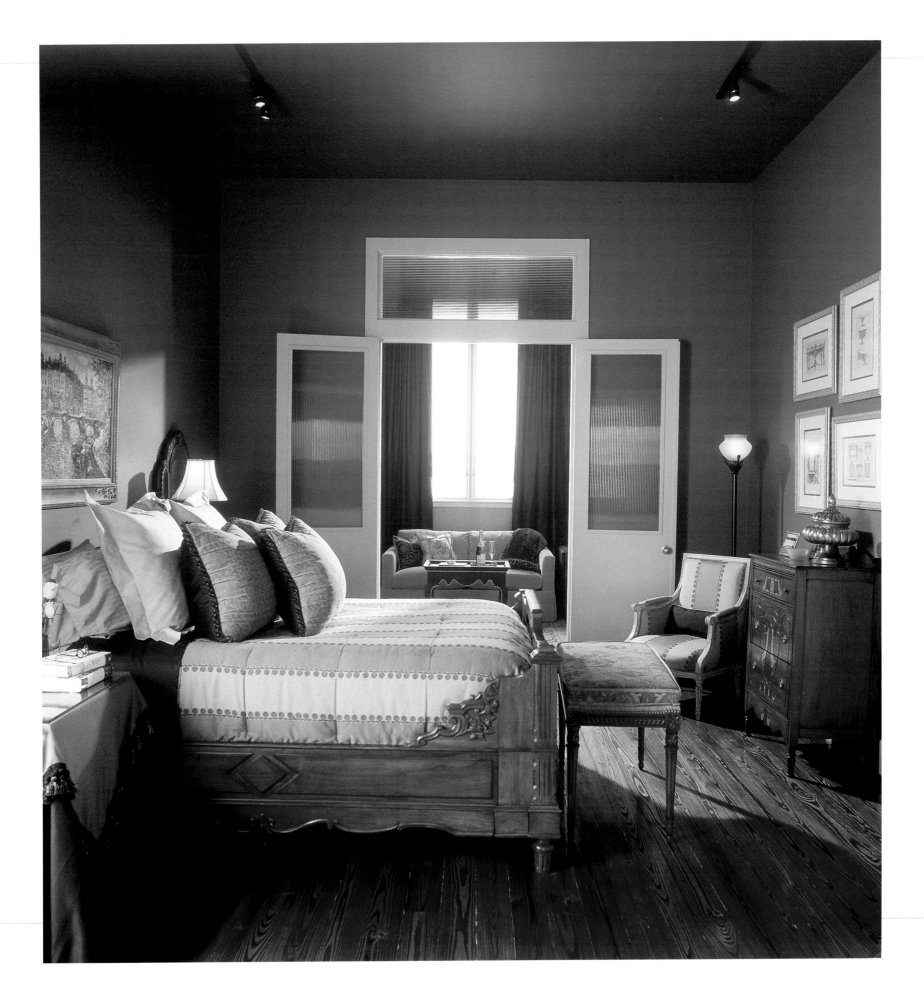

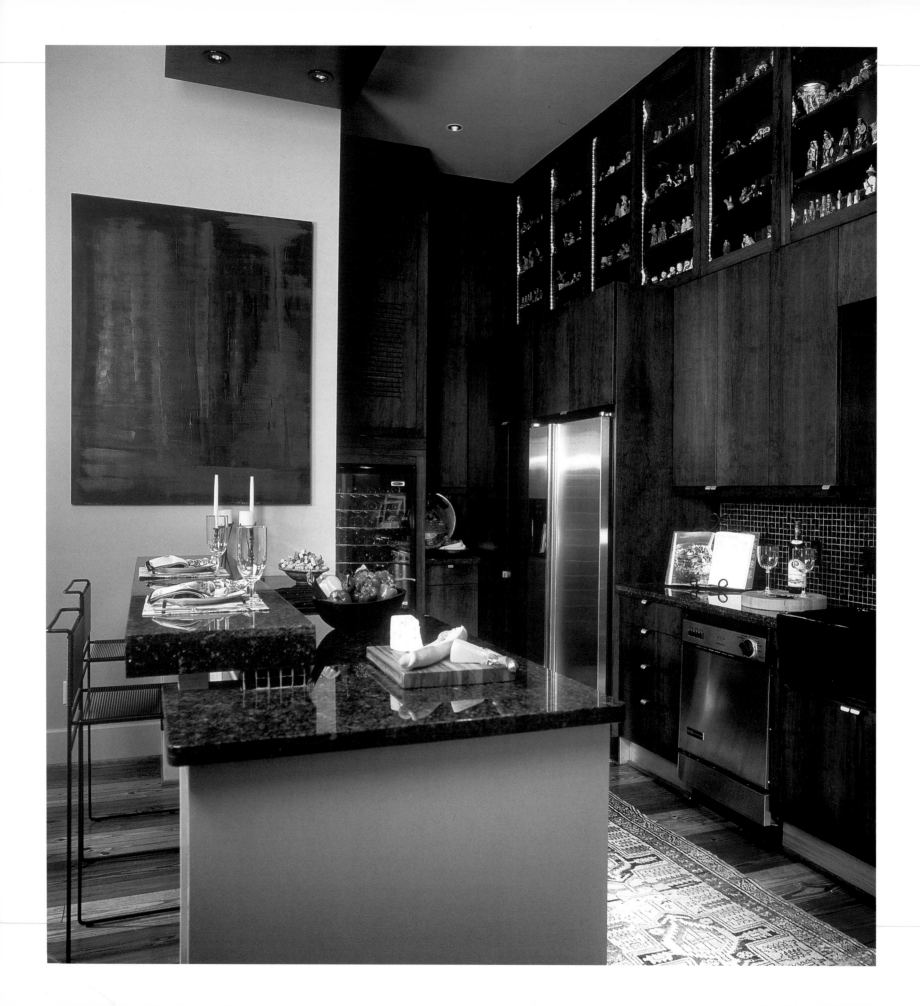

Left: A contemporary painting by Ken's partner Ollie Wilson offers surprise punch in their kitchen. More than 1,000 miniature liquor bottles collected by Ken's grandmother are on display.

Top right: In this living room, Ken creates a home for his client's Egyptian antiques and artifacts. He custom designed several pieces to complete the elegant yet friendly ambiance.

Bottom right: This dining room is the ideal setting for a client's antique china collection and baby grand piano.

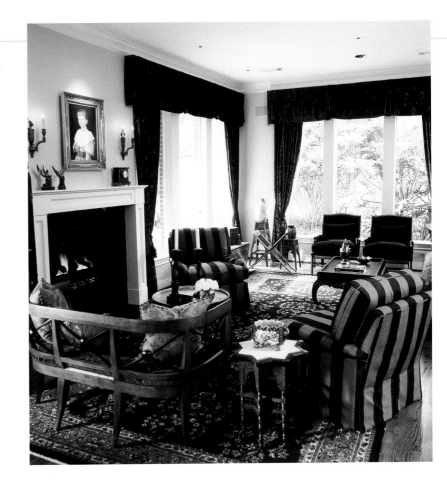

Ken's creative streak extends to the kitchen, where he enjoys cooking healthy comfort food for friends, usually delicious basic meals such as filet mignon with béarnaise sauce and a Caesar salad. He's also a budding wine connoisseur. While he often visits California's Sonoma and Napa valley wineries, he also has tasted wines first hand in Canada, Chile and France, as well as in Texas and the U.S. Northwest. Ken travels extensively, most frequently to southern France where he relaxes and purchases antique furniture for clients. His favorite destination is Bali, Indonesia, for a little fun in the sun.

MORE ABOUT KEN. . .

How do Ken's friends describe him?
They say he's entertaining and sociable.

If he could eliminate one design element from the world, what would it be?
Shiny brass.

What is the single thing Ken would do to a room to bring it to life?
Relight it.

What personal indulgences does he spend the most money on?
Travel, wine and food. Ken loves to eat in great restaurants!

What is the most expensive item Ken has purchased for a client?
An Oriental rug.

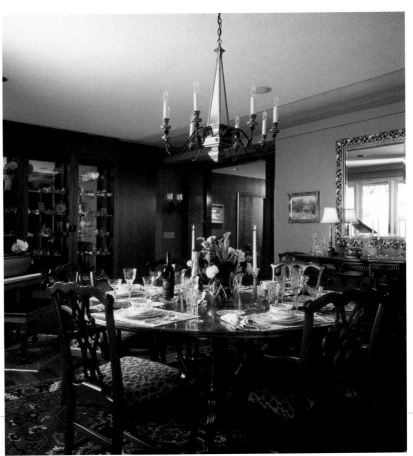

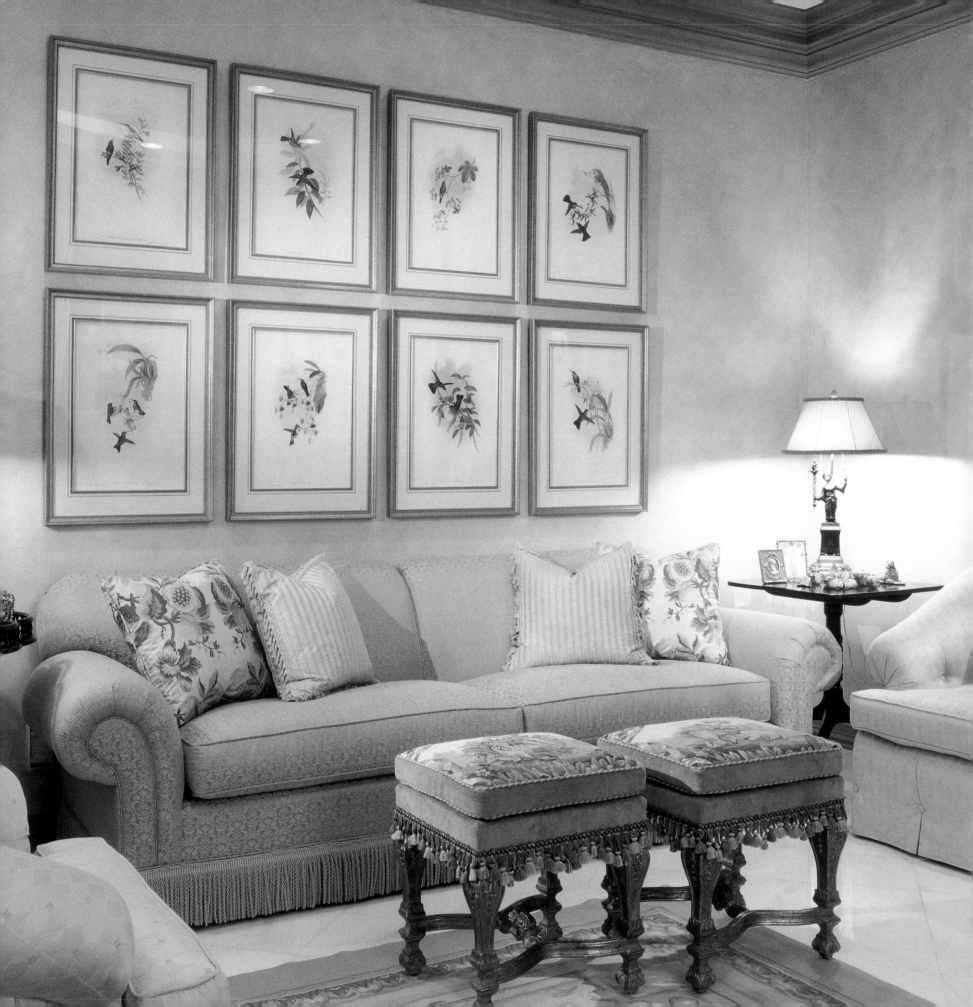

EDWINA VIDOSH

Edwina Vidosh, ASID

Edwina Alexis Interiors

3815 Garrott

Houston, Texas 77006

713-533-1993

Edwina Vidosh understands the meaning of adventure. After receiving a bachelor's degree in psychology and interior design from Texas Christian University, Edwina set out on her own. She chose to begin her interior design career in Chicago because she believed the city was eclectic and "approachable." And she looked forward to delving into its world-famous art district and museums.

This seventh generation Texan knew it was time to leave the Windy City for warmer climes when she thought she had lost her car, then discovered it buried under a small mountain of snow. Returning to her native Houston, Edwina established her design business and, only a year later, was named a rising design star by a respected national trade publication. Since then, Edwina's work in ASID showcase homes and design-related benefit functions has been featured in additional trade publications and the Houston media.

Well known for her classic style, Edwina handles projects ranging from new construction and renovations to accessorizing clients' homes. She strives to create elegant but comfortable environments where families can unite and grow.

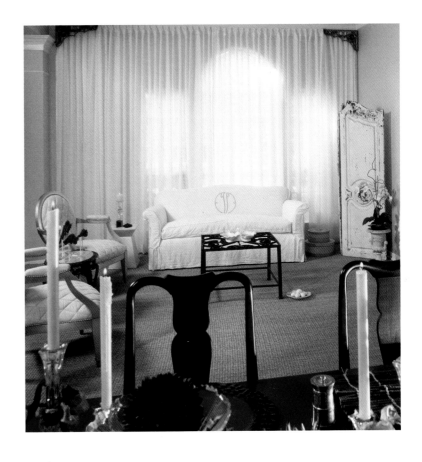

Left: Edwina upholsters 18th century gilded footstools with remnants of a 19th century French Aubusson rug. Antique Audubon engravings are arranged over the Scalamandre silk sofa.

Right: Edwina individualizes her living room with a sofa slipcovered in antique linen with a hand-embroidered monogram, screens made from French armoire doors and a coffee table crafted from a French grate. Baccarat crystal candlestick holders circa 1800s accent the dining room table.

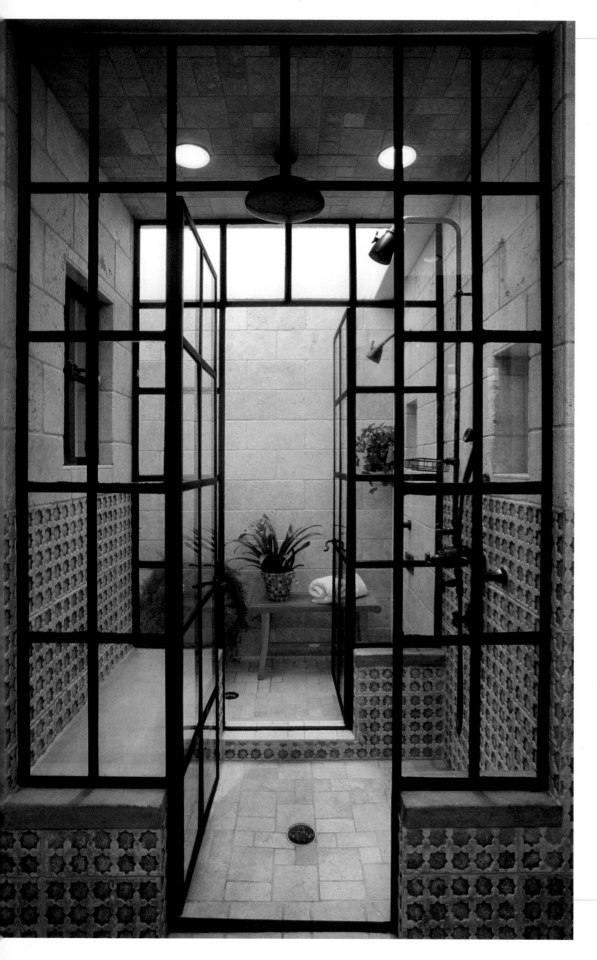

Because her design philosophy hinges on individuality, the most important question Edwina asks a new client is, "How do you want your home to *feel?*" She says it's nearly effortless to create beautiful surroundings. The challenge lies in individualizing each design so it's compatible with a client's personality, needs and lifestyle.

Edwina mixes old and new elements to give a home functionality as well as charm. And she uses clients' treasures throughout her work to add a harmonious personal touch for soulful living.

A home's landscape and outdoor area should be an extension of the interior's design and color scheme, a natural haven for enjoyment and relaxation especially in the Texas climate. Likewise, she encourages clients to bring plants and flowers indoors to subconsciously soothe their psyches.

Edwina always has been a nature lover. Growing up, she spent weekends with family on the equestrian circuit, showing hunters and jumpers across the United States, as well as in Canada, Mexico and Europe.

Left: An indoor shower by Gochman leads to a private outdoor shower where the ceiling is open to the elements. Decorative concrete and travertine marble tiles blend for a natural yet elegant look.

Right: The centerpiece of this luxurious dining room is a table wrapped in Scalamandre warped printed silk taffeta. A subtly striped Roman shade with ruching detail peeks through mocha silk damask drapes. An 18th century tapestry screen hangs above a silver-leaf and marble console.

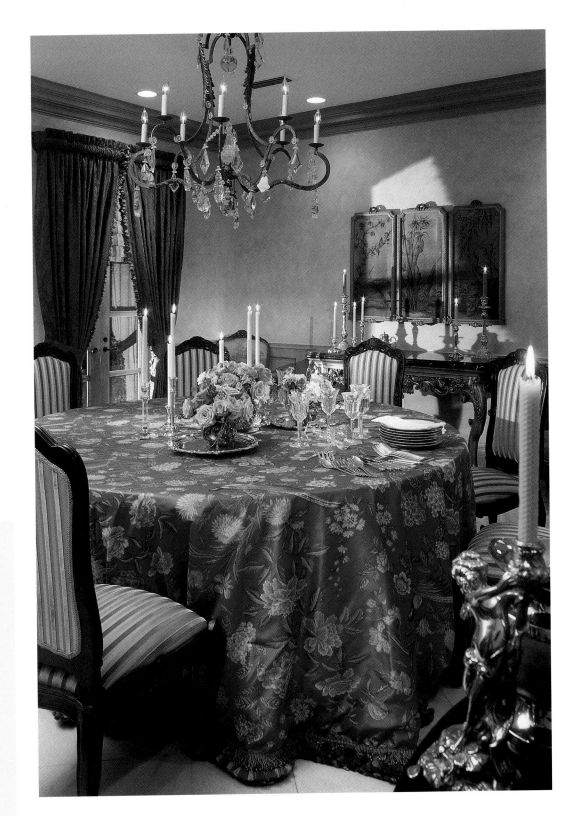

Today, Edwina still is captivated by nature, which brings her balance and tranquility and rejuvenates her creative spirit. She enjoys hiking and horseback riding on her family's ranch, or simply lounging by the swimming pool listening to the waterfall. Edwina finds relief from her busy schedule spending quality time with her husband, Lee, and twin sons, Alex and Brian, who keep her centered.

MORE ABOUT EDWINA. . .

How do Edwina's friends describe her?
They say she is spontaneous, fun and whimsical, and has a sound spiritual base.

What is her favorite color?
Red, because it's exciting yet elegant.

What objects has Edwina had for years that remain in style today?
She likes to use architectural remnants in her designs to add interest in unexpected places.

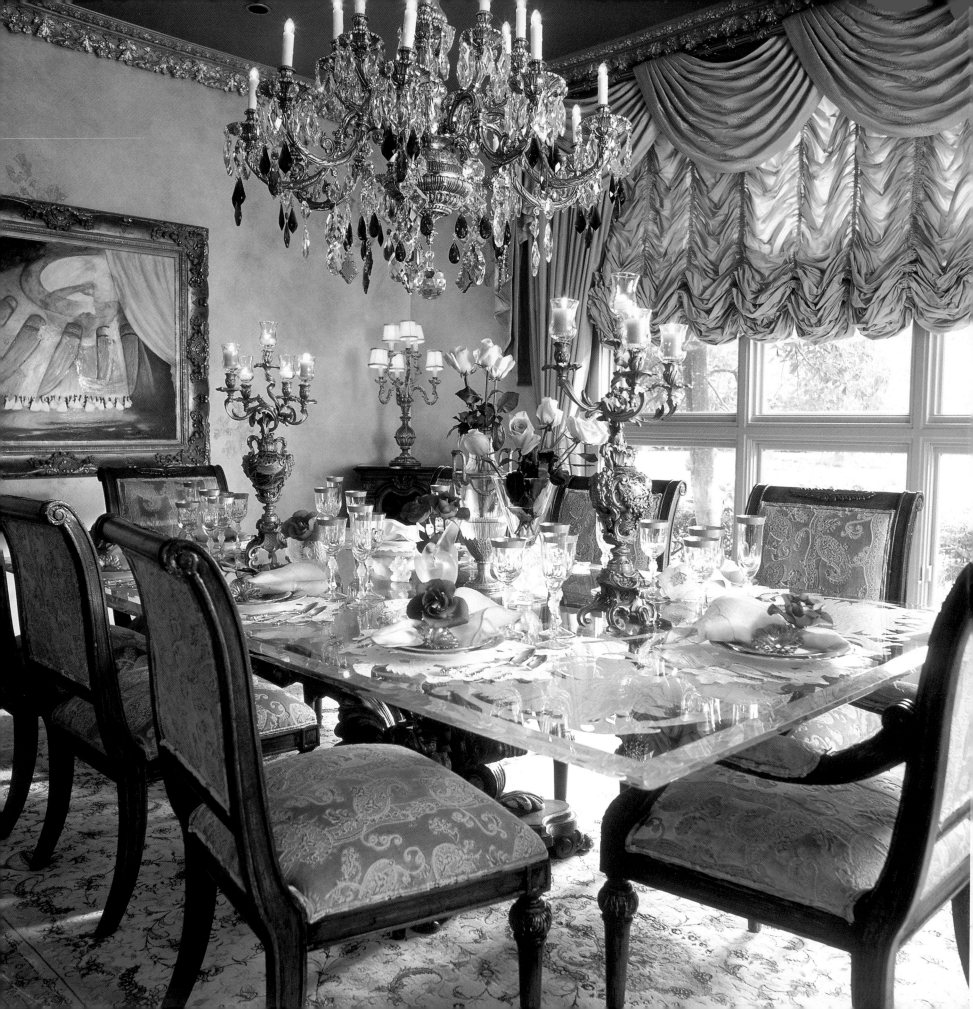

SHERRI ZUCKER

Sherri Zucker, ASID
Brittany Blake Interiors
4323 Richmond Avenue
Houston, Texas 78209
713-780-1337

Sherri Zucker is founder and owner of Brittany Blake Interiors, an award-winning, full-service design firm in Houston. Sherri, who's been creating innovative and luxurious spaces for 34 years, is a member of the American Society of Interior Designers and the International Furniture Design Association and is a licensed board certified interior designer.

With a 13,000-square-foot retail and design showroom displaying everything from upscale furniture and accessories to crystal and linen, Sherri provides the retail and wholesale publics with one-stop shopping. Known for a high-style, elegant, eclectic look, she excels at both residential and commercial design and is considered one of the best colorists in the country.

Inspiration comes easy to Sherri, who often looks to a special fabric for that creative spark. For her, the design business is about people, and bringing beauty into their lives. She says the most important element of a client-designer relationship after talent is service, and Brittany Blake Interiors, named after Sherri's daughter, is known for giving 110%. Perhaps this philosophy has contributed to Brittany Blake Interiors being ranked one of the city's top design firms by the *Houston Business Journal*.

Brittany Blake Interiors has been featured in the *Houston Chronicle* (receiving the 1999 ASID/*Houston Chronicle* Award for Residential Entertainment Space for a Malibu, California, project), *Houston Post*, *Paper City*, *Houston Home and Garden*, Houston's *City Moves* magazine, *House Beautiful* and *Ultra Magazine*. The work of Brittany Blake Interiors also has appeared on the television shows "Lifestyles of the Rich and Famous" and Houston's "The Debra Duncan Show."

Left: Sherri creates a dining room that's a jewel. She surrounds the custom-etched star fire glass-top table with faux-finished walls topped by a gold-leaf frieze. Citron and topaz Austrian crystals hang from the custom bronze doré chandelier.

Above: Sherri transforms a lion-legged console into the world's most sophisticated powder room vanity with black granite top and carved-glass vessel sink. Topaz and amber crystals decorate the chandelier, and the floor combines black granite with glass tile inlaid with 22-carat gold.

Acknowledgements

The professionalism and talent of an extraordinary team of people made this beautiful book a reality. Working with everyone on this project – the most harmonious effort I've ever been part of – was a delight. I've made some great friendships, which are what I cherish most from the experience.

This book would be only a dream if it hadn't been for Brian Carabet. I thank Brian for taking a leap of faith on *Spectacular Homes of Texas* – and me. I am grateful to Brian, the love of my life, for believing in my vision. I will always remember his generous support and continual encouragement. Thank you, Brian. Your guidance kept me grounded.

Many thanks to the interior designers and designers in this book – the real creators of *Spectacular Homes of Texas*. Their exquisite artistry and tasteful style make the photographs jump off the page. I owe Robin Black and Bobby Kremer a huge thank you for helping me identify some of these great designers.

I am especially thankful to the book's designer, Derrick Saunders, whose focus and creativity were outstanding during the book's design and production. Derrick's visionary gifts bring life to each layout.

Danny Piassick's photos are divine. I am indebted to Danny's willingness to get up early in the morning and drive with me to Houston on a whim to photograph a home. His professionalism during each shoot was incomparable. Not only do I adore Danny, but everyone he met and photographed adored him as well.

An extra special thank you goes to Chris Bell, editor and writer. Chris's unswerving faith in my vision and her diligence during the process made assembling this book a joy.

Personal thanks go to my mom, Jonnie Shea, and my friends who were so generous with their support – Trish Bollman, Carrie Dennis, Kara Shea, Lori Bollman, Patty Dorocy, Sylvia Felter, Tammy Emmele and Shawnee Wimberly. Thanks to everyone for being so thrilled for me. It's been exciting to share this project with you.

I am fortunate to be surrounded by such fantastic people in my life. And I am especially grateful to have been given the opportunity to work with such skilled professionals during this book's production. The project has been so much fun that I don't feel like I worked a day during the process.

With heartfelt appreciation,

Jodie Carpenter

Brian Carabet

Brian is owner and president of Signature Publishing Group. With more than 20 years of experience in the publishing industry, he has produced more than 100 magazines and books. He treasures his Allison Lefcort painting of Roy Orbison because it conjures up great memories of the days when he produced concerts for Roy.

Danny Piassick

Danny, the book's principal photographer, resides in his live-in studio in downtown Dallas with three dogs and his Harley. His favorite piece is a 1954 Schwinn Phantom black bicycle that hangs from his kitchen ceiling.

Jolie Carpenter

A native Texan from New Braunfels, Jolie is the creator of *Spectacular Homes of Texas* and also works in private practice as a psychotherapist. She loves her Kreiss and Yves Delorme bedding in her softly lit gold and white bedroom – her sanctuary for relaxation.

Derrick Saunders

The book's graphic designer, Derrick, is also a talented artist. He lives in an engaging 1920s home in Fort Worth and prizes the bathroom countertops he designed and built.

Crystal C. Bell

Chris, the book's editor and writer, is an investor relations and PR consultant. She believes her antique transferware and majolica plate collections add incomparable charm to her English Tudor-style Dallas cottage.

Vicki Lindsey

Vicki, trusted Signature Publishing office manager, handles details with ease. She enjoys her fireplace, especially when she's sitting in front of a crackling fire finishing detail work on one of her handmade recycled blue-jean purses.

DIFFA
DESIGN INDUSTRIES FOUNDATION
20 YEARS FIGHTING AIDS

The Design Industries Foundation Fighting AIDS turns 20 in 2004. With 15 chapters and community partners, DIFFA is one of the largest funders of HIV/AIDS service and education programs in the United States. Since its founding in 1984, DIFFA has mobilized the immense resources of the design communities to provide more than $31 million to hundreds of AIDS organizations nationwide.

Started with volunteers from fashion, interior design and architecture, DIFFA now has supporters from every field associated with fine design. DIFFA's fundraising activities are among the most celebrated in AIDS philanthropy.

DIFFA grants are available to AIDS service organizations that provide preventative educational programs targeted at populations at risk of infection, treatment and direct-care services for people living with AIDS, and public policy initiatives that contribute resources to private sector efforts.

AIDS is not over. Find out how you can help DIFFA work toward a world without AIDS by visiting www.DIFFA.org.

DIFFA Dallas
1400 Turtle Creek Blvd., Suite 147
Dallas, Texas 75207
214-748-8580

DIFFA Houston
P.O. Box 131605
Houston, Texas 77219
713-528-0505

Photography Credits

Mali Azimi ...48, 49

Terry Balch186, 187, 188, 189, 189

Paul Bardagjy ...185, 185

John Benoist ...9

Fran Brennan ...181, 182, 183

Francki Burger ...85

Van Chaplin ...*177

*©*Southern Living* magazine*

Leigh Christian ...133

George Craig ...190, 191

Ben Darresano ...89

Swain Edens1, 138, 139, 140, 141, 142, 143, 148,
149, 154, 155, 156, 157, 158, 159

Libby Goff ...9

Brian Harrison44, 45, 46, 47

Lynn Herrmann ...131

Steve Hinds ...21, 21

Richard Klein ...68, 70

Alyssa Klossner ...92, 93

Mark Knight94, 95, 96, 97, 102, 103,
104, 105, Front Cover

Rick Kroininger ...153

Kevin Hunter Marple32, 33, 33, Front Flap

Thomas McConnell2, 3, 90, 120, 121, 121, 122,
122, 123, 124, 125

Emily Minton-Redfield14, 40, 41, 42, 42, 43, 50,
51, 86, 87, 88

Ira Montgomery23, 24, 25, 26, 27, 54, 55, 55,
56, 56, 62, 63, 65

Rob Muir200, 202, 203, 204, 204, 205, 206,
207, 208, 209

Mary E. Nichols ...80

Michael Osborne128, 129, 130, 132,
150, 152, 152

Dan Piassick4, 8, 10, 11, 12, 12, 13, 16, 17, 17, 18, 19, 20,
28, 29, 30, 30, 31, 34, 35, 36, 37, 38, 39, 52,
57, 58, 59, 60, 60, 61, 61, 64, 68, 69, 71, 72,
73, 74, 75, 76, 77, 78, 79, 98, 100, 101, 101,
107, 110, 126, 135, 136, 137, 144, 145, 146,
147, 147, 160, 162, 163, 164, 165, 165, 166,
167, 168, 169, 170, 171, 184, 192, 193, 194,
195, 196, 196, 197, 198, 199, 199, 210, 211, 213

Hall Puckett ...Back Cover

Hickey Robertson178, 180, 180

Jeremy Samuelson114, 115, 116, 117, 118, 119,
172, 173, 174

Rex Spencer106, 107, 175, 176

Tim Street-Porter82, 84, Back Flap

Ann Tucker ...99

Peter Vitale*81, 108, 109, 111, 112, 113

*for *Veranda* magazine*

James F. Wilson ...22

Michael Wilson ...83

Index of Designers

Renea Abbott-Manteris162

Kelly Gale Amen166

Ginger Barber172

Paige R. Baten-Locke8

Debbie Baxter128

Richard Branch178

Joe Burke120

Bryn Butler92

Orville Carr134

Kathryn Clinton10

David Corley14

Hilary Crady190

Jane-Page Crump184

Derrick Dodge138

Julie Evans94

Adrienne Faulkner-Chalkley18

Charles A. Forster144

Gloria Frame190

Sherry Hayslip22

Marla Henderson98

Jenny Heusner100

John Holstead28

Doug Horton66

Kim Johnson34

Susie Johnson102

Helen B. Joyner192

Marcia Kaiser198

Ken Kehoe200

William Alexander Kincaid106

Allan Knight40

Diane Linn42

Lisa Luby Ryan46

Lolly Lupton58

Toni McAllister148

James McInroe50

Kim Milam34

Christi Palmer150

Gay Ratliff108

Marilyn Rolnick Tonkon52

David Salem58

Fern Santini114

Justin Seitz34

Mark Smith120

Beth Speckels62

Neal Stewart66

Richard Trimble72

Cheryl Van Duyne76

Edwina Vidosh206

Trisha Wilson80

Joanie Wyll86

Don Yarton154

Sherri Zucker210